THE ICONS OF THEIR BODIES:
SAINTS AND THEIR IMAGES IN BYZANTIUM

THE ICONS
OF THEIR BODIES

Saints and their Images in Byzantium

HENRY MAGUIRE

Princeton University Press
Princeton, New Jersey

COPYRIGHT © 1996 BY PRINCETON UNIVERSITY PRESS

PUBLISHED BY PRINCETON UNIVERSITY PRESS, 41 WILLIAM STREET, PRINCETON, NEW JERSEY 08540

IN THE UNITED KINGDOM: PRINCETON UNIVERSITY PRESS, CHICHESTER, WEST SUSSEX

ALL RIGHTS RESERVED

WWW.PUP.PRINCETON.EDU

LIBRARY OF CONGRESS CATALOGING-IN-PUBLICATION DATA

MAGUIRE, HENRY

THE ICONS OF THEIR BODIES: SAINTS AND THEIR IMAGES IN BYZANTIUM/HENRY MAGUIRE

P. CM.

INCLUDES BIBLIOGRAPHICAL REFERENCES AND INDEX

ISBN 0-691-02581-9 (CL : ALK. PAPER)

ISBN 0-691-05007-4 (PB : ALK. PAPER)

1. ICONS, BYZANTINE. 2. ORTHODOX EASTERN CHURCH AND ART.

I. TITLE

N8189.B9M34 1996 2000 704.9'482—DC20 96-4113 CIP

THIS BOOK HAS BEEN COMPOSED IN MONOTYPE BEMBO

PRINTED IN HONG KONG

FIRST PAPERBACK PRINTING, 2000

10 9 8 7 6 5 4 3 2 1

10 9 8 7 6 5 4 3 2 1 (PBK.)

CONTENTS

LIST OF FIGURES

The source of the photograph is indicated in parentheses.

PREFACE

This book was born out of a conviction that the true subject of art history is art and that the practice of art history begins with seeing. Nevertheless, the present work is indebted above all to a historian, Alexander Kazhdan, who first opened my eyes to the importance of the written saints' lives for understanding Byzantine art. In 1989 I had the privilege of collaborating with him on the preparation of an article,[1] which became the kernel from which this study has grown. There is no doubt that had Alexander Kazhdan been the gardener, rather than myself, the plant would have grown in another direction and assumed a different, and surely better, form. All the same, my debt to him is profound and gratefully acknowledged.

Many other colleagues have contributed to this work in ways both direct and indirect. In particular, I am indebted to the participants in two seminars, on the shrine of the Virgin of the Source at Constantinople and on Byzantine epigrams devoted to works of art, which were held at Dumbarton Oaks in 1992 and 1993 respectively, and especially to Alexander Alexakis, Ihor Ševčenko, Lee Sherry, Alice-Mary Talbot, and Wolfram Hörandner. A graduate seminar at the University of Illinois on the saints in medieval art gave me an opportunity to test some ideas before a critical audience of students from various fields of art history; I am grateful for their insights, especially for the reference to the Menas textile provided by Eric de Sena. On numerous other occasions I have benefited from the advice and counsel of friends and colleagues, especially Peter Brown, Carolyn Connor, Vassa Contoumas, Kathleen Corrigan, Slobodan Ćurčić, Anthony Cutler, Sharon Gerstel, Anna Gonosová, Herbert Kessler, Cécile Morrisson, Andréas Nicolaïdès, Nancy Ševčenko, and Denis Sullivan. I am indebted also to Charles Barber for the reference to the Iconoclastic Council of St. Sophia that provided the title of this book[2] and to the two anonymous readers of the Princeton University Press for their numerous suggestions for improvements. In the last stages, Hedy Schiller and Allison Sobke provided invaluable help in updating disks and obtaining photographs.

I am grateful to two institutions for permission to make use of material from articles that I previously published in periodicals or collective volumes produced by them: to Dumbarton Oaks for portions of chapters 1 and 3, and to the Department of Art and Archaeology at Princeton University for sections of chapters 2 and 4.

It is a bittersweet task to record the help of two colleagues who have passed away. I profited greatly from conversations with Svetlana Tomeković, and from hearing her speak of the iconography of the saints in Byzantine art, a field that she knew so well. Sotirios Kissas with characteristic generosity showed me the painted churches of Kastoria and its region, and shared his unrivaled knowledge. Their writings continue to instruct and their memory to give heart.

Finally, I owe continuing debt to Eunice Dauterman Maguire for guidance and support in matters both magical and practical.

<div style="text-align: right">

Dumbarton Oaks,
July 1994

</div>

THE ICONS OF THEIR BODIES:
SAINTS AND THEIR IMAGES IN BYZANTIUM

INTRODUCTION

The Byzantines surrounded themselves with their saints, invisible but constant companions, whose bodies were made visible by dreams, by visions, and by art. For the Byzantines, it was the image, whether in icons or in visions, that made the unseen world real, and the unseen world that gave real presence to the image. The composition and presentation of this imagined gallery followed a logical structure, a construct that was itself a collective work of art created by Byzantine society. My purpose in this book is to analyze the logic of the saint's image in Byzantium, not from the perspective of a social historian but from that of an art historian. In other words, it is my main intention to discuss not the role that icons had in Byzantine society but rather the role that society had in the design of icons. In the centuries after the end of the iconoclastic controversy in the ninth century, the Byzantines gave to their images differing formal characteristics of movement, modeling, depth, and delineation according to the tasks that the icons were called upon to perform in the all-important business of communication between the visible and the invisible worlds. The design of the artwork was conditioned by the nature of the saint's role in relation to the viewers and users of the icon. The perceived role of the saint reinforced the characteristic appearance of the icon, while the appearance of the icon in its turn reinforced the perception of the saint's role.

This book falls into four chapters. The first is devoted to the problem of the verification of icons and to the Byzantine concept of the sacred portrait as it was developed after the end of iconoclasm—a concept that was closer to what we would call definition than to portraiture. Here are discussed the requirements of good definition as they were seen by the Byzantines, and how those requirements controlled the distinctive features of their images of holy men and women, including costumes and attributes, facial features, and inscriptions. The second chapter describes the different formal qualities of modeling and movement given by post-iconoclastic Byzantine artists to each class of saints, and demonstrates the correspondences between the physical forms of the saint's images and the varying roles that they were believed to play in the invisible processes of intercession and salvation. The third chapter considers the questions of why and when the Byzantines developed this system of hagiographic portraiture. It shows that during the early centuries of Byzantium the problem of magic played an important part in

the conceptual debates concerning icons, especially since images of the saints were perceived as an important recourse against envy and the malice of demons. As a consequence of the iconoclastic dispute of the eighth and ninth centuries, it became necessary to circumscribe more strictly the ways in which images were functioning in order to exclude any possibility of their autonomous operation. The post-iconoclastic restriction of the role of icons had a decisive effect upon their physical appearance, resulting in the development of a much more regulated display and iconography of sacred portraits. Finally, the last chapter turns from portrait icons to narrative depictions of the lives of the saints, and shows how the visual biographies also had differing formal characteristics that enabled them to work in different ways on behalf of the viewer.

The presentation of the Byzantine system of sacred portraiture and narrative that is given in these pages emphasizes the norms. My discussion is intended to lay bare the anatomy of a visual language rather than to describe all the small variations and accidents to which the flesh structured by that anatomy was subject. For this reason, the book for the most part is not concerned with Byzantinizing art produced beyond the borders of the empire, where the rules might be broken, often creatively. Nevertheless, the visualization of the saints in Byzantium did not have an anatomy that was dry and dead. It was a living structure, one which responded to the Byzantine viewers' deeply felt emotional and spiritual needs.

The reader of this book will find two bibliographies. The first, and longer, bibliography gives the most important secondary literature that is pertinent to the topics of each chapter. In addition, there is a short bibliography of relevant saints' lives in translation, for these biographies offer the most direct and the most vivid insight into the everyday experience of art in Byzantium.

LIKENESS AND DEFINITION

The concept of sacred portraiture that developed in Byzantium after the end of iconoclasm in the ninth century was different from our own.[1] Many of the features that a modern viewer expects to see in a portrait were considered by the Byzantines to be unnecessary in a likeness, or even distracting. For them, in order to be lifelike, a portrait had only to be accurately defined in relation to the portraits of other saints.

However viewers today may describe Byzantine portraits, there is no doubt that the Byzantines themselves considered them to be true-to-life. In the biographies of the saints, Byzantine writers frequently claimed that their painters could produce lifelike portraits, both of saints who were still living or who had only recently died, and of those who were already long dead at the time that their images were made. For example, the Life of Athanasios, the tenth-century abbot of the Monastery of the Great Lavra on Mount Athos, states that Kosmas, the former sacristan of the monastery, saw a portrait of the abbot whom he had known personally and immediately recognized "that it was accurately made to the highest degree of likeness."[2] It is possible to visualize what kind of portrait this was from a drawing that serves as the frontispiece to a copy of the saint's biography in the library of the Great Lavra (fig. 1). The sketch was probably made in the eleventh century, sometime after the saint had died in 1004. It shows the features that were to become standard in portraits of Saint Athanasios of Athos in Byzantine art, namely a high, domed forehead, a receding hairline, and a forked, white beard.[3]

Another case in which a contemporary, or near contemporary, of a saint acknowledges his portrait to be very lifelike can be found in the Greek Life of Saint Pankratios of Taormina, a disciple of Saint Peter. This biography was supposedly written by Pankratios' successor as bishop of Taormina, his disciple Evagrius, but in reality it may be as late as the ninth century. Evagrius describes how, after the death of Pankratios, he built a church and decorated it with paintings:

> I adorned the whole building with the story of the Old Testament, . . . according to the Book of Genesis. In another place I had the story of the New Testament depicted. I also depicted the appearance of my lord Pankratios in an

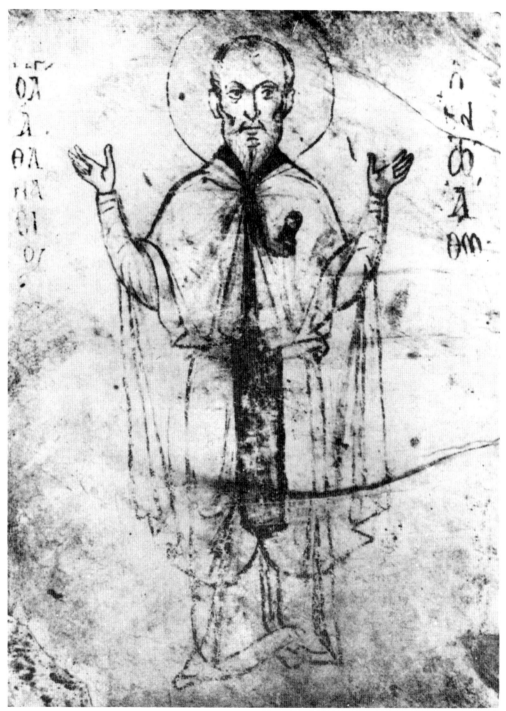

1. Mount Athos, Monastery of the Great Lavra, MS K122, fol. 4v (Life of St. Athanasios): St. Athanasios

image, precisely as he once was. And when I see his reverend appearance in the image, it seems to me then that I meet with him in the flesh and look upon him.[4]

The Byzantines, therefore, could claim that their images were sufficiently lifelike to give viewers the impression that they were actually with a saint in person. How was such verisimilitude achieved? The saints' lives make it plain that sittings were often necessary for artists to achieve the required degree of likeness. This was the case both for living saints and for those who had been long deceased. One of the most graphic accounts of a sitting for a portrait is contained in the early-eleventh-century Life of Irene, abbess of the convent of Chrysobalanton, in Constantinople. We learn from the text that Irene was a contemporary of the emperor Basil I (867–886), who sentenced to death a relative of the saint who had been wrongfully accused of treason. The emperor had the condemned man thrown into a dark dungeon in the palace, and a rumor went around that he was going to be thrown into the Bosphoros at night. His family appealed to Saint Irene for her aid. The saint intervened by appearing that night to the emperor in a vision; he awoke from his slumber to see an unknown woman standing beside his bed. The woman commanded Basil to release her kinsman because the accusations against him were false. She then announced her name three times and poked the emperor sharply in his side to make sure that he realized that he was awake and not dreaming, and vanished through the bolted doors of his bedchamber. The next morning the alarmed emperor sent his high officials, including the *protovestiarios* and the *sakellarios*, to the nunnery. The envoys also took in their retinue a painter to make the portrait of the abbess. Once they had reached the convent, they managed to engage her in conversation sufficiently long for the painter to produce an accurate likeness of the saint. When this portrait was brought back to the emperor, he was frightened by the degree of its resemblance to the woman whom he had seen in his vision.[5] The eleventh-century biographer, therefore, felt that a sitting was necessary to produce an accurate likeness, and he considered that the sitting should last a certain length of time.

Another case of a sitting being required to produce the portrait of a living saint can be found in the much earlier biography of Theodore of Sykeon, who died in 613. The author of the Life was Theodore's disciple George, who wrote at some time after the year 641. According to George, the monks of the monastery of St. Stephen of Rhomaioi in Constantinople wished to set up a portrait of Theodore of Sykeon in their monastery so that they could remember the saint through it and obtain his blessing. They asked an artist to paint Theodore's portrait, but the saint

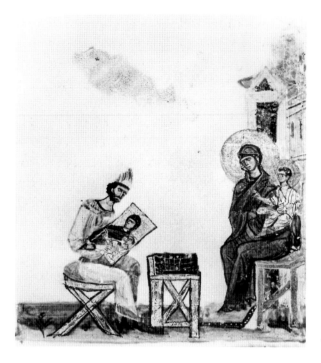

2. Jerusalem, Greek Patriarchal
Library, MS Taphou, 14, fol. 107v
(homiliary): St. Luke paints the
Virgin and Child

seems to have been reluctant to have his picture taken. The painter had to resort to
the subterfuge of spying on the holy man surreptitiously through a small hole in
order to obtain his likeness without being seen. Later, the saint was asked to bless
the portrait; he complied but accused the painter of theft.[6]

The first artist who painted the portrait of a saint from life was none other than
the evangelist Luke, who, according to legend, painted the Virgin with her child.
This session was illustrated by Byzantine artists, such as the eleventh-century illu-
minator of a book of homilies now in the collection of the Greek Patriarchal
Library at Jerusalem (fig. 2). In the miniature, the seated saint can be seen carefully
reproducing the features of his models on the panel that he holds on his lap. The
icon he is painting is of the well-known *Hodegetria* type, in which Mary holds
Christ on her left arm and gestures toward him with her right hand, while the
seated child blesses with his right hand and holds a scroll in the other. Thus, the
Hodegetria icon did not represent a conventional type for the Byzantines, as it
does for modern art historians who classify images; rather, it reproduced a real-life
posing at a specific moment in time, which was captured for all time by the artist.

These stories of sittings involved saints who were living contemporaries of the
painters. But what was the artist to do if the saint was dead? How was he to
obtain an accurate likeness if the saint was no longer available to pose for a por-

trait? The best solution was for the sitting to be arranged miraculously, and the saints' lives contain several stories of this type. One of the best known is found in the Life of Saint Nikon the Metanoeite of Sparta, who died in the early eleventh century; his biography was written by a later abbot of Nikon's monastery at Sparta, perhaps in the mid-eleventh century. Nikon the Metanoeite was a saint who modeled himself on John the Baptist and on his call to repentance. His physical characteristics, as they are described in the Life, also resembled the characteristic features of John the Baptist in Byzantine art. We are told that Nikon wore a tattered garment and was tall in stature, but the limbs of his body shriveled, and his face became withered from fasting: "His face," said his biographer, "changed due to his excessive asceticism and became emaciated." His hair and beard were black, and the appearance of his head was squalid.[7] These features may be seen in the earliest surviving portrait of the saint, the mosaic in the monastery church of Hosios Loukas, which dates to the first half of the eleventh century (fig. 3). Here may be found the long face of the ascetic, the sunken cheeks, and the disheveled black hair that hints at holy squalor. In a similar fashion, a long face and disheveled black hair characterize the mosaic portrait of Nikon's role model, Saint John the Baptist, that is preserved in the same church (fig. 4).

The original portrait of Saint Nikon, however, was not the mosaic at Hosios Loukas, but a now lost painting which the author of the Life tells us was venerated in the saint's shrine at Sparta. This image had been produced in the following manner. A local grandee of Sparta, named John Malakenos, was saved by Nikon from conviction and punishment for the crime of treason. After the death of the saint, Malakenos wanted a portrait of his savior. He found a skilful artist and described to him Nikon's exact appearance—his stature, his hair, and his dress—and asked the painter to produce a likeness on a panel. The artist went back to his home and tried to start work on the image, but he could not paint. He could not, says the Life, recreate the precise similarity of a man he had never seen, even though he possessed the utmost skill in his profession. At this point a monk entered his house and claimed a perfect similarity to Nikon. The artist rushed to his panel, intending to start painting from this fortuitously provided sitter, only to find the holy appearance of the saint already automatically impressed (ektypōtheisa) upon the wood. When the artist turned to look at the mysterious monk once again, he found that his visitor had vanished. The artist finished the painting and brought it to Malakenos, who found it to be an indistinguishable likeness of Nikon.[8]

The author of this story enhanced its effectiveness by deliberately echoing the automatic creation of the holy mandylion of Christ. The mandylion was an image of

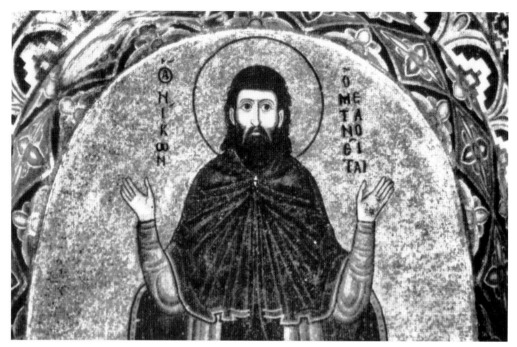

3. Hosios Loukas, Katholikon, mosaic: St. Nikon

the features of Christ miraculously imprinted onto a towel, which Christ had sent
to King Abgaros of Edessa when the latter had fallen ill. This famous relic was
transferred from Edessa to Constantinople by the Emperor Constantine VII in 944,
following upon Byzantine military successes against the Arabs. Constantine VII had
an account of the translation written, in which the mandylion was referred to as an
"image," or "impression" (*ektypōma*) that was without colors.[9] The biographer
implies that Nikon, in a similar manner, arranged for his features to be miracu-
lously, and accurately, reproduced on the panel for the benefit of Malakenos.

 Another story of a supernatural sitting is contained in the Life of a female saint,
Maria the Younger of Vize, in Thrace, who died in 903. According to her biogra-
pher, who wrote in the eleventh century, Saint Maria appeared after her death to
an old painter, who lived as a recluse, and commanded him to paint her icon "as
you see me now." She asked the artist to represent her on the icon in company
with her two boys and her maidservant, Agathe. The old man produced her image
"as he had seen her in his dream." When the portrait was finished, he sent it to
Vize, her hometown. The people there who had seen Maria when she was alive
were amazed by the icon's resemblance to the woman they had known.[10]

 In some cases, therefore, a miracle enabled an artist to take the likeness of a

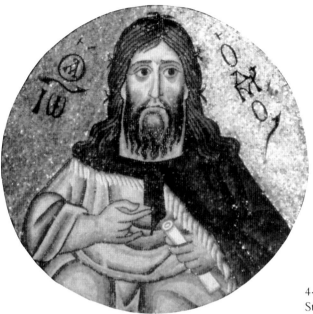

4. Hosios Loukas, Katholikon, mosaic:
St. John the Baptist

saint who had died. But what was the artist to do if the saint was dead and no
miracle provided a sitting? It was an important axiom of icon theory that the
icons venerated by the Byzantines were not new inventions but accurate copies of
their prototypes. Thus, the ninth-century patriarch Nikephoros, in one of his
polemics against the iconoclasts, contrasted Christian iconography with the mon-
strous inventions of the pagans, writing: "We say that the depicting or imaging of
Christ did not take its origin from *us*, nor did it begin in our age, nor is it a new
invention. The picture has the authority of time, it is preeminent in its antiquity,
it is coeval with the proclamation of the Gospels."[11] In other words, the images of
Christ and of his saints were authentic portraits of the persons portrayed, however
long ago they had lived. In order to produce this authenticity, one icon had to be
copied laboriously from another. The process of copying is shown in a miniature
in a ninth-century manuscript, now in Paris, containing the *Sacra parallela*, an
anthology of texts attributed to John of Damascus (fig. 5). The painting illustrates
a passage from one of the letters of Saint Basil the Great, who explained that
"painters, when they paint icons from icons, looking closely at the model, are
eager to transfer the character [i.e., features] of the icon to their own master-
piece."[12] However, Basil also complained that artists, while copying icons, usually
wandered from the archetype.[13] The Byzantines were well aware that in the
process of copying, inaccuracies could be introduced. Their anxiety about the

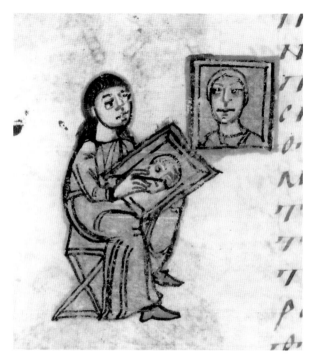

5. Paris, Bibliothèque Nationale, MS gr. 923, fol. 328v (*Sacra parallela*): painter copying an icon

accuracy of copies from icons even haunted their dreams, as we discover from the dream book of Achmet, a compilation of interpretations which was probably put together in the tenth century. Achmet gave the following advice:

> If a king dreams that he ordered icons of the saints made, . . . and if the copies of the icons succeed in their accuracy, his [waking] affairs also will succeed; if not, the opposite will happen. Likewise, if the dreamer is a commoner, each of his actions will turn out in accordance with the success [that is, the accuracy] of the copies.[14]

Therefore, in order to be effective, the icons of the saints had to be true. But how was it possible to check the veracity of icons of saints who had died a long time ago? Here, again, dreams and visions had an essential role to play, for they enabled the verisimilitude of icons to be matched against the actual appearance of long-deceased saints. There were two mechanisms for this process of checking. By the first mechanism, an icon would be verified by a subsequent vision of the saint. By the second mechanism, a vision of a saint would be verified by a subsequent viewing of his or her icon—for visions, as well as icons, might be false. From the outsider's perspective, the whole process was circular, but to the Byzantines it provided reassurance and reaffirmation for their faith in both their saints and their icons.[15]

A typical example of a story in which an icon is verified by a vision is related in the Life of Saint Stephen the Younger. Stephen the Younger was a saint of Constantinople who defended the cult of icons and was martyred by the iconoclast Emperor Constantine V in 765. His biography was written by another Stephen, the deacon, in 807. We are told that the mother of Saint Stephen the Younger went to the church of the Blachernae in Constantinople to pray for a son. She addressed her prayers to an image in the church which showed the Virgin Mary holding her own son Jesus in her arms; the text says that Stephen's mother stood in front of this icon and beseeched it with tears. Later, she had a vision in which the Virgin appeared to her in "the same form" (*homoioplastōs*) as she was shown in her image in the church. The Virgin struck Saint Stephen's mother in her loins, promising her that she would have a son. As the biographer explained: "By such means, she who in a maternal way most swiftly moves her son's pity to the succor of our race, transformed the despondent woman into a contented mother."[16]

Here, then, it was the vision that corresponded to the icon; but in other cases it was the icon that corresponded to the vision. Dreams and visions, being usually private and outside regular social controls, were inherently suspect. Their origin could just as well be from the devil as from God. The ambivalent status of dreams was succinctly explained by Niketas David Paphlagon, the author of a biography of the ninth-century patriarch Ignatios. He said: "Even if many dreams have their source in daily thoughts and cares, many are conjured up in sleepers by demons; but it also happens that they are formed by angels of God on His command."[17] The problem then, for the Byzantines, was to determine the nature of a dream's source, whether it was holy or unholy. Here an icon could provide useful assurance that a nocturnal visitor had been saintly and not demonic. We have already encountered a case of this type in the story of the condemned kinsman of Irene of Chrysobalanton. It will be recalled that when Irene made a supernatural appearance to Basil I by night, in order to demand her relative's release, she poked the emperor in his side to make sure that he realized that he was awake and not dreaming; for a dream that was entertained while asleep was inherently more suspect than a vision seen while awake. All the same, the emperor still felt that his vision was diabolic in origin; the following morning he summoned the condemned man and accused him of working magic and sorcery. The biography explains that Basil's doubts were removed only after he had seen that the newly made portrait of Irene matched the woman whom he had seen in his vision.[18]

A similar story of this type comes from the Life of Pope Sylvester, who was in office between 314 and 335, during the reign of Constantine the Great. The dating

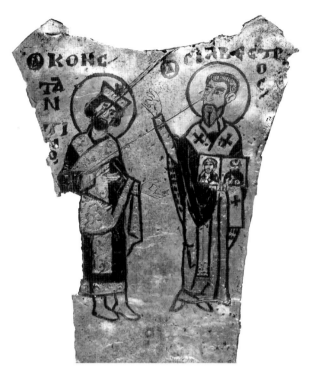

6. Washington, D.C., Dumbarton Oaks, silver cross: Pope Sylvester displaying icons of Peter and Paul to the Emperor Constantine

of the Greek version of the Life is debated, but it may belong to the second half of the eighth century. In this Life, and in various legends dependent upon it, we are told how Constantine fell ill and subsequently had a dream in which he was approached by two men who, identifying themselves as Peter and Paul, promised to cure him on condition that he summon the pope. However, the emperor did not know his two visitors and consequently did not know whether or not he should trust the dream. When Sylvester came before Constantine, the pope showed the emperor bust-length icons of the apostles Peter and Paul, and Constantine acknowledged that the apostles in the portraits were the same individuals as the men who had appeared to him by night. Thereupon, Constantine allowed himself to be baptized.[19] This story is illustrated on an eleventh-century nielloed silver cross, now at Dumbarton Oaks, which shows Pope Sylvester displaying the two icons of Peter and Paul to the emperor (fig. 6); in spite of their small size, the saints in the images held by the pope can readily be recognized by their usual portrait types, that is, by the short beard and short, light-colored hair of St. Peter and by the balding hair and dark, pointed beard of St. Paul.

A third story that has the icon confirming the vision is found in the Life of the fifth-century Saint Elisabeth the Wonderworker. According to her medieval

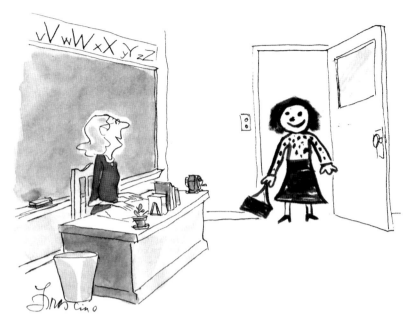

7. "Mrs. Hammond! I'd know you anywhere from little Billy's portrait of you." Drawing by Frascino; © 1988 The New Yorker Magazine, Inc.

biographer, shortly before her death, Saint Elisabeth was at prayer in the church of the Theotokos Chalkoprateia in Constantinople, when she saw a vision of Saint Glykeria. Following instructions from the apparition, Saint Elisabeth went to another church in the city, the shrine of the martyr Romanos, where she recognized an icon of the woman she had just seen in the church of the Theotokos Chalkoprateia. As if to allay any doubts and to make sure that there was no mistake, Glykeria spoke to Elisabeth again from the icon: "I whom you see even now, am also she whom you saw before in the church."[20]

METHODS OF DEFINITION

Many modern critics have been puzzled by the Byzantines' claims that their images were true-to-life and precisely resembling their subjects, for viewers today tend to observe that Byzantine icons do not look "lifelike" at all.[21] The present-day perception of Byzantine portraiture might be compared to a modern cartoonist's view of children's art (fig. 7). In a drawing by Frascino, which originally appeared in the *New Yorker*, a schoolteacher, about to begin a conference with a parent, is delighted to discover that the appearance of the boy's mother in real life

corresponds exactly to her son's childish portrait of her. To the modern viewer, therefore, Byzantine portraits might seem to resemble children's drawings that may seem true to the children who produced them but not to the adult viewer. Such a perception of Byzantine icons, however, would be wrong, for the Byzantines were neither children nor naive. The difference between the present-day and the Byzantine viewer is not that of sophistication as opposed to naiveté, for no people have ever been more sophisticated in their approaches to images than the Byzantines. Rather, the difference is one of expectation. When a modern viewer speaks of an image being "lifelike," the expectation is that it will be illusionistic, with realistic effects of lighting and perspective, like a photograph. The Byzantines, however, did not seek optical illusionism in their portraits, but rather accuracy of definition. Their expectation was that the image should be sufficiently well defined to enable them to identify the holy figure represented, from a range of signs that included the clothing, the attributes, the portrait type, and the inscription. For the Byzantines, these features together made up a lifelike portrait. As we shall see in the following chapter, modeling and perspective did play a role in Byzantine images of some saints, but their role was not to create an illusion. Rather, their purpose was also that of definition; that is, to make statements about the nature of the holy person being portrayed and about his or her position in the scheme of intercession and salvation.

The saints venerated by the Byzantines were divided into classes by their costumes and by the usual attributes that they held: evangelists, for example, wore the antique tunic and himation and displayed their books, holy bishops were attired in their liturgical vestments and also held books or scrolls, monks wore their habits, soldiers wore their military tunics and cuirasses and brandished their weapons, and doctors grasped their medicine boxes and surgical instruments. The classes of saints provided the first category of definition for the Byzantine viewer. Further, the class to which the saint belonged tended to govern the age at which he or she was shown. Thus, bishops and monks were often portrayed as old, with white or grayish hair, while doctors and soldiers were shown younger; women, with a few exceptions, also tended to be shown as young. A story in the Life of Saint Andrew the Fool reveals how a Byzantine author expected an evangelist to be recognizable from his age, his costume, and his attribute of a book. The biographer tells us of Epiphanios, a disciple of Saint Andrew, who prayed that the holy man's status in heaven should be revealed to him. Epiphanios was rewarded that night with a splendid vision in which "a dignified old man dressed in white garments" came to his side. This old man showed Epiphanios the heavenly court and Saint Andrew's

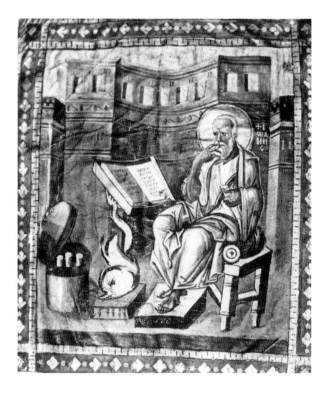

8. Mount Athos, Stauronikita Monastery, MS 43, fol. 13r (Gospel book): St. John the Evangelist

honored place within it. As Epiphanios followed walking behind his reverend guide, he saw that he "was holding the Gospel in his right hand."[22] Thus, from his clothing and the book that he held, Epiphanios could tell that his elderly companion was one of the evangelists, although the text does not tell us which one.

Within the classes of saints, such as evangelists, bishops, monks, soldiers, and doctors, there were for the more important individuals relatively precise standard portrait types, which were for the most part created by variations in the color and arrangement of the beard and hair.[23] These portrait types were the second element in the definition of the image. Some saints already had their portrait types before the onset of iconoclasm in the eighth century, but from the tenth century onwards many more saints were differentiated by their facial features, and those distinguishing features tended in time to become more accentuated. Unlike later medieval artists in western Europe, the Byzantines did not develop a very extensive iconography of specific attributes for specific saints, such as a tower for Saint Barbara or a wheel for Saint Catherine. Only a relatively few Byzantine saints wore or held their own attributes: Saint Stephen the Younger, for example, was sometimes shown holding an icon, while the military officers Saints Sergius and

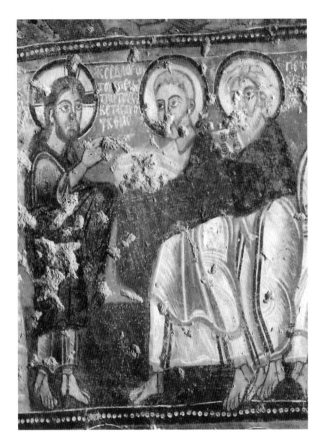

9. Göreme, Tokalı Kilise, fresco: Blessing of the Loaves and the Fishes

Bacchus were portrayed wearing torques around their necks (fig. 121). In Byzantine art attributes were more important for establishing the *category* of saints to which an individual belonged; within each category, the more important individual saints were identified by their facial features. Byzantine artists developed a much more extensive gallery of facial portraiture than did artists in the west. As we shall see, these portraits could be amazingly consistent over several centuries.

Even though many saints never acquired standard portrait types, those who were so honored became instantly recognizable by their images alone, without the necessity to read the legend. For example, among the apostles, who were generally clad in the antique tunic and himation, Byzantine artists distinguished John the Evangelist as a venerable old man with balding gray or white hair and a long, wavy beard. Such a portrait of Saint John can be seen in a fine illumination painted in a tenth-century Gospel book preserved in the Stauronikita monastery on Mount Athos (fig. 8). Andrew, on the other hand, was shown as an old man whose white hair was abundant and unkempt. His portrait may be seen in another tenth-century

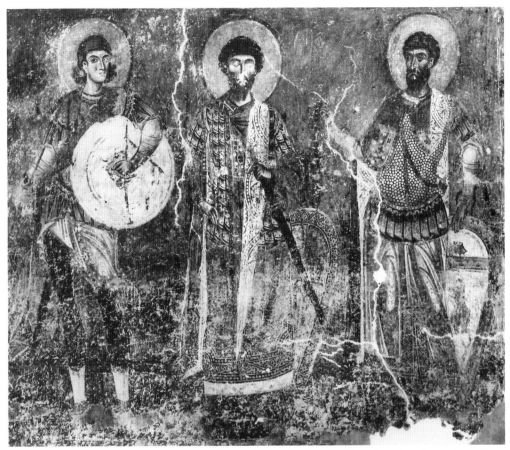

10. Nerezi, Church of St. Panteleimon, fresco: St. Prokopios, St. Theodore the General and St. Theodore the Recruit

painting, a fresco of the Blessing of the Loaves and the Fishes from the cave church of Tokalı Kilise in Cappadocia, where he stands to the right of Saint Peter, who is shown, as usual, with short white hair and beard (fig. 9). Their clothing and their portrait types were enough to enable a Byzantine viewer to recognize these saints. Thus the monk Kosmas, who wrote an account of a visionary visit to heaven which he made some time after 933, claimed that he was able to recognize his two "gray-haired and venerable" guides to the heavenly kingdom as the apostles Andrew and John, "as far as I could infer from [their resemblance to] the appearance of the sacred icons."[24] Similarly, in the Life of Patriarch Ignatios by Niketas David Paphlagon, we are told that the caesar Bardas had a dream in which he saw, sitting on the *synthronon* in the sanctuary of the Great Church of St. Sophia, "an aged man precisely resembling the icon of Peter, the chief of the apostles."[25]

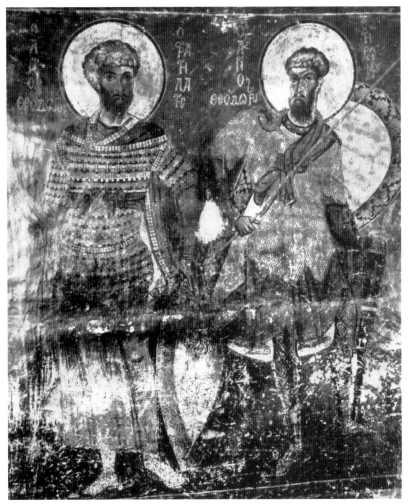

11. Kastoria, Church of the Hagioi Anargyroi, fresco: St. Theodore the
General and St. Theodore the Recruit

In the case of soldier saints, the distinctions between the individual portrait
types could be especially subtle. A fine gallery of warriors is preserved on the
north and south walls of the western arm of the church of Nerezi, whose fres-
coes were painted in 1164. Figure 10 illustrates the portraits on the north wall.
The soldier with a round shield who stands on the left can be identified as Saint
Prokopios; he is recognizable from his smooth, unbearded chin, and from his
long, elegant locks of hair, which are bunched at the neck in a bouffant style. He
can thus be distinguished clearly from other beardless warrior saints, such as
Saint George, whose hair was usually shown shorter and curly (compare fig.

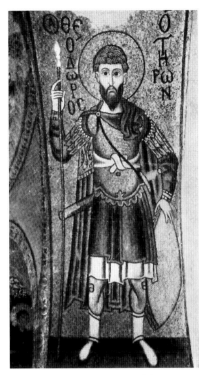

12. Hosios Loukas, Katholikon,
mosaic: St. Theodore the Recruit

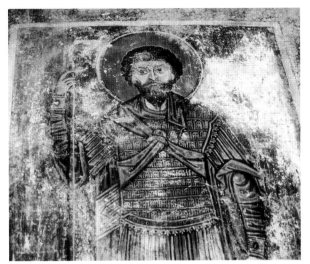

13. Hosios Loukas, Katholikon, fresco: St. Theodore the
General

163). The portrait types of the two saints to the right of Prokopios at first sight
appear remarkably similar. They are the two Theodores, Theodore Stratelates,
or "the General," in the center, and Theodore "Tiro," or "the Recruit," on the
right. Both of these namesakes have long faces with thick, curly hair and long,
pointed beards. Closer inspection, however, reveals some subtle differences
between the two portraits.[26] The General has a slight cleft in his beard, while the
Recruit has a somewhat longer face than the General, and his beard is slightly
thicker. Most significantly, his hair is shorter, so that all of his left ear is visible;
the General's ears, on the other hand, are partly covered by his hair. These dis-
tinctions between the portraits of the two Theodores, small though they are,
were maintained with remarkable consistency in Byzantine painting from the
eleventh to the fifteenth century; they are a striking demonstration of the
importance of facial features in the Byzantine definition of their saints. For
example, the same portrait types reappear in the somewhat later twelfth-century
frescoes in the church of the Hagioi Anargyroi at Kastoria (fig. 11). Here again,
it can be seen that Theodore the General has a central cleft in his beard, while

Theodore the Recruit, on the right, has a longer face than the General, a somewhat wider beard, and shorter hair which leaves all of his ears uncovered. A similar differentiation occurs in the mosaics and frescoes of the monastery church at Hosios Loukas, which date to the first half of the eleventh century (figs. 12, 13). In this case the style is much more schematic than in the paintings of Nerezi and of the Anargyroi at Kastoria, but the essence of the distinction remains: Saint Theodore the Recruit, who is portrayed in a mosaic (fig. 12), has a longer face and shorter hair than his namesake, who is portrayed in a fresco (fig. 13); there is the same telling contrast in the treatment of the ears. These portrait types were still preserved in late Byzantine works of art, such as the early-fourteenth-century frescoes in the church of the Kariye Camii in Constantinople (figs. 14, 15). Now the artists were painting in yet a different style, in the classicizing manner of the "Palaiologan Renaissance." Nevertheless, the distinctions persisted: the Recruit's face is longer, and his ears are fully visible (fig. 14), while the General's beard preserves its slight cleft (fig. 15).

An episode in a twelfth-century biography of Saint Theodore the Recruit shows the importance that Byzantine viewers attributed to the accuracy of his image. The story is of a type that will, by now, be familiar to the reader. We are told that after the death of Saint Theodore, his benefactress Eusebia wanted to obtain his portrait. She visited an artist and described to him as well as she could the appearance and facial features of the departed saint. Like the painter of Saint Nikon, however, the artist found it hard to produce a good portrait merely on the basis of a verbal description. Fortunately, Saint Theodore himself came to the painter's aid; soon after his patron had made her visit, the artist had a vision of the saint in the guise of a soldier returning from a long expedition. Theodore commanded the artist to paint him as he saw him "with precision." The artist complied, and as soon as the portrait was finished, his miraculous sitter vanished. When the painter showed the image to Eusebia, she was overjoyed, recognizing the portrait as the fulfillment of her desire.[27]

Sometimes the portrait types of the saints were recorded as thumbnail descriptions in their biographies. We have already encountered such a verbal portrait in the Life of Saint Nikon, and we have seen that this list of the physical characteristics of the saint matched his mosaic image at Hosios Loukas, which was made not very many years after the death of the saint (fig. 3). Another monastic saint whose appearance was described in his biography was Theodore of Stoudios, the famous abbot of the Stoudios Monastery of Constantinople, who lived from 759 to 826. The Life of the saint, attributed to his

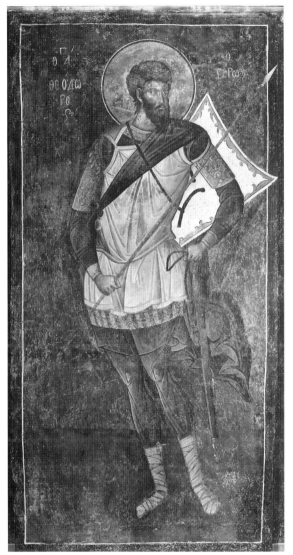

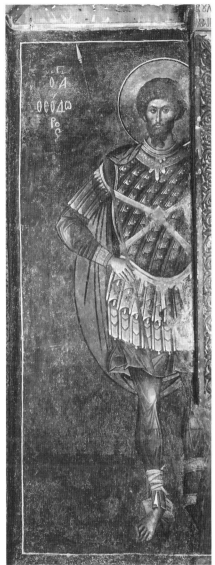

14. Istanbul, Kariye Camii, fresco: St. Theodore the Recruit

15. Istanbul, Kariye Camii, fresco: St. Theodore the General

disciple Michael, relates that Theodore appeared in a vision as a tall man, withered, and pale in the face, with grizzled hair and a balding head.[28] Another version of this biography adds that this was the saint's appearance in real life.[29] This verbal sketch corresponds to the saint's portrait type in art, which was followed more or less faithfully by artists from the eleventh century to the post-Byzantine period.[30] It can be seen, for example, in a mosaic at Hosios Loukas,

17. Mount Athos, Stauronikita Monastery, MS 43,
fol. 13v (Gospel book): St. Euthymios

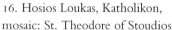

16. Hosios Loukas, Katholikon,
mosaic: St. Theodore of Stoudios

where the old man's receding hair and pinched-in, withered cheeks are given
due emphasis (fig. 16).

A third monastic saint who was described in his written Life was Saint
Euthymios. According to a sixth-century biographer, Cyril of Scythopolis, at the
time of his death Euthymios had "the form of an angel," specifically "completely
gray hair" and "a long beard that reached as far as his belly."[31] Elsewhere in the
same text, the saint appears to a sick man in the form of "a grizzled monk with a
long beard."[32] From the tenth century on, the saint was regularly distinguished
by these features in art, that is, by gray hair and by a long beard descending, in
many instances, as far as his waist. Such portraits can be seen, for example, in the
tenth-century Gospels of the Stauronikita Monastery (fig. 17) and in another

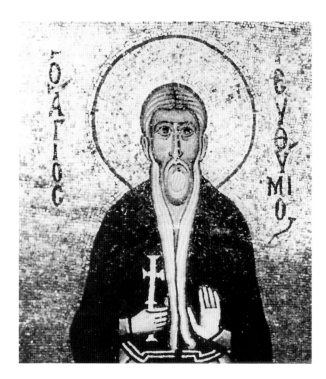

18. Hosios Loukas, Katholikon,
mosaic: St. Euthymios

mosaic at Hosios Loukas (fig. 18). Thus, for some of the holy monks, at least, there were established portrait types that accorded with written descriptions in their biographies.[33]

As with the apostles, soldiers, and monks, so too with the bishops: the most important saints came to be distinguished by their individual portrait types. This was especially true for the three hierarchs, Saint John Chrysostom, Saint Basil, and Saint Gregory of Nazianzus, and also for Saint Nicholas, a very popular saint in Byzantium as in the west.[34] The portraits of these four saints are found in their fully developed form by the beginning of the eleventh century. All of them can be seen portrayed in the miniatures of the *Menologium* of Basil II in the Vatican Library. Saint John Chrysostom, in a scene of his journey into exile, is strikingly characterized with a narrow chin, a small pointed beard, a bald dome to his head, and an ascetic appearance with deeply sunken cheeks (fig. 19). Much less ascetic is the appearance of Saint Basil, who is portrayed as younger than the other bishops, because he died at the age of fifty (fig. 20). He has an elongated face, with dark black hair and a long, pointed beard. Saint Gregory of Nazianzus is shown as a balding white-haired man with a broad spade-shaped beard (fig. 21), while Saint Nicholas has white, receding hair, sunken cheeks, and a short beard (fig. 22). In

19. Rome, Vatican Library, MS gr. 1613, p. 178 (*Menologium* of Basil II): St. John Chrysostom going into exile

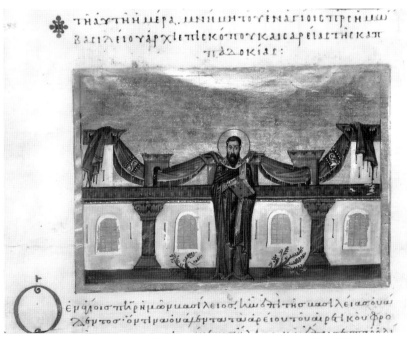

20. Rome, Vatican Library, MS gr. 1613, p. 288 (*Menologium* of Basil II): St. Basil

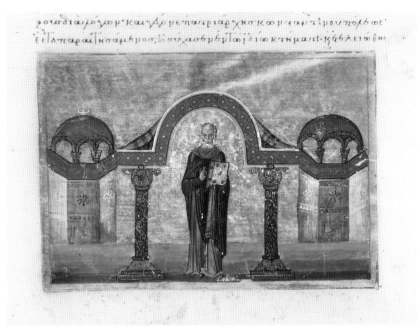

21. Rome, Vatican Library, MS gr. 1613, p. 349 (*Menologium* of Basil II): St. Gregory of Nazianzus

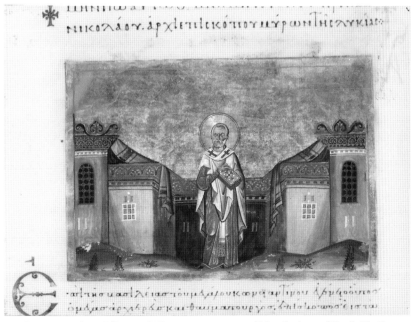

22. Rome, Vatican Library, MS gr. 1613, p. 226 (*Menologium* of Basil II): St. Nicholas

later centuries some of these portrait features were exaggerated, as can be seen in an early-fourteenth-century mosaic icon of Saint John Chrysostom at Dumbarton Oaks (fig. 23).

There was one group of saints who stood apart from the others and who were treated by Byzantine artists in a somewhat different way, namely the female saints. Like the men, the women were classified by means of their clothing—as nuns, for example, or as empresses—but it was rare for the individual female saints to acquire specific portrait types. In part this was a question of status; we have seen that among the various categories of male saints, only the more important were honored with specific portraits. In a male-dominated institution such as the Byzantine church, it was not surprising that the female saints were accorded less attention than their male counterparts. But there was also a practical difficulty. The dress of most of the women saints concealed their hair, and, of course, they had no beards. Since the creation of individual facial portraits in Byzantine art was in large part a matter of the color and arrangement of the beard and hair, the artists had little to work with when it came to portraying women.

One female saint who did acquire a recognizable facial portrait type was Saint Barbara. According to the tenth-century version of her Life by Symeon Metaphrastes, Saint Barbara was "exceedingly fair of face, and extraordinary for her beauty."[35] In Byzantine art she is usually depicted richly dressed, wearing earrings and a crown or a diadem. In later Byzantine art, such as a fresco of 1280 in the church of the Panagia Amasgou at Moutoullas, on Cyprus, she appears with full cheeks, giving her face a distinctly rounded appearance (fig. 24). At Moutoullas, the richness of Barbara's costume and the roundness of her face contrasts with the more severe mien of her two companions to the right, Saints Marina and Anastasia. A round face was considered by the Byzantines to be a mark of especial beauty. Thus, the twelfth-century historian Anna Comnena, describing the good looks of her mother Irene, claimed: "Her face was not absolutely round . . . but it departed only a little from a perfect circle."[36] Sometimes, also, Saint Barbara allows her hair to fall loose over her shoulders, in a display of immodesty unusual for a Byzantine saint. This can be seen, for example, in a late-thirteenth-century painting in the church of the Panagia Olympiotissa in Elasson (fig. 25); here, too, Saint Barbara's cheeks are full, giving the face a somewhat rounded appearance.

Another female saint who displayed her hair, though for different reasons, was the ascetic Saint Mary of Egypt. Like Saint Barbara, Saint Mary of Egypt was one of the few Byzantine female saints to be given a recognizable physical portrait type,

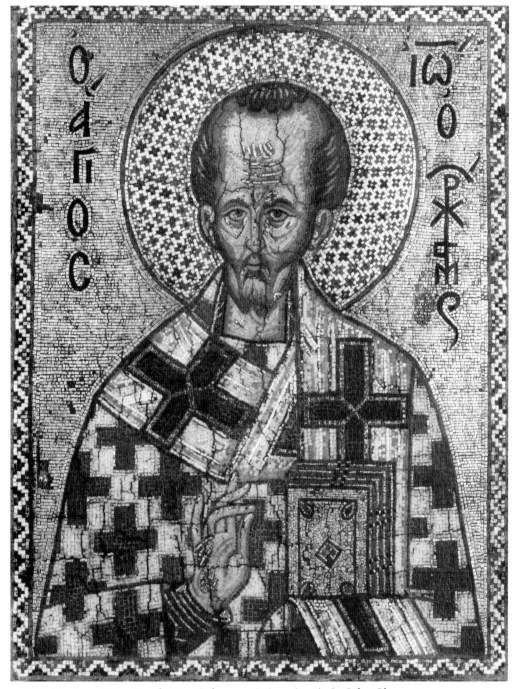

23. Washington, D.C., Dumbarton Oaks, mosaic icon (54.2): St. John Chrysostom

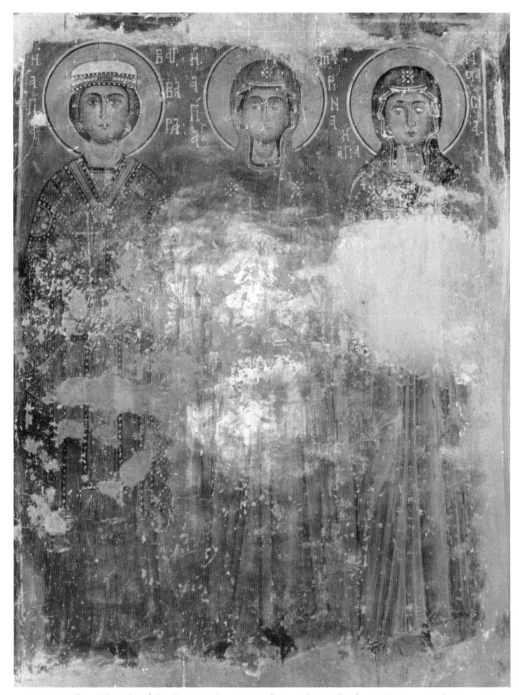

24. Moutoullas, Church of the Panagia Amasgou, fresco: Saints Barbara, Marina, and Anastasia

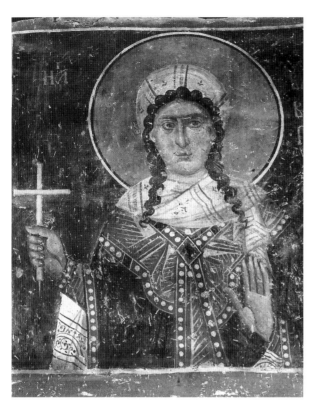

25. Elasson, Church of the Panagia Olympiotissa, fresco: St. Barbara.

for she came to be shown as an emaciated figure with a haggard face, skeletal limbs, and unkempt, matted white hair. A striking portrayal of her is found among the early-twelfth-century frescoes in the sanctuary of the church at Asinou on Cyprus (fig. 26). Saint Mary of Egypt was also one of the few female saints to be shown as old, for her many years of asceticism in the desert had aged her. Another woman saint who was sometimes shown with lined features, on account of her advanced age at the time that she conceived, was Saint Anne, the mother of the Virgin. In a late-twelfth-century fresco in the church of St. George at Kurbinovo, for example, her face appears wizened and wrinkled, even as she suckles her child (fig. 27).[37]

For the most part, however, female saints were shown as young. The biographies of women saints often dwelt on their youthful beauty. For example, according to a biographer of the tenth-century Saint Thomais of Lesbos, her internal virtues were reflected in her external beauty and in her "perfect bodily harmony."[38] In the Life of Theodora of Thessaloniki, who died as a nun in the year 892, we read that when she was a small girl she was "praised and admired for the beauty of her body and her pretty face." Her father was so pestered by her admirers that he had Theodora

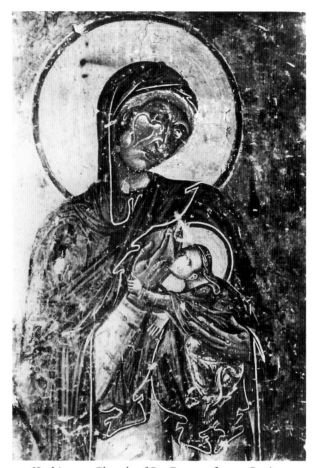

26. Asinou, Church of the Panagia
Phorbiotissa, fresco: St. Mary of
Egypt

27. Kurbinovo, Church of St. George, fresco: St. Anne
and the Virgin

engaged to be married at the age of seven, which was the youngest possible legal
age.[39] The Life says that the saint was still beautiful when she entered a nunnery at
the age of 25.[40] After a long life in the cloister, she died at the age of eighty.[41] In art,
however, she was not depicted as an aged monastic, as she would have been were
she a man. On the contrary, as can be seen in her supposed eleventh-century por-
trait in the church of St. Sophia in Thessaloniki, she was shown as a young woman
(fig. 28). This fact was noted by her biographer, who relates how, after Theodora
died, a painter named John made her icon under guidance from a dream, depicting
her "in such a way that those who knew her well said that she looked [in the icon]
just as she did when she was younger."[42]

 Byzantine artists compensated for the lack of female portrait types by giving a

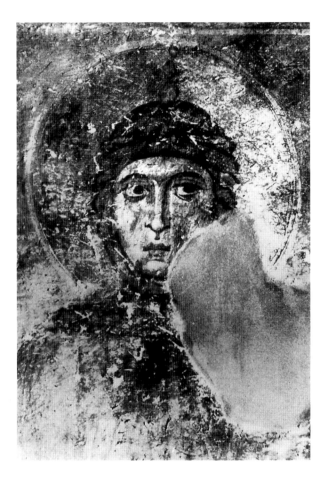

28. Thessaloniki, Church of St.
Sophia, fresco: St. Theodora

few women individual attributes by which they could readily be recognized. The most conspicuous of these attributes is the True Cross associated with Helena. The mosaic at Hosios Loukas is one of many images in Byzantine art showing the empress standing beside her son Constantine and holding this relic (fig. 29). Other female saints with specific attributes included Thekla, who was often shown with a book, as she was a close disciple of Saint Paul; she also appears among the mosaics at Hosios Loukas, in a gallery of female saints placed in the porch (fig. 30). Saint Anastasia Pharmacolytria, true to her name, often holds a medicinal flask.[43] The most picturesque of the attributes held by female saints is the copper mallet of Saint Marina of Antioch, with which she struck the demon Belzebuth. She can be seen wielding this weapon in a late-twelfth-century fresco in the church of the Hagioi Anargyroi at Kastoria (fig. 31).[44]

Thus, for the Byzantines, the true portrait of the saint was a set of characteristic features: the clothing and attributes generally indicated the category, while, for

29. Hosios Loukas, Katholikon, mosaic: Helena and Constantine holding the True Cross

prominent saints, the portrait type and in some cases an attribute indicated the individual. Essentially, these features would form the underdrawing of a painting or a mosaic, which could be finished by the artist with colors, with highlights and shading, and with a background, in a variety of styles.[45] But we have seen that whether the styles used to finish the portraits were relatively schematic, as in the mosaics of Hosios Loukas, or relatively classicizing, as in the frescoes of the Kariye Camii, the specific identifying features of the saint remained constant. With the exception of the added hair color, it is usually possible to identify the characteristic features of an important Byzantine saint from the underlying sketch alone. This may be observed in several fine Byzantine underdrawings which are preserved on the island of Cyprus. Figure 32 illustrates a detail from the scene of the Communion of the Apostles in the Church of the Holy Apostles at Perachorio, where Saint Paul is recognizable among the apostles from his bald head and medium-length, pointed beard (compare fig. 6). In the Church of St. Nicholas tis Stegis at Kakopetria there is an underdrawing of Saint Gregory of Nazianzus, exposed beneath the wall paintings in the apse (fig. 33). He can be recognized from his balding head, his sunken cheeks, and his spade-shaped beard, features which can

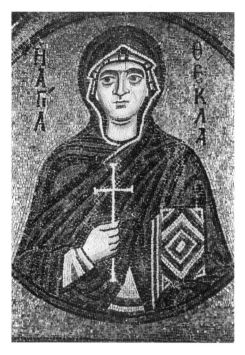

30. Hosios Loukas, Katholikon,
mosaic: St. Thekla

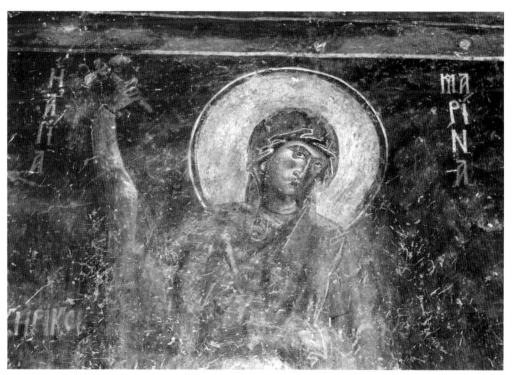

31. Kastoria, Church of the Hagioi Anargyroi, fresco: St. Marina of Antioch

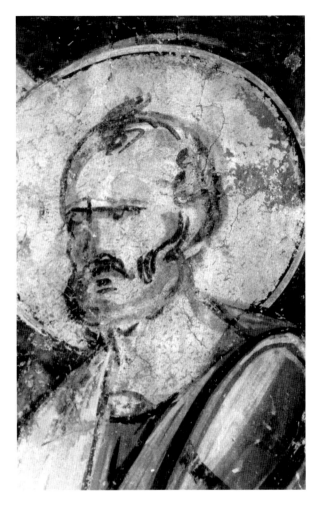

32. Perachorio, Church of the
Holy Apostles, underdrawing: St.
Paul, from the Communion of
the Apostles

also be seen in other portrayals of the saint (compare fig. 21). Such sketches help us
to understand the story of the creation of Saint Nikon's portrait, which has already
been related. The biographer of the saint makes it clear that the image that was
miraculously transferred to the painter's panel was an underdrawing. As we have
seen, the author compares the impression of Nikon's features to the mandylion of
Christ, which, according to the account of its conveyance from Edessa to Con-
stantinople in 944, was an image "without coloring or painter's art." Nikon's
biographer says that when the drawing had been miraculously fixed upon the
panel, that is, when the saint's likeness had been captured, then the artist was able
to "add the remaining colors" in order to finish the image.[46]

There is one other important aspect of the definition and recognition of sacred
portraits to consider. Even though the most important saints were distinguished

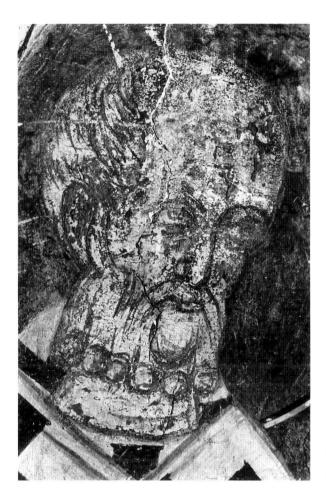

33. Kakopetria, Church of St. Nicholas tis Stegis, underdrawing: St. Gregory of Nazianzus

by individual portrait types, not all saints were so honored. In the case of the less common saints, who had no standard facial features, it was possible for the viewer to determine only to which category they belonged (e.g., bishops or soldiers). The complete identification had to be through the accompanying inscription. The inscription, then, became the final element in the definition of the image, of which it was an essential part. The importance of the naming of images is set out by an episode in the Life of the Sicilian bishop Pankratios, who, as seen above, was a disciple of Saint Peter, but whose Life may have been written as late as the first half of the ninth century, during the second period of iconoclasm. The story may be quoted in its entirety:

The blessed apostle Peter, summoning Joseph the Painter, said to him: "Make me the image of our Lord, Jesus Christ, so that those who see it may

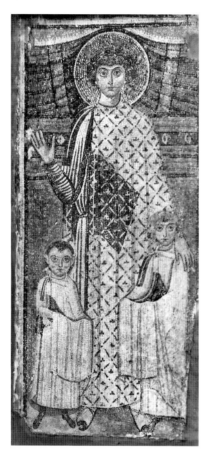

34. Thessaloniki, Church of St. Demetrios,
mosaic: Unnamed saint

believe the more, seeing the imprint of His form, and may remember what I
have preached to them." So the painter, taking bright wax colors, painted
the image of Our Lord, Jesus Christ. And the apostle said: "Paint, child, my
image too, and that of my brother Pankratios, in order that those who use
them for remembrance might say: 'This is the one who preached the word
of the Lord to us, the apostle Peter,' and concerning my brother Pankratios,
'this is the one who built the tower of the sacristy.'" So the young painter
finished these paintings also, and *he wrote on each image its own name.*[47]

After the ninth century, therefore, saints in Byzantine art, even those saints, such
as Saint Peter, who were readily recognizable from their portraits, were almost
always accompanied by a legend. Before iconoclasm, however, names were fre-
quently omitted from holy images, both in monumental paintings and mosaics,
and on smaller panel paintings. Many of the saints portrayed in the sixth- and sev-
enth-century mosaics in the Church of St. Demetrios at Thessaloniki are not

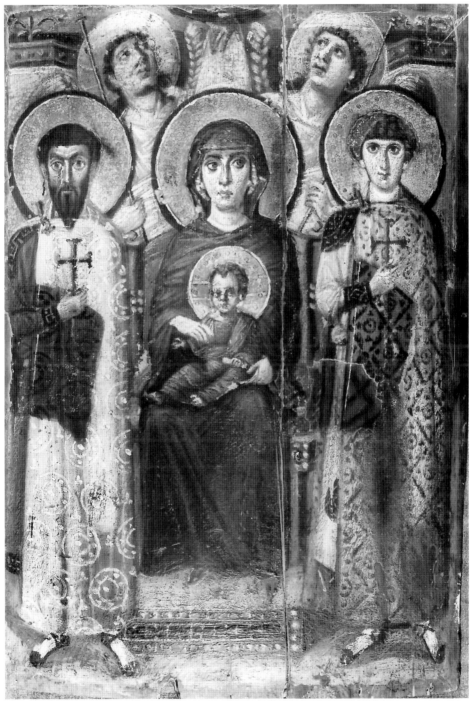

35. Mount Sinai, monastery, panel painting: Virgin and Child between two unnamed saints

36. Thessaloniki, Church of St.
Demetrios, mosaic: St. Demetrios
with angels

named by inscriptions (figs. 34, 36, 37), nor are there any inscriptions on the
famous sixth-century icon at Mount Sinai which shows the Virgin between two
anonymous saints (fig. 35). But after iconoclasm it became the rule for images to
be accompanied by legends; in the words of the Life of Pankratios, "on each
image its own name." This change, as we have seen, was accompanied from the
tenth century onward by the creation of a much more extensive and precise
iconography of portrait types for individual saints. The reasons that lay behind
these developments are explored in a later chapter (see below, chap. 3).

THE RECOGNITION OF SACRED PORTRAITS

To modern viewers, the details of costume and hairstyle that differentiated the
portraits of saints in Byzantium seem comparatively small and insignificant; to
most people today, the two military Theodores, for example, appear remarkably
similar to each other (figs. 10-15). It is natural, then, to ask whether the majority
of the Byzantines were really capable of distinguishing between these images.
Were they more sensitive than the average viewer of our time to the nuances

37. Thessaloniki, Church of St. Demetrios, mosaic: The Virgin with St. Theodore the Recruit

between the portraits, or were the images recognizable to only a few learned cler-ics in the Middle Ages, just as they can be identified by only a few specialists today? The answer is provided by the Byzantines themselves, for they do seem to have expected worshipers to be alert to the visual signs that distinguished one sacred portrait from another and to tell the important saints apart from each other, even without the aid of inscriptions. We have already seen how the monk Kosmas was able to recognize the apostles Andrew and John in his vision "on account of their resemblance to the sacred icons." A mid-ninth-century bishop of Thessa-loniki, named Leo, told in one of his sermons a story about a conversion that is especially revealing in this respect. He related that there was a young Jewish woman in the city, who during one night had a dream in which she saw the Vir-gin Mary accompanied by Demetrios, the patron saint of the city, dressed in white. Being Jewish, the woman was not familiar with the two saints and did not recognize them. She dreamed that her two visitors led her into the baptistry of the Church of the Virgin in Thessaloniki (now known as the Church of the Acheiropoietos). When she awoke, she went in actuality to the baptistry of that church. Having been baptized there, she was able to single out the portraits of the two saints who had appeared to her, on account of their characteristic features. The text of the sermon says: "Looking at certain images that were set up together with others in that holy baptistry, and which had distinct characteristics, she pointed out from among the other images our Lady the Holy Mother of God and the all-glorious martyr Demetrios, saying that it was they who had come to her by night."[48] The story is reminiscent of a modern witness to a crime, who is supposed to pick out a suspect from a line-up of photographs arranged by the police. With the aid of two of the surviving mosaics in the Church of St. Demetrios in Thessa-loniki, one showing the patron saint in the company of angels (fig. 36) and the other, the Virgin in the company of Saint Theodore the Recruit (fig. 37), we may visualize how the images seen by the woman may have looked.

Another story that confirms the Byzantines' ability to recognize the images of their saints is found in two texts, one of the tenth century and one of the four-teenth. The earlier text is an anonymous collection of miracles that had been per-formed at the shrine of the Virgin of Pege, that is "of the Spring," which was located just outside the walls of Constantinople. The later text is a rewriting of these tales by an author of the early fourteenth century named Nikephoros Kallistos Xanthopoulos. The story concerns a sick man who tried to obtain a cure by the practice of incubation, that is, by spending the night in the shrine. In the tenth-century version of the *Miracles* it is told as follows:

A certain John, a *protospatharios* [a high official], who was half dead from the attacks of his diseases, came to the Church of the Theotokos [the Virgin]. And while he was lying down asleep in the church he saw, as he said, the Mother of God instructing the martyr Panteleimon [as follows]: "See what is wrong with the sick man. . . ." And the martyr [Panteleimon] said: "His insides are suffering terribly, Lady." And again the Theotokos said to the martyr: "You may consider this one worthy of a cure." And having been awakened from sleep by those words, he experienced a complete remission of his disease. . . .[49]

This imagined dialogue between the Virgin and Panteleimon, a well-known doctor saint, can be compared with the arrangement of images in the monastery Church of Hosios Loukas, which functioned as a healing shrine to which sick pilgrims came for cures. Here, in the south arm of the church, mosaics of the Virgin and of Panteleimon, set low down so as to be accessible to the visitors, face each other across the narrow space (figs. 38, 39). As in the miracle story, the two saints in these images worked together on behalf of the suppliant.

The later version of the *Miracles*, the fourteenth-century retelling by Xanthopoulos, gives to the account a much more scientific quality. The later author tries to answer two questions: first, how did the sick man recognize Panteleimon in his vision? And, second, how precisely was the supernatural cure achieved? Xanthopoulos' version of the story reads as follows:

The water of the spring [of Pege] was shown to be a holy refuge for a certain man—he was a protospatharios in rank—who was wasting away in all his limbs with a succession of diseases, and as a consequence had become half dead. For one day as he was there, exceedingly cast down, a divine vision stood by him, as he was turning to sleep. And the vision looked like an exceedingly beautiful woman, with a solemnity of spirit, flashing with a kind of beauty and grace. And a young man followed beside her, with his hair very raised up, and looking striking in a new garment, his left hand weighed down by a box full of medicines, while his right hand was equipped with a blade with a handle. In appearance and in all other respects he resembled the divine Panteleimon. And the woman, standing by the place where John (for so the spatharios was named) happened to be lying, commanded the one who followed her to examine the sick man closely [to find] what ailed him. And he, palpating the man's body, reported that his insides were corrupted, and that it would be necessary to treat his condition

38. Hosios Loukas, Katholikon, mosaic in the south arm: Virgin and Child

with an incision. And he brought down his small knife, piercing the chest, and the other man, having been cut, awoke from his sleep, extolling the Mother of God, discerning nothing of what he had undergone before, but only seeing the flowing wound [that had resulted] from the cut.[50]

It may be noted here that Xanthopoulos gives the two elements necessary for the identification of Panteleimon in Byzantine portraits. He lists the attributes, the scalpel and the medicine box, which indicated that the saint belonged to the class of doctors. And he describes the individual portrait type: the saint was a young man, with "raised-up hair"—that is, full and curly rather than long and lank—which narrowed the identification further within the category of physicians. The portrayal of Panteleimon at Hosios Loukas corresponds to this description (fig. 39), as do most other images of the saint in later Byzantine art.[51] The same portrait type is found, for example, among the paintings of 1192 at Lagoudera (fig. 40). Furthermore, Xanthopoulos did not have to specify that the young man resembled Panteleimon as he was shown in *icons*, but simply that "he resembled the divine Panteleimon." The implication is that Xanthopoulos knew the saint's portrait type as an absolute fact, and he expected the reader to know it also. Finally, we may note the device for verifying the truthfulness of the vision,

39. Hosios Loukas, Katholikon, mosaic in the south arm: St. Panteleimon

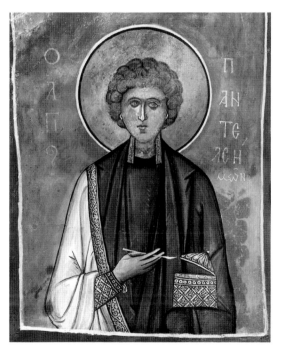

40. Lagoudera, Church of the Panagia tou Arakou,
fresco: St. Panteleimon

namely the physical scar that was left behind on the man's body after the vision itself had faded.

As with all the stories in the saints' Lives, these tales are true and false on different levels. We may doubt whether the miracles and visions actually happened, but the biographers, in order to give credence to their claims concerning the supernatural, had to anchor them in reality. A story that was evidently complete fantasy would be ignored by everyone. Therefore the authors had to create a context for their claimed miracles from details of daily life that were realistic and from expectations that were credible to their Byzantine audience. Among those expectations can be included the assumption that both individual saints and their images could be recognized from their physical characteristics by ordinary people.

Finally, from the very end of the Byzantine period, from the fourth decade of the fifteenth century, we have striking testimony of how a Byzantine viewer could become disoriented if he was confronted with Christian images from a different tradition, which he was unable to recognize. The costume, the attributes, the portrait types, and the inscriptions together made up the elements of a familiar code enabling the Byzantine viewer to recognize and relate to the saints that were portrayed in the art of the orthodox church. Without this code, the Byzantine worshiper was at a loss, as can be seen from the manner in which one of the Greek delegates at the Council of Ferrara reacted to the alien tradition of church art represented by the early Italian Renaissance. This Byzantine cleric, Gregory Melissenos, complained:

> When I enter a church of the Latins, I do not revere any of the [images of] saints that are there, because I do not recognize any of them. At the most, I may recognize Christ, but I do not revere Him either, since I do not know how he is inscribed. But I make my own [sign of] the cross and revere it. I revere the cross that I make myself, and not anything else that I see there.[52]

In other words, the Byzantine viewer could not recognize the western images, however "lifelike" they might be in our terms, because they were not properly defined according to the code that he knew.

CONCLUSION

For the Byzantines, therefore, portraiture was a matter of definition, not of illusion. In one of his philosophical works, John of Damascus, the great champion of images, provided a definition of definition. In his *Dialectica* he wrote:

A sound definition has neither a deficiency nor a superfluity of words. A bad definition has not enough words, or too many. A perfect definition is one that is reciprocal with the object defined. An imperfect one does not reciprocate. Therefore, neither the definition that has a deficiency of words, nor the one that has a superfluity, reciprocates with its object. For, when it has too many words, the definition is wanting in concrete realities, and when it is lacking words, it includes too many realities.

John of Damascus goes on to explain that the perfect definition of "man" would be "a living being that is mortal and has reason." If one were to add the words "and is a grammarian" to this definition, it would exclude too many realities (that is, categories of men), for not all men are grammarians. On the other hand, if one were to omit the words "that is mortal," then the definition would include too many categories, for among the beings that have reason one can include the angels as well as men.[53] The same logic also controlled the Byzantine approach to portraits of their saints; the images had to be just detailed enough to define and distinguish each saint from the others, but not so burdened with extraneous detail that the definition would be too narrow. For example, a detailed background setting that would pin the saint's image down to a particular time and place would be overly restrictive and would thus create a bad portrait. On the other hand, in the case of the two Theodores, the portrait type had to be sufficiently detailed to allow the two saints to be distinguished from each other and not to be confused. At any event, the image should not necessarily show the qualities of photographic illusionism. As we shall see, that kind of illusionism did have its place in Byzantine art, but it was used only when necessary, when good definition so required.

2

CORPORALITY AND IMMATERIALITY

FORMAL DISTINCTIONS BETWEEN CLASSES OF SAINTS

As we saw in the last chapter, the essence of Byzantine portraiture lay in the underdrawings of the images. Nevertheless, the Byzantines held these drawings to be incomplete. The only images that the Byzantines considered to be complete without colors were the miraculously produced icons of Christ, such as the mandylion of Edessa. In the Life of Saint Nikon, we are told that after the panel had miraculously received the saint's image, which is described as a "formed likeness" (*ektypōtheisa emphereia*), the painter himself "added the remaining colors" in order to finish the icon.[1] Indeed, the incompleteness of the uncolored sketch, or shadow, as opposed to the finished image, with its colors, was a common simile used by Byzantine writers to describe the relationships between the Old and the New Testaments.[2] For example, the fifth-century theologian Cyril of Alexandria wrote: "We say that the law was a shadow and a type, and like a picture. . . . The outlines are the first marks made by the skill of those who paint on panels, and if the brightness of the colors is laid upon these, then indeed the beauty of the picture flashes forth."[3] More succinctly, John of Damascus wrote in the eighth century: "As the Law [is]. . . a preliminary foreshadowing of the colored picture, so Grace and Truth are the colored picture."[4] The simile was used not only by theologians but also by the biographers of the saints. For example, Ignatios the Deacon, in his ninth-century Life of the Patriarch Tarasios, says that Christ is announced by the word of truth, as if sketched in black by the servants of the Word, but is painted and circumscribed by the deed, as if through colors.[5]

The underdrawing, therefore, which captured the accurate features of the saint, was incomplete without the painted layer that covered it. This upper layer would contain the image's coloring, its lighting, and its modeling.[6] These added elements were essential to the truthfulness of the image because they helped to convey the nature of the saint who was being portrayed. That is, the color, lighting, and modeling, together with other formal elements such as perspective, motion, and frontality, were used by the Byzantines after iconoclasm, and especially from the tenth century onward, to convey differing degrees of corporality or immate-

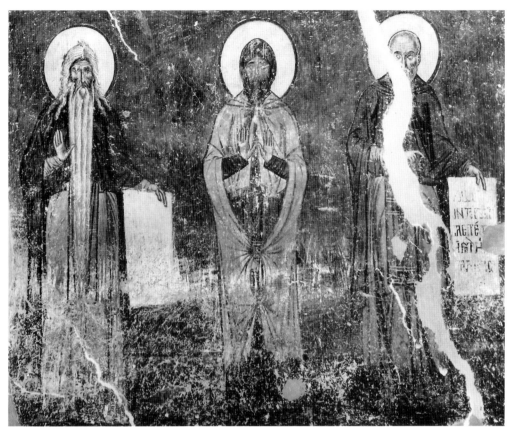

41. Nerezi, Church of St. Panteleimon, fresco: Monks

riality, appropriate to the holy person in the image.[7] The Byzantines did not seek
to make all their icons resemble modern photographic portraits, with all images
displaying an equal degree of illusionism and spontaneity, but they did aim to
distinguish between saints according to their types, so that some were shown
with more, and some with less, modeling and movement. These distinctions were
not absolute but relative. Within the formal range of a given artist or period,
some classes of saints were given a greater freedom and three-dimensionality as a
sign of their corporality, and some less.

To illustrate this point, we may return to the soldier saints depicted in the
twelfth-century paintings at Nerezi (fig. 10) and compare them to the monks
who are depicted nearby on an adjoining wall of the same church (fig. 41). Here
it can be seen that, whereas the soldiers move their bodies freely in space, the
monks have less bodily presence and are more constrained in their movements.

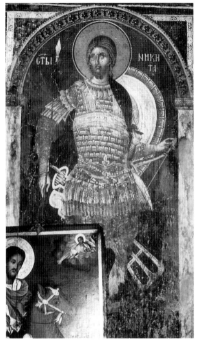

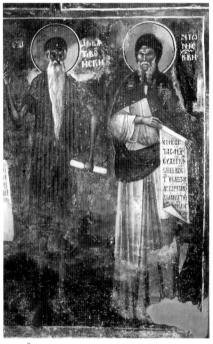

42. Čučer, Church of St. Niketas,
fresco: St. Niketas

43. Čučer, Church of St. Niketas,
fresco: Saints Paul of Thebes and
Anthony

The monks stand in stiff, columnlike postures, which are almost completely frontal. Their gestures are disciplined, repetitive, and shallow, being confined to the front plane of the picture. The military saints, by contrast, display much more motion, and even an exaggerated contrapposto, as in the case of Saint Prokopios on the left. This warrior stands in a swaying pose, his weight supported on his right leg. He turns his body sharply, so that his head and his torso face in different directions. He steps forward with his left foot while drawing back his sharply foreshortened right arm into the picture space behind his body, as if he were intending to throw his spear over the head of the viewer. The saint's round shield, meanwhile, is held under his left arm, in front of his chest, and parallel to the picture plane. In short, this is a man of action, twisting and moving in space, contrasting with the rigid portraits of the monks, whose freedom of movement, both laterally and in depth, is severely restricted.

The same formal distinctions between soldiers and monks can be observed in other Byzantine churches painted at other periods and in other styles. For example, among the early-fourteenth-century frescoes of the Church of St. Niketas at

Čučer, in Macedonia, we can see the same differentiation of monastic and mili-
tary saints relative to each other. The warrior Saint Niketas is almost a swagger-
ing figure, his torso twisted in a vigorous contrapposto, his right arm held
akimbo, and his well-rounded chest thrust toward the viewer (fig. 42). By con-
trast, the two ascetic saints Paul of Thebes and Anthony stand in more rigid pos-
tures, virtually without contrapposto (fig. 43). Their bodies are flattened against
the front plane of the picture, and their garments resemble shadows cast against
the wall. In other words, while the overall period style of these fourteenth-
century frescoes is more naturalistic than that of the earlier paintings at Nerezi,
the formal distinctions between the two sets of images are maintained.

Similar contrasts can be observed if we juxtapose Byzantine images of warrior
saints with those of holy bishops. Among the late-twelfth-century wall paintings
of the Church of St. Nicholas tou Kasnitzi at Kastoria, for example, there is a
striking difference in presentation between the bishop saints portrayed at the east
end and the soldier saints at the west end of the south wall of the nave. At the
western end, the soldiers Nestor and Merkurios stand ready for battle, the one
grasping his spear and the other drawing his sword from its scabbard (fig. 45). At
the eastern end of the the wall, the bishops—Saint Cyril (fig. 44, lower left), a
companion now too effaced to be identified, and Saint Nicholas (under the arch
on the right)—stand in identical frontal poses, with books held in their left hands,
and with their right hands raised in blessing. As in the case of the soldiers and the
monks, the contrast between the treatments of the soldiers and the bishops
became more pronounced in the fourteenth century. Among the paintings of
1359-60 in the Church of the Taxiarches at Kastoria, for instance, we may juxta-
pose the portraits of the two Theodores with that of the bishop Saint Ignatios
Theophoros. Theodore the General is painted with panache (fig. 46). He draws
his spear back in his right hand, while he turns his head to his right; his eyes,
meanwhile, are directed straight at the viewer. His stomach swells gently under
his fine red cloak and brazen armor. Opposite the general, Theodore the Recruit
also stands in an active pose, with his head inclined as he pulls his sword from its
sheath. The vigor of the two warriors contrasts with the motionless, frontal,
wraithlike figure of Saint Ignatios (fig. 47), whose materiality has evaporated
behind the severe black and white pattern of crosses on his vestments.

Another set of formal antitheses, between corporality and insubstantiality, and
between motion and immobility, can be found in the sanctuaries of later Byzan-
tine churches, where a choir of holy bishops was juxtaposed with the twelve
apostles. From the twelfth century onward it was common to find in Byzantine

44. Kastoria, Church of St. Nicholas tou Kasnitzi, fresco: Holy Bishops

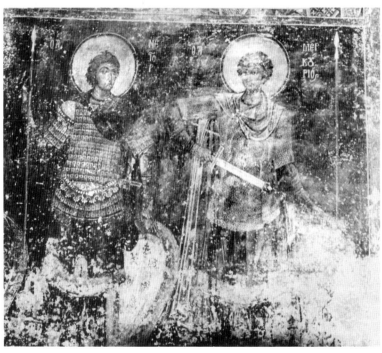

45. Kastoria, Church of St. Nicholas tou Kasnitzi, fresco: Saints Nestor
and Merkurios

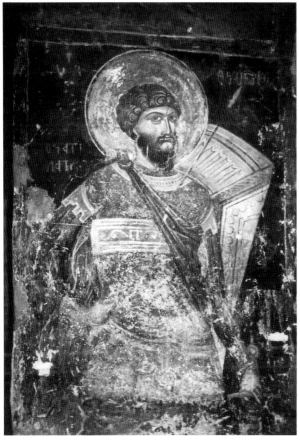

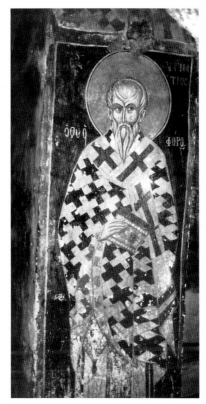

47. Kastoria, Church of the
Taxiarches, fresco: St. Ignatios
Theophoros

46. Kastoria, Church of the Taxiarches, fresco: St.
Theodore the General

apses two painted liturgies, one above the other, as can be seen in the twelfth-
century frescoes of Nerezi (fig. 48).[8] The upper liturgy is the scene known as the
Communion of the Apostles, which represents a doubled figure of Christ stand-
ing on each side of a central altar and distributing bread and wine to his disciples,
who approach in two files from the north and the south sides of the apse as com-
municants. The lower liturgy is that of the Holy Bishops, who are also shown in
two files, converging on the altar. Though the number of bishops varies, they
usually include the three Hierarchs, Saints Gregory of Nazianzus, Basil of Cae-
sarea, and John Chrysostom, each depicted by his usual portrait type. Each bishop
holds a liturgical roll containing a text, and, like the apostles, they bow their
heads and backs toward the center of the apse. But while the two scenes are
broadly similar in their composition, they are completely different in their formal

48. Nerezi, Church of St. Panteleimon, Frescoes in apse

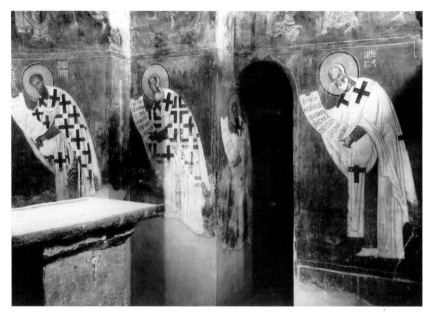

49. Nerezi, Church of St. Panteleimon, fresco: Liturgy of the Holy Bishops

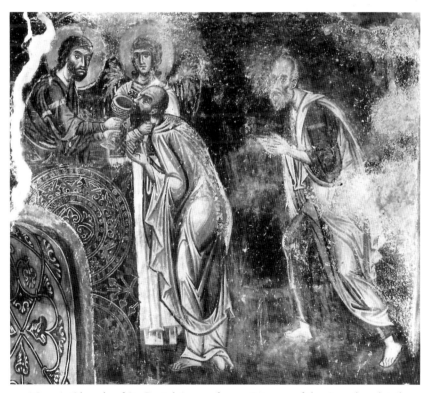

50. Nerezi, Church of St. Panteleimon, fresco: Liturgy of the Apostles, detail

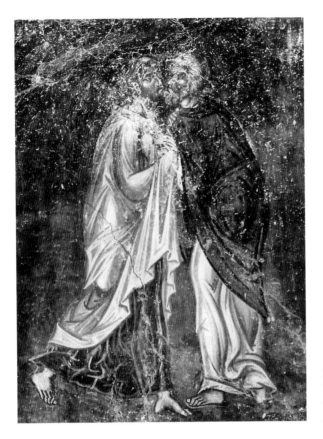

51. Nerezi, Church of St.
Panteleimon, fresco: Liturgy of the
Apostles, detail, St. Luke and St.
Andrew exchanging a kiss

characteristics. At Nerezi, the bishops all stand in identical poses, with their backs
bowed to the same degree, their heads inclined at the same angle, and their scrolls
held in the same way (fig. 49). In contrast, the pose of each apostle is different. On
the south side of the apse, for example, the first apostle, Paul, bows more deeply
to receive bread from the hands of Christ, while the second bows only slightly
(fig. 50). On the north side two apostles face each other to exchange the "Kiss of
Peace" (fig. 51). The apostle on the left can be identified as Saint Luke from his
characteristic features of a tonsure and a short, pointed black beard, while the
apostle on the right has the long, unkempt white hair of Saint Andrew (compare
fig. 9). Saint Luke is shown running forward impetuously to exchange the greet-
ing with his companion, while Saint Andrew, in effect, turns his back on his mas-
ter who stands behind him at the center of the apse.

At Nerezi, the bishops and the apostles differ from each other not only in their
relative degrees of motion, but also in the extent of their modeling and corporality.
The bishops wear heavy, pleatless white vestments covered with black crosses—the

polystavrion and the *omophorion*. Most of these crosses are not foreshortened, so that each garment is reduced to a flat, two-dimensional grid, clinging to the surface of the wall (figs. 48, 49). By contrast, the draping of the apostles makes them appear more substantial. They wear their usual antique garb of tunic and himation, swathing them in ample folds of cloth which are relatively well modeled with light and shade. The garments of the apostles are thinner and more revealing than those of the bishops, showing their bodies in motion, twisting and turning in space (figs. 50, 51). Here one could truly say that "the clothes make the man," not only by showing the saints' rank, but also by conveying the very natures of their bodies.

A similar contrast of forms can be seen in the apse of an early-fourteenth-century building, the Church of St. George at Staro Nagoričino in Macedonia (fig. 52). This church was painted more than one hundred fifty years after Nerezi, when Byzantine artists were working in a more classical idiom with a stronger emphasis on the construction of illusions of space. Nevertheless, within the parameters of this more illusionistic style, the same formal distinctions were made between the different classes of saints. Again we find that the stances of the bishops in the lower zone are, with one exception, identical. Only Saint Cyril of Alexandria breaks the regular sequence of bowed figures by looking upward toward Christ who distributes the bread and the wine. In contrast, the poses of the apostles above are extremely varied. As they come forward, some of them have their hands covered, and others uncovered. Some raise their hands as they prepare to receive the gifts, others lower them. Some cross their hands, others spread them apart. Some approach with their backs bent, others are more straight. Some look forward toward the altar, others look behind them. The artists have also endowed the two groups of saints with differing degrees of corporality. The bodies of the apostles are well modeled in their classicizing robes; their draperies even have a somewhat "inflated" appearance. The vestments of the bishops, on the other hand, are flat and two-dimensional. And here, in these early-fourteenth-century frescoes, there is an added element of contrast, namely pictorial space. The apostles are given an illusionistic space in which to move, created by the green ground on which they stand and the architectural backdrop of buildings solidly constructed in oblique perspective, while the bishops are simply silhouetted against flat fields of the colors blue and green.

The same formal distinctions that divided apostles from bishops also separated them from other classes of saints, such as deacons and monks. A good example of this kind of diagraming of the saints can be found in the late-twelfth-century mosaics in the apse of the Cathedral of Monreale in Sicily, mosaics made for

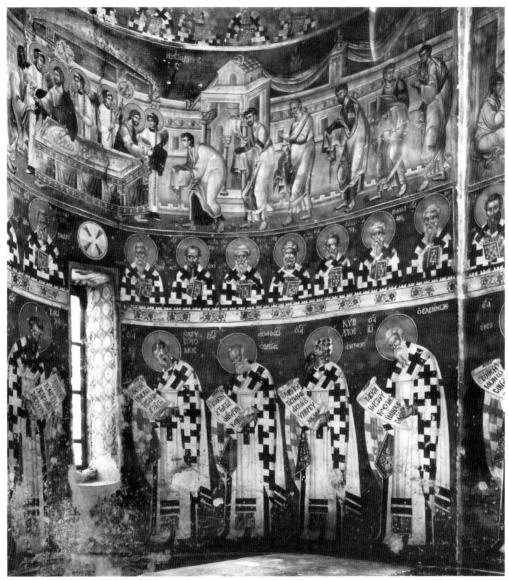

52. Staro Nagoričino, Church of St. George, frescoes in apse: Liturgy of the Apostles and of the Holy Bishops

Norman patrons but set under the supervision of Byzantine-trained artists. Here there is a choir of holy bishops, deacons, monks, and virgins in the lower zone of the north and south walls, juxtaposed with a grouping of the twelve apostles in the upper zone (fig. 53). All the saints in the lower zone are completely frontal, but the apostles above are represented in much freer attitudes, either turning toward each other or toward the enthroned Virgin and Child in the center of the apse.[9] Thus,

53. Monreale, cathedral, mosaic on the north wall of the apse: Apostles and saints

on the north side of the apse (fig. 53), the apostles Philip and Bartholomew, on the left, interact with each other as a pair, while Luke, John, and James all face the center of the apse, with Luke and John bowing their heads in reverence. In contrast, the virgin martyr Agatha, the monk Anthony, the bishops Blaise and Martin, and the deacon Stephen do not communicate with other figures in the apse but face the viewer in strict frontality. Their deportment may be characterized in the words of an anonymous Byzantine epigram which is found in a large anthology of poems preserved in a late-thirteenth- or early-fourteenth-century manuscript now housed in the Marciana Library at Venice. The poem, which refers to the stoning of Stephen and was probably written to be inscribed on an icon of the saint, begins:

> Stephen was steadfast with a manly purpose.
> In the face of the stoning it was as if he had a nature above nature,
> and a flesh that would manifestly deny the laws of nature. . . .
> In the face of the blows from the stones, he was [himself] a stone.[10]

In other words, the deacon saint, who had a "nature above nature," was rigid and immovable, like the images in the lower zone of mosaics at Monreale.

Such formal distinctions between different classes of saints were not confined to the apses of churches but were observed consistently throughout the entire spectrum of post-iconoclastic Byzantine art, in all media. For example, figure 54 illustrates the frontispiece to a copy of John Chrysostom's homilies on Matthew's Gospel, a manuscript which was probably made in the mid-eleventh century for presentation to the newly founded imperial monastery of St. George of Mangana in Constantinople. The miniature shows the evangelist offering his gospel to its exponent, while the bishop puts out his hands to receive it. Although the two saints both are portrayed in three-quarter view, as if turning toward each other, and their gestures are reciprocal, there is a striking difference in their stances. Matthew moves more freely than John Chrysostom; his arms reach out further, while those of John Chrysostom are held more tightly and rigidly against his body. The outline made by Matthew's body is uneven and dynamic, while John Chrysostom's frame fits within the severe confines of a rectangle. There is a contrast, also, in the modeling of the saints' clothing. While the fall of the evangelist's garments creates complex fold patterns, which are carefully rendered with shading and highlights, the vestments of the bishop are flat, without life and movement, and simple in their visual effect.

Some of the most substantial and three-dimensional images in Byzantine painting are portraits of the evangelists. The distinction between the corporeal

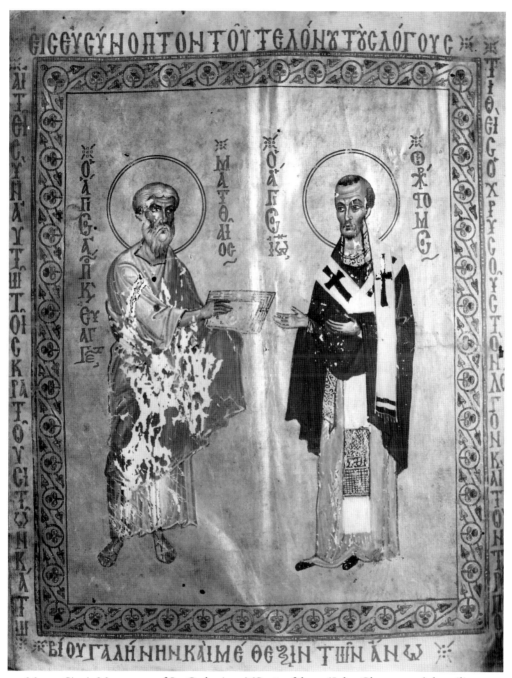

54. Mount Sinai, Monastery of St. Catherine, MS 364, fol. 2v (John Chrysostom's homilies on Matthew): Saints Matthew and John Chrysostom

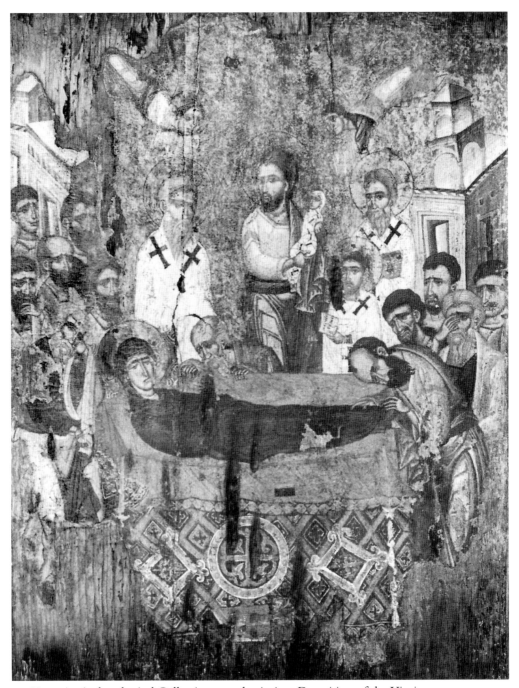

55. Kastoria, Archaeological Collection, panel painting: Dormition of the Virgin

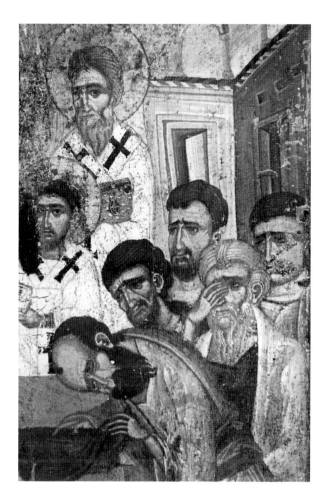

56. Kastoria, Archaeological
Collection, panel painting, detail:
Bishops and apostles present at the
Dormition of the Virgin

evangelist and the incorporeal ascetic is made with especial force in the famous
paintings of the tenth-century Gospel book in the Stauronikita monastery on
Mount Athos. We have already seen the portrait of Saint John, a voluminously
draped figure seated in a spacious antique setting with a curved architectural
niche behind him (fig. 8). We have also seen that, if we turn this page of the man-
uscript, there is overleaf a circular icon of the monk Saint Euthemios raising his
hands in front of his chest in a symmetrical gesture of prayer (fig. 17). This image
of the monastic saint, small, tight, and austere against a flat gold ground, is strik-
ingly different from the ample form of the evangelist on the preceding page.

Byzantine artists observed these formal distinctions between different classes of
saints not only in individual icons and in ceremonial scenes, such as frontispieces
and the celestial liturgies, but also in Gospel narratives. That is, even in the con-
text of the earthly life of Christ, the different classes of saints participating in the

57. Lagoudera, Church of the Panagia tou Arakou, fresco: Dormition of the Virgin

events show their distinctive natures through their deportment and through their varying degrees of corporality. The clearest demonstration of this princi-ple is to be found in Byzantine portrayals of the Dormition of the Virgin, such as a remarkable icon from Kastoria, in Greece, which dates to the first half of the thirteenth century (fig. 55). Here we see the mourning apostles gathered around the deathbed of the Virgin, with Christ, at the center, receiving her soul. As became the custom in later Byzantine painting, the artist also shows three bishops flanking Christ, who were believed to have been present at her death and to have witnessed the funeral. The bishops included Dionysios the Areopagite, who was thought on the basis of his own writings to have been an eyewitness to the scene,[11] and James, the Brother of the Lord, the first bishop of Jerusalem, who was also believed to have attended at the Dormition and to have written an account of the event.[12] But in this icon the demeanor of the bishops is very different from that of the apostles (fig. 56). The apostles show their intense grief and emotion in their lined cheeks and tensely furrowed brows, and, in the case of Peter, Paul, and John, through their postures as they bend over the bier. The expressions on the faces of the saintly bishops, on the other hand, are impassive and unmoved. They appear as disembodied presences in their flat white garments, floating, unbending spectators, rather than fully

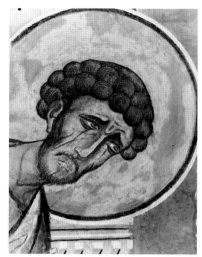

58. Lagoudera, Church of the
Panagia tou Arakou, fresco, detail:
Bishop present at the Dormition of
the Virgin

59. Lagoudera, Church of the
Panagia tou Arakou, fresco, detail:
Apostle (Luke) present at the
Dormition of the Virgin

engaged participants in the drama. Similar distinctions between the witnessing
bishops and the mourning apostles can be observed in Byzantine wall paintings
of the Dormition, such as the well-preserved fresco of 1192 in the church at
Lagoudera on Cyprus (fig. 57). In his drawing of the faces of the participants,
the artist distinguished between the three bishops standing to the right of
Christ and the Twelve Apostles. While the bishops' complexions are marked by
the lines of old age (fig. 58), their eyebrows are not disfigured by the S-shaped
distortions that signify the sorrow of the apostles (fig. 59), nor are there streaks
of tears descending from their eyelids. The contrasts are more subtle than in the
later icon from Kastoria, but they are already there.

Byzantine artists after iconoclasm, therefore, sought consistently to make dis-
tinctions between different classes of saints according to their degrees of corporal-
ity, motion, and emotive response. In the remainder of this chapter we shall see
how the formal idioms chosen for the portrayals of soldiers, monks, bishops,
apostles, and evangelists corresponded to the perceived natures and functions of
these groups of saints, as expressed in their biographies, in poems that were com-
posed for their icons, and in dedicatory inscriptions. Finally, at the end of the
chapter, we will consider a special case, that of images of the Virgin.

MONKS AND ASCETICS

The monastic saints of Byzantium restricted both their lives and their movements.[13] In their biographies, monks were compared to living "monuments" or "columns" of virtue. A biographer of Saint Alypios the Stylite, for example, described him as standing "like a motionless living column upon a lifeless column."[14] The ascetic monks had human feelings, but they overcame their emotions by the greatness of their minds. They possessed *apatheia,* that is, freedom from human passions and emotions. As an example of the inflexibility of monastic saints, we may take a touching scene which is described in the Life of Saint Nikon of Sparta, whose miraculously created image has already been discussed. As a young man, says the biographer, Saint Nikon is leaving his family for the last time, setting off for the life of a wandering ascetic. By a miracle, he has crossed a swollen river, leaving his pursuing father and brothers stranded on the far bank. From across the raging water, Saint Nikon hears his aged father lamenting his son's departure. The saint, says the author, was human; he loved his father. On hearing the old man's pleas, Nikon "turned himself a little" toward his father and brothers, so that they could see his face which, by now, was withered through asceticism (fig. 3): "Facing them he bent his head three times toward the ground, then took his face away and gave them his back, taking up his journey."[15] It was a highly charged moment, but it has the visual formality of a liturgy. This slight concession to his distraught family was the expected deportment of the monastic holy man.

Female monastics also cultivated *apatheia.* For example, the biographer of the ninth-century saint Theodora of Thessaloniki (fig. 28) tells us how she came to master her feelings of maternal affection toward her daughter, Theopiste, who was a nun in the same convent. When Theodora, "becoming subject to human emotions," showed signs of paying special attention to her daughter, the abbess imposed upon her a penance of not speaking to her daughter for fifteen years. After this long period of silence, mother and daughter gave no thought to their relationship.[16]

Monastic saints, therefore, were restricted both in their movements and in their emotions. But they also restricted themselves by physical privation, wasting themselves through fasting, so that they became lifeless and bodiless. Again, we can quote the biographer of Nikon, who says of his hero: "One would have said that the shadow of a statue was to be seen in him, but not a man in a body."[17] Elsewhere we are told: "His body was so wasted away and fatigued from toil that he differed not from a shadow."[18] But privation in the material world brought a new freedom. Those whose quest for immateriality was particularly successful were able to levitate themselves, or even become invisible. The tenth-century

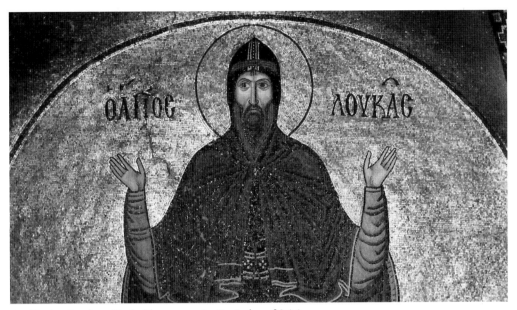

60. Hosios Loukas, Katholikon, mosaic: St. Luke of Stiris

saint Luke of Stiris, whose portrait survives in his monastery (fig. 60), used to levi-tate himself a cubit from the ground whenever he prayed.[19] Saint Nikon was able to put his powers of levitation to practical use and travel between Corinth and Argos flying through the air.[20] As for the ability to make oneself invisible to others, this was the subject of a dialogue recorded in the biography of the ninth-century monk Saint Anthony the Younger, which was written by a contemporary of the saint. We are told that a certain ascetic had the power to make himself invisible. One day he disappeared before the eyes of Saint Antony, who could only confirm the holy man's presence by touching his garment with his foot. In wonderment, Antony addressed the man as follows: "In truth, master, if you wish, someone can see you, but if you do not wish it, you are not seen by anyone." To which the ascetic replied, smiling: "And are you unable to do this? Truly, if you have not yet attained this, you have not yet become a monk."[21]

In truth, the summit of the monastic achievement was to reach a completely immaterial state of being, like that of the angels. From the time of the early desert fathers, monks had been compared to the bodiless angels, the *asomata*. We saw in the last chapter that the sixth-century writer Cyril of Scythopolis said that Saint Euthymios, at the time of his death, possessed the form of an angel. Since angels were sexless, they were associated also with nuns. In the Life of the fifth-century Saint Elisabeth the Wonderworker, we are told that upon entering a con-

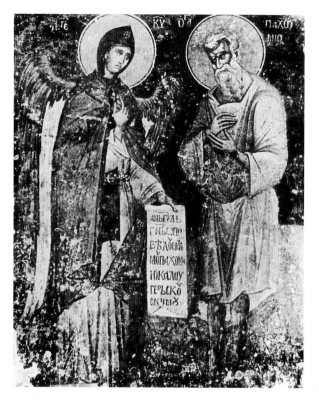

61. Staro Nagoričino, Church of St. George, fresco: Angel dressed as a monk beside St. Pachomios

vent she "put on the angelic garb."[22] As for the tenth-century saint Nikon, his existence was said to be "on the boundary between human nature and the angelic and disembodied." The saint, "while living in the flesh, on account of his likeness to disembodied powers, was not weighed down by the appendage of the body; but his life was upwards, walking on air together with the powers of heaven."[23] In the fourteenth century, the prolific Byzantine court poet Manuel Philes wrote a poem "On *Apatheia,*" stating that the aim of the monk's life was to reach the state of the angels:

> When you become a completely passionless man
> then you wisely resurrect the buried soul.
> For it [the soul] seeks to go to the light of the angels,
> having shed the dust of the passions and the darkness.[24]

The desire expressed by this poem was also conveyed by works of art. In later Byzantine painting, angels were sometimes actually depicted as monks, wearing the monastic habit, as can be seen in an early-fourteenth-century fresco in the Church of St. George at Staro Nagoričino, which is contemporary with the

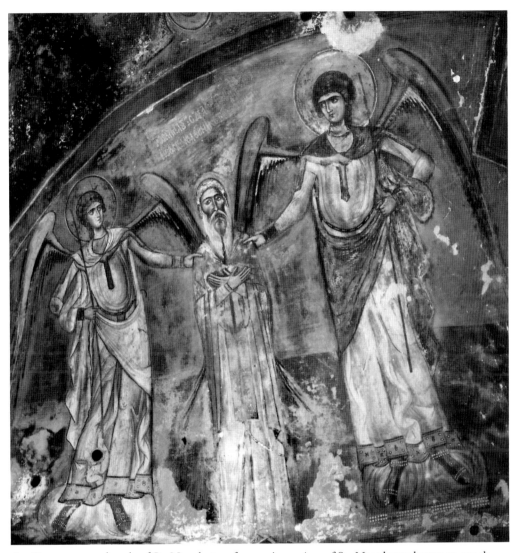

62. Cyprus, cave church of St. Neophytos, fresco: Ascension of St. Neophytos between angels

poem by Manuel Philes (fig. 61). Here the hooded angel/monk is portrayed beside the desert father Pachomios, flanking the western door of the monastery church. A precursor to these images is a remarkable fresco which the Cypriot hermit Saint Neophytos had painted toward the end of the twelfth century on the ceiling of the rock-cut chapel that adjoined his cell (fig. 62).[25] It shows Saint Neophytos himself being escorted up to heaven by two winged angels. Thus the ascetic, while still alive, could look up and see painted above him the realization of his dream: to "walk on air together with the powers of heaven."

The painting of Saint Neophytos brings us to the role of angels in Byzantine portrayals of the saints. The Byzantines understood that since angels were purely spiritual beings, without matter, their depiction in art had to be entirely conventional. This idea was expressed in poems that were composed to accompany their images. For example, one Byzantine epigram queries the artist of an icon of the archangel Michael as follows:

> If you wish to display the movement of an angel,
> why, painter, do you paint this winged man,
> and not intelligence, spirit, light, and flame?
> Only one could not paint the immaterial with what is material.[26]

This poem poses a problem which had already been answered by another epigram on an image of the archangel Michael, written by the eleventh-century bishop John Mauropous:

> We know that the angels are light, spirit, and fire,
> higher than all matter and every passion.
> But the general of the immaterial hosts
> stands [here] painted with material colors.
> O faith! What wonders you have power to work!
> How easily you give form to the nature that is formless!
> Only the painting shows the one that is painted
> not as he is by nature, but as he often seemed to be.[27]

In other words, Byzantine art showed angels not as they actually were, but in the forms that they had assumed in their earthly appearances, which did not reflect their true natures. On the other hand, as we shall see, the formal attributes of earthly saints in art *were* believed to be a reflection of their real natures, and not a matter of convention. This distinction between angels and humans in art made it possible for angels to play a double role as a foil for mortal saints. In contrast to disembodied saints, such as monks, the angels were painted with more movement and substance; in contrast to more corporeal saints, such as apostles, they were painted with less. In the words of Theodore of Stoudios: "In comparison to a solid body, the nature of the angels is bodiless; but in comparison to the deity it is neither bodiless nor uncircumscribable. For this reason the Apostle says: 'both celestial bodies and terrestrial bodies'" (I Cor. 15.40).[28] In art, the role of the angels was to provide points of contrast in a binary system, by which the saints' degree of disembodiment or corporality could be gauged. In the fresco in the cave church of

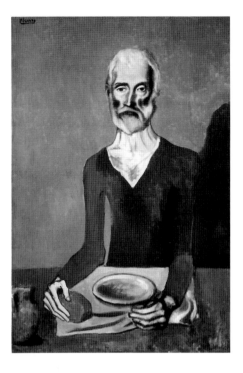

63. Philadelphia, Barnes Collection: *The Ascetic* by Pablo Picasso

St. Neophytos, therefore, we see that the angels wear classical garb, with sinuous folds descending to their feet, while Saint Neophytos wears a monastic habit that is flat in its rendering, with severely straight and vertical pleats (fig. 62). The undulating patterns of the angels' garments give them life and movement, while Neophytos is immobile. The angels have rounded, slightly bulging stomachs, and they flank the saint with a swaying gait; Neophytos, on the other hand, is as stiff as a column. In other words, Saint Neophytos is seen as more incorporeal and superhuman than the angels; their comparatively lively and robust forms emphasize his special nature. We shall see, however, that where angels are portrayed together with evangelists and apostles, the contrast is reversed.

The twentieth-century artist Pablo Picasso understood well the nature of monks in Byzantine art, as can be seen in his painting *The Ascetic*, which is now in the Barnes Collection in Philadelphia (fig. 63). This canvas from the artist's Blue Period, which he painted in 1903 under the influence of El Greco, shows the typical flattened body of the Byzantine monk, thinly painted and devoid of volume, surmounted by a more heavily modeled bearded head. This modern-day ascetic, with his empty dish in front of him, echoes the formal values of the confident Saint Neophytos (fig. 62), even while the expression of his face bespeaks an epoch of history that is spiritually less secure.

Thus, formal contrasts of modeling and movement, expressed through binary oppositions between monks and soldiers (figs. 10, 41-43), or even between

monks and angels (fig. 62), were important signs of monastic self-denial in Byzantine art. But there was another way by which Byzantine artists illustrated asceticism, not by formal means, but by realistic images of fasting and self-privation. Here the model was John the Baptist, who, from the eleventh-century onward was frequently depicted as a desert ascetic, half naked, clad only in a short fur tunic or in a skimpy cloak, and exhibiting emaciated, sticklike limbs. A striking icon of this type is preserved in the collection at Mount Sinai (fig. 64). The appearance of Saint John in this image accords well with a poem by John Mauropous, which describes the saint in a painting of the Baptism: "a man with long hair, cultivating a wild and squalid appearance . . . fleshless, half naked, the type of an angel."[29] Even more graphic is a description of John the Baptist in a sermon by Philagathos, a Greek monk of the twelfth century, who lived in southern Italy: "He was shaggy and wild in appearance, from having been raised in the desert from childhood. His head was squalid, filthy, and covered with flowing locks. He was shaded by the mass of his own hair. His beard was thick, and his body was skeletal on account of his meager way of life."[30] Philagathos' characterization of the saint, with its contrast between his thick, shaggy hair and his emaciated limbs, is an exact counterpart to the icon at Mount Sinai (fig. 64).

This portrait type of John the Baptist represents an alternative mode for representing asceticism in Byzantine art, not through flattened draperies but through a more realistic portrayal of sticklike limbs and unkempt hair. Other saints who were portrayed in this manner included Saints Makarios and Onouphrios, who went so far as to be shown completely nude, their withered but hirsute bodies uncovered by any clothing, their modesty preserved in the paintings only by strategically placed trees and bushes. Both of these saints were portrayed on the walls of the cave church of St. Neophytos, where they provided models for the hermit's quest for monastic perfection (fig. 65). Even these naked images related to the concept of *apatheia*. According to the monastic writer Symeon the New Theologian, who lived at the turn of the tenth to the eleventh century, the saint who had *apatheia* was not ashamed to be, or to be seen, naked. Writing about his spiritual father, Symeon Eulabes, he said in one of his hymns:

> Saint Symeon Eulabes, the Studite
> was not ashamed at the limbs of anyone,
> neither to see other men naked, nor to be seen naked,
> for he possessed the entire Christ and he himself was entirely Christ.
> And all his limbs and the limbs of every other person,

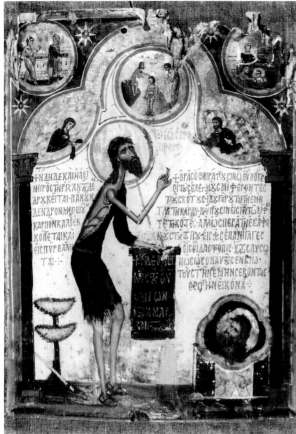

64. Mount Sinai, Monastery of St. Catherine, panel
painting: St. John the Baptist

65. Cyprus, cave church of St.
Neophytos, fresco: Saints Makarios
and Onouphrios

every and each one were always in his eyes like Christ.
And he remained immobile, innocent, and without passion.[31]

In other words, even though his flesh be naked, the monk who has attained per-
fection can remain unmoved by the passions.

The female counterpart to these realistically portrayed male ascetics in Byzan-
tine art is Saint Mary of Egypt, who is often shown as exceedingly emaciated,
almost skeletal in appearance, with a drawn face and matted hair. This is the con-
dition in which she was found by the monk Zosimas, when she was aged sev-
enty-six and had been living in the wilderness for forty-seven years. In the Life of
the saint ascribed to the seventh-century writer Sophronius, her body is com-
pared to a shadow, her skin is said to be scorched black by the sun, and her hair is

described as white as wool.[32] Furthermore, she had the power of levitation,[33] like Saint Luke of Stiris, and she was able to cross the River Jordan by walking upon the water.[34] Some of the most vivid portrayals of her in art are in Cypriot frescoes, such as the painting of 1105-6 at Asinou, seen in the last chapter (fig. 26). Her dark, scrawny features and long, white matted hair contrast with the plump face and smooth coiffure of Saint Barbara's portraits (figs. 24, 25).

These ascetic portraits of Saint Mary of Egypt also had their literary counterparts. Byzantine poets, in particular, were moved to match the artists' graphic rendering of her asceticism. Thus, Manuel Philes, who composed many poems for icons, wrote the following epigram to be inscribed upon an image of the saint:

> O Painter, your hand has painted the shadow of a shadow,
> for the body of the Egyptian woman was a shadow;
> or rather, to put it precisely,
> from a shadow you have painted material suffering.[35]

A poet of the late twelfth and early thirteenth centuries, John Apokaukos, used the same image of a shadow but also described the realism of the saint's image in more concrete terms:

> She had the fleshless quality of the angels,
> and it is a marvel how she turns weight into shadow
> and how she is both substance and again remains shadow,
> and how the thinness of a shadow is embodied [in her],
> being composed of condensed sinews.
> But the thickness of the weight is thinned out,
> so that it has nothing more than shadow. . . .
> It seems to me that they paint the Egyptian woman
> as the nature of angels was often seen.
> For she is not inferior to the angels, even by a little.[36]

Saint Mary of Egypt, then, was a full counterpart to the male monastics: fleshless, disembodied, a shadow cast upon the wall. In the following pages we shall see how greatly different were the Byzantine expectations of their warrior saints.

SOLDIERS

A story in the *Miracles* of Saint George provides an interesting insight into the way that the Byzantines viewed images of their military saints. We are told that a group

of infidel Saracen soldiers insulted Saint George by going into his church to drink, sleep, and even play dice there. They had with them some Christian prisoners, one of whom warned them that the saint was able to repay such behavior. But the Saracens only laughed and asked their prisoner to point out Saint George from among the holy images set up above them in the church. The Christian indicated the mosaic of the martyr with his finger; according to the text, the saint in the image was "girt about with brightness and a military corselet, wearing bronze leg-coverings, holding a war-spear in his hand, and looking in a terrifying manner upon those who gazed straight at him." In spite of the fearsome character of this portrait, one of the Saracen soldiers still made so bold as to hurl a missile at it. But the weapon was returned to the attacker in such a way that it struck him in the heart. The saint's active participation in this miracle was proved by the icon itself, which was seen by the other soldiers to stretch out its hand.[37]

This story belongs to a familiar class of legends concerning images that responded to attacks by infidels and iconoclasts. But it is also notable for its stress on the physically active role of the image; the portrait wears its armor and carries its weapons in such a way as to appear terrifying to its beholder; the image even seems to be extending its hand. This last detail of the story is matched by several Byzantine portrayals of warrior saints in which their weapons project beyond the frame of the image, into the space occupied by the viewer, as can be seen in the fresco of Theodore the Recruit at the Kariye Camii (fig. 14).

Another literary source where we find a fearsome characterization of a soldier saint is the tenth-century *Synaxarion* of Constantinople, a compilation of brief notices devoted to the lives of the saints. Concerning Saint Sabas the General, this text declares: "The glances of his eyes had a fierce and terrifying character, show-ing the utmost of manly and military qualities."[38] The description corresponds to works of art in which the soldier saints, even while they turn their bodies and heads to the right or the left, focus their eyes fixedly on the viewer (fig. 46).

Some of the most vivid tales of the physical prowess displayed by images of warrior saints come from Christian Egypt. One of them relates that during the reign of the patriarch Cyril of Alexandria, who was in office from 1078 to 1092, a bedouin entered the Church of St. George in the village of Damallū and stood fighting with the image of the saint. The saint in the icon then struck him, and the bedouin died immediately.[39] A gentler story concerns an infidel ruler, Hama-rawayh, the son of Ahmad ibn Tulun, who, passing an image of Saint Theodore, mocked the icon by throwing a bunch of basil at it with the words: "Take it, O knight, O valiant one!" Whereupon the picture of the saint reached out a hand

and took the plant. Hamarawayh was so impressed by this response that he treated the Christians well thereafter.[40] Stories such as these demonstrate that medieval Christians looked to the soldier martyrs for strength to help them through life and that the images of these saints had to look the part.

Byzantine poems composed for inscription on icons also show how the Byzantines viewed their military saints. The warriors were expected to be restless and vigorous, with healthy red complexions, not motionless, fleshless, and pale, like the shadow portraits of the monks. For example, this is how Manuel Philes writes of a painted image of Saint George:

> The restless man at arms, courageous against enemies,
> sports a red bloom on his cheeks.
> For to be absolutely pale before battle
> is a mark of unmanliness, not manliness.[41]

A good example of the type of image addressed by this poem can be found among the post-Byzantine frescoes in the Church of St. George of the Mountain (tou Vounou) at Kastoria (fig. 66). Here Saint George sits in a shifting pose as if he were about to rise for combat, his legs turned to the right, his upper body facing the front, and his sword pulled half way from its scabbard. The poem by Philes can also be compared with a marble relief of the soldier saint Demetrios, which is now built into the facade of the Church of S. Marco in Venice, but which was a probably a Byzantine work of the eleventh century (fig. 67). Here, too, can be seen the restlessness described by the Byzantine poet, the movement of the legs and the sword being withdrawn for battle. This warrior is well fed; there is even the hint of a paunch.

Another Byzantine poet, Nicholas Kallikles, addressed a poem in the first half of the twelfth century to a marble icon of Saint George, which no longer survives but which must have been similar to the carving of Saint Demetrios in Venice. According to the title of the poem given in two of the manuscripts, the carving was preserved in the Monastery of the Mangana in Constantinople. The verses play upon the whiteness of the marble; one would expect, says the poet, that the saint's countenance be robust and red, but here it is not. He says of this stone martyr that:

> If he had any ruddiness of flesh
> this became like snow, and was found to be white,
> having been washed out by a martyr's sweat.[42]

A similar stress on qualities of movement, watchfulness, and robustness is found in epigrams devoted to images of the two Saints Theodore. A typical example is

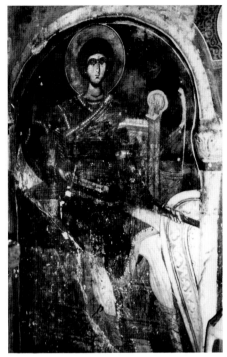

66. Kastoria, Church of St. George of the Mountain, fresco: St. George

67. Venice, S. Marco, marble relief: St. Demetrios

this poem on an icon of Theodore the General, which is attributed to the twelfth-century writer Theodore Prodromos:

> The martyr is living; do you not see how he watches?
> If you look you will say that he even brandishes his spear.
> Thus the painter paints the General.[43]

A poem by Manuel Philes, seeking to characterize portraits of the two Theodores in their armor, turns to the classical imagery of Hercules. The epigram was commissioned from Philes by Theodore Komnenos Palaiologos, the younger son of the emperor Michael VIII, to be inscribed upon an icon. Although Theodore Palaiologos, the namesake of the saints, only commissioned the poem and the icon, in the verses he speaks both as author of the one and as artist of the other:

> I painted the champions armed,
> so that Satan, humbled, may turn his back
> and may not assault us boldly.
> "Not even Hercules," they say, "is a match for two"—
> especially when they are triumphant even over feverish heat and volleys.

But I, bearing their beautiful name,
rejoice and have confidence in every battle.
For I seem to see them living everywhere,
whom I have engraved as soldiers even in my heart.
Therefore let every enemy, seen or unseen,
discard their shields and flee the noble (pair) as if they were fire.
For Christ strengthens them mystically
For the battles that have been drawn up against us.
Theodore Palaiologos [wrote] this.[44]

The two armed saints, therefore, whom not even Hercules would be able to overcome, brought courage to the donor in his daily conflicts, both against his visible human enemies and against the invisible legions of demons.

In summary, the soldier saints in Byzantine art had to look strong, solid, and physically active if they were to inspire confidence in the beholder. Perhaps it was for this reason that surviving relief icons of military saints, carved in both stone and wood, are relatively common (fig. 67), while there are very few relief icons of ascetics such as monks or bishops. The latter classes of saints had natures that were thinned out and insubstantial, and for them relief carving was not a suitable medium.

BISHOPS

Like the monastic saints, the holy bishops also were expected by Byzantine viewers to show qualities of disembodiment and immateriality in their images. Such an expectation is clearly expressed by three poems attributed to Manuel Philes, which were written to accompany icons of Saint John Chrysostom. They are all variations on the same theme, namely the ascetic bishop's lack of material substance. The poems may be compared to a famous contemporary image of the saint, the early-fourteenth-century mosaic icon now in the Byzantine collection at Dumbarton Oaks (fig. 23). The three epigrams are as follows:

O painter, your hand has painted the shadow of a shadow
For the body of the Chrysostomos was a shadow,
thinned out from fasting as if it were fleshless,
and this is a wonder, how you paint the shadow of a shadow.[45]

There is no softness and weight of luxury in you, father,
nor is there any excess of body, water, or flesh.

For you have thinned out physical thickness
and severely stripped it down with a harsh regimen.[46]

Like a living instrument and a speaking lifeless shell,
you were accurately shown thin and pale,
both living and dead and painted,
you to whom it befell to be the golden mouthpiece
 [*Chrysostomos*] of Christ.[47]

Here the language is the opposite of the words used by Philes to describe the soldier saints; the bishop is "pale", not "red"; he is "lifeless" as well as "living". The poems are a perfect complement to the portrait in the mosaic icon, which is still, frontal, and two-dimensional (fig. 23). Only the small gesture of speech made by the right hand and the modeling of the forehead hint at movement and substance. The white vestments of the bishop, with their black crosses completely without foreshortening, flatten the figure and endow it with austerity and pallor. We may note, however, that the first two lines of the first poem by Philes on John Chrysostom are almost identical with the opening of his poem on an image of Saint Mary of Egypt: "O Painter, your hand has painted the shadow of a shadow, for the body of the Egyptian woman was a shadow."[48] On the other hand, the corresponding images in art are quite different. For Saint Mary of Egypt, who was represented half naked in art, Byzantine painters employed the more realistic figure type of an emaciated body with matted hair and skeletal limbs (fig. 26). For the bishop saint, they used a clothed figure that was more abstracted, a frontal image, flattened, and drained of life, like a shell. The use of identical words by Manuel Philes to describe the two categories of image does not mean that he was an uninventive poet; rather, it shows that the two portraits, the realistic and the abstracted, had essentially the same message, namely, to convey the idea of asceticism and the stripping down of the flesh.

Among the other bishop saints, Basil the Great was also singled out for the ascetic appearance of his portraits. An anonymous poem from a collection composed at the turn of the ninth to the tenth century addresses an icon of this saint with a familiar metaphor: "Even the shadow of your flesh, O Basil, / speaks while being silent, and addresses admonishments."[49] These verses can be compared with the somewhat later miniature of the saint in the *Menologium* of Basil II (fig. 20), which shows the bishop standing straight and severe before a line of columns that reflect his rectitude.

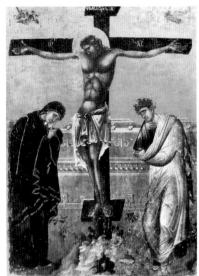

69. Ohrid, National Museum, panel
painting: Crucifixion of Christ

68. Mount Athos, Monastery of the Great Lavra, mosaic
icon: St. John the Theologian

As in the case of John Chrysostom, the poems on Saint Basil also referred to
the ascetic pallor of the saint. In the eleventh century, for example, John Mau-
ropous described a painting of him as follows: "A certain august pallor from self-
control / befits the wise teacher."[50] The same author addressed another poem to
an icon of John Chrysostom, in which he described the saint as "weak-voiced
from fasting."[51] Thus, whereas the soldier saints were seen as vigorous, ruddy and
strong, the bishops were viewed as pale and physically weak; their strength was of
an immaterial kind.

APOSTLES AND EVANGELISTS

In the Monastery of the Great Lavra on Mount Athos there is another mosaic icon
of the early fourteenth century, which differs strikingly from that of John Chrysos-
tom (figs. 23, 68). This work, which portrays John the Theologian holding his book
and his pen, introduces us to the fundamental logic that lay behind the formal

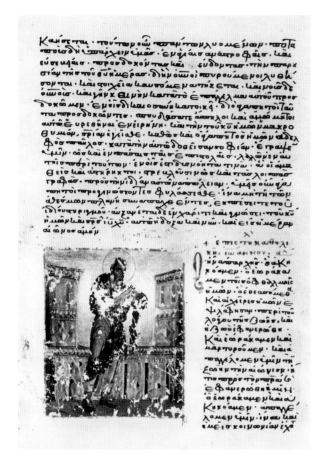

70. Jerusalem, Greek Patriarchal
Library, MS Taphou 47, fol. 153v
(New Testament): St. John

distinctions between different classes of saints in Byzantine art. Unlike Saint John
Chrysostom, and the other bishop saints depicted by Byzantine artists, John the
Theologian has a well-rounded body, with carefully modeled drapery folds. He is
turned to the left in a hunched pose, with his right hand bent forward in an awk-
ward posture under his chin; his demeanor is very different from the frontality and
straight-backed rigidity of Saint John Chrysostom. The posture of John the The-
ologian is a reference to his role at the Crucifixion of Christ; in Byzantine Cruci-
fixion scenes, such as an early-fourteenth-century icon from Ohrid (fig. 69), a
younger Saint John was commonly shown with his head bowed in sorrow and his
right hand raised and crooked under his chin in a gesture of weeping. Thus, in the
mosaic icon, even as he writes his Gospel, John echoes his participation in the cru-
cial event of Christ's earthly life. Portrayals of Saint John similar to the mosaic icon
in the Great Lavra were sometimes painted as frontispieces in Byzantine manu-
scripts containing the Epistles. For example, there is a painting of the evangelist in a

71. Ohrid, Church of St. Sophia, fresco in the vault over the sanctuary: Ascension of Christ

similarly hunched pose in a late-twelfth-century copy of the New Testament now in Jerusalem (fig. 70). The poet Manuel Philes wrote a poem to accompany such a miniature. His epigram bears the title: "On the image [of St. John] set in the Epistles," and it begins: "The son of Zebedee is bent to the ground, / for he carries on his shoulders the yoke of the Lord."[52] It is, therefore, as if the pose of Saint John carries the weight of the crossbar of Christ's death. From this example it can be seen that the formal distinction between the two groups, bishops and apostles, meant more than the difference between ascetic and non-ascetic saints. It was also a sign that the apostles had participated in the historical events of Christ's life on earth; that is, they bear witness to his incarnation. When John of Damascus wrote his *Treatise on Images*, he said of the apostles that "they saw Christ corporeally, both his sufferings and his miracles, and they heard his words. . . . They saw him face to face, because he was present in the body."[53]

Like the ascetic monks, the apostles were sometimes juxtaposed with angels in Byzantine art, but with a view to emphasizing their corporality, not their immateriality. One of the most striking contrasts of this kind can be seen in the sanctuary of the Church of St. Sophia at Ohrid, which was decorated in the eleventh

72. Ohrid, Church of St. Sophia, fresco in the vault over the sanctuary, south side: Apostles from the Ascension and angels in adoration

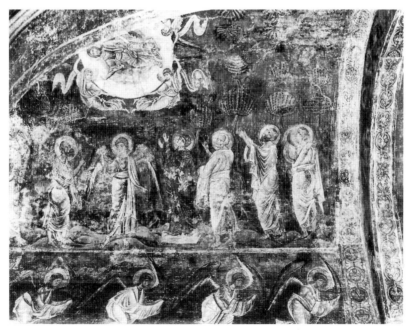

73. Ohrid, Church of St. Sophia, fresco in the vault over the sanctuary, north side: Apostles from the Ascension and angels in adoration

century. Here there is a large painting of the Ascension of Christ which covers the barrel vault over the sanctuary; the ascending Christ is shown enthroned in an aureole of light borne up by angels at the center of the composition, while the apostles and the Virgin are ranged along each side (fig. 71). Below the feet of the apostles, on either side of the vault, there is a line of kneeling angels all facing to the east, toward the image of the Virgin and Child that appears in the apse (figs. 72, 73). In these frescoes, all the portrayals of angels are governed by strict principles of repetition and bilateral symmetry. Beneath the apostles, each heavenly being bends on one knee in a virtually identical posture of adoration. Furthermore, all the angels in the Ascension scene above are symmetrically posed; even the angels who address the watching apostles are mirror images of each other (fig. 71). In contrast, the postures of the witnessing apostles have been consciously varied: some are seen from the front, some from the side, and others from the back; some stride toward the ascending Christ, and others step away; some point with their right hands, others shield their eyes from the light, and yet another pensively touches his chin (figs. 72, 73). Thus, the artist plays up the transitory and earthly variety of the apostles' movements, contrasting them to the repeated poses of the angels, who are fixed in eternal heavenly reverence. We have seen that in the paintings in the cell of Neophytos the effect of the comparison was the reverse; that is, in the ascension of the ascetic monk, the angels showed movement and life, while the saint was rigid and disembodied (fig. 62).

The rationale for this formal distinction between angels and apostles can be found in a sermon composed in the late ninth century by the learned emperor Leo VI for the dedication of a church by his father-in-law, Stylianus Zaoutzas. Describing the mosaics in this church, Leo contrasts the images in the dome, where the angelic beings surround Christ as his ministers, and the images in the lower part of the church, which depict "the events of the incarnation through the flesh". Among the latter, he observes a vivid portrayal of the Ascension. Here Christ can be seen ascending "with his human nature" to heaven, while "his disciples are standing there, fashioned with such lifelike character by the painter, that they seem indeed to be seized by the various emotions of living persons. One of them gives the impression of following the ascending [Christ] with his eyes; another is seen to be all ears, attempting to capture the meaning of the words that are uttered above. . . ; another is pensive because of his astonishment; another is filled with wonderment and fear."[54] Life, emotions, movement, all of these were features that were avoided in portrayals of ascetic saints, as we have seen. But for the apostles they were desirable, because these saints witnessed the earthly life of Christ.

We have observed that in Byzantine art some of the most strongly three-dimensional images of saints are those of the evangelists. Another epigram attributed to Manuel Philes specifically associates the corporeal form of an evangelist with the incarnation of Christ. The poem is one of a set addressed to paintings of the evangelists seated and accompanied by their "beasts," or symbols: Saint Matthew with the winged man, Saint Mark with the lion, Saint Luke with the calf, and Saint John with the eagle.[55] It is probable that Philes wrote these epigrams to go with illuminations in a manuscript.[56] Although the book for which he intended the poems does not survive, it may have been similar to a surviving Gospel book of the fourteenth century in Paris (Bibliothèque Nationale, ms. gr. 106), which contains a set of epigrams on the evangelists and their symbols.[57] The closest surviving counterparts of the illuminations described by Philes are four evangelist portraits added in the fourteenth century to a tenth-century Gospel book now in the Megaspelaion Monastery. Here each author is shown seated as he writes, with his symbol perched above his lectern. Figure 74 illustrates the portrait of Matthew, who is accompanied by his "anthropomorphic" symbol of the winged man, which resembles an angel. The poem that Philes wrote for the miniature of Matthew bears the title "On his [i.e. Matthew's] anthropomorphic symbol," and it reads:

> Since you do not possess the fleshless nature of angels
> you bear the form of a fleshly evangelist,
> not because the angels have something higher,
> but because you write for us the incarnate Word.[58]

Here Philes is making a contrast between Matthew and his symbol. Like Byzantine painters who depicted the apostles, he uses the image of the angel as a foil to emphasize the corporality of the evangelist. He says that the writing evangelist bears a fleshly form, not the fleshless appearance of an angel, because it was as a man that the evangelist bore witness to the incarnation. In this poem we are given the reason for the strongly three-dimensional evangelist portraits such as those in the Stauronikita Gospels, with their deep spatial settings (fig. 8). The evangelists, who announce the incarnation, above all other saints belong to the material world of the flesh.

In conclusion, the apostles and the evangelists were depicted in a more corporeal manner in art because they bore witness to Christ in his human nature. But holy bishops and deacons, as well as monastic saints, were not completely subject to the laws of physical nature. These saints, to quote again from the epigram on the icon

74. Megaspelaion Monastery, MS 1, fol. 18v (Gospel book): Matthew
accompanied by his "anthropomorphic" symbol (below) and the Nativity (above)

of Saint Stephen, had a "nature above nature." Thus, paradoxically, the apostles were depicted as more corporeal because they participated in the life of Christ as a man; the monks and the holy clergy were disembodied because they had a special closeness to Christ as God, achieved by their self-denial and asceticism.

THE VIRGIN

In Byzantine art, when the Virgin is accompanied by other saints, she often appears more fully modeled than they and especially shows more movement and emotion. She also appears very frequently in relief icons of stone and wood, a medium in which, as we have seen, ascetic saints were very rarely portrayed. The logic is apparent: the mediation of the Virgin is effective on account of her humanity. She is the mother of Christ and has a special closeness to him. The human bonds between Christ and his mother were seen by Byzantine viewers as a guarantee of the strength of her intercession on their behalf.[59] This idea is stated expressly by one of the poems of Manuel Philes, which describes an icon of Christ with the Virgin at the shrine of the Pege, outside Constantinople:

> The Lord stands silently here,
> listening to the words of the Virgin.
> Do thou, my soul, seeing the expression of affection,
> receive the pledges of salvation.[60]

The icon described by Manuel Philes may have resembled a mosaic in the inner narthex of the Kariye Camii, which shows Christ standing beside the Virgin, who beseeches him with open hands and a face expressive of tender emotion (fig. 75). At their feet are the two suppliants on behalf of whom she addresses her appeal: Isaac Komnenos and Melane the Nun. But if it was the bond of human feeling that gave power to the intercession of the Virgin, in the case of the ascetic saints it was the opposite; their prayer, as we have seen, was effective precisely because they had overcome human needs and feelings. The Virgin Mary was celebrated for her motherhood and her bond with her son, but we have seen that the ascetic nun Theodora was praised for conquering her feelings for her daughter, so that she "gave no thought to their relationship."

The distinction between the Virgin and other saints was expressed in all periods of Byzantine art, from the sixth century to the fifteenth. It may be seen already in the famous sixth-century icon of the Virgin enthroned between two standing saints that is preserved in the collection at Mount Sinai (fig. 35). Typically for the

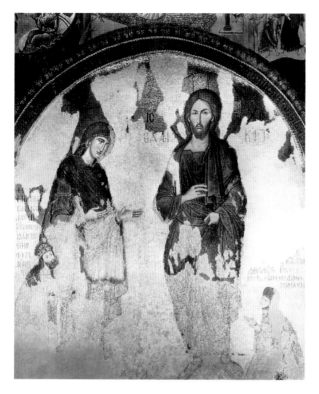

75. Istanbul, Kariye Camii, mosaic:
Christ and the Virgin with Isaac
Komnenos and Melane the Nun

early period, none of the saints is identified by an inscription. The one on the left
is almost certainly Saint Theodore, whose portrait type was relatively well estab-
lished by this time, although there was not yet the distinction between Theodore
the General and Theodore the Recruit. The saint on the right, curly-haired and
unbearded, bears the portrait type of Saint George. These two soldiers stand in
frontal poses, although their left legs are very slightly bent, causing a slight raising
of the left heel and a shadow under the left knee. Their eyes, however, stare
fixedly to the front. The Virgin, in comparison, displays much more motion; her
eyes are turned markedly to the right, and she sits with one knee raised higher
than the other, as she supports the Christ Child on her lap.

A somewhat later image of the Virgin accompanied by Saint Theodore the
Recruit is preserved among the mosaics in the church of St. Demetrios at Thessa-
loniki (fig. 37). The date of this panel, which we have already encountered in the
first chapter, is controversial; it may belong to the seventh century, or to the
ninth-century period after the restoration of images following iconoclasm. In the
mosaic there is a stark juxtaposition of Saint Theodore, on the right, who is in a
symmetrical and completely frontal pose with his two palms raised in prayer, and

the Virgin, on the left, who stands in three-quarter view as she mediates between the viewer and Christ appearing in heaven above. Whereas the stance of Theodore is completely motionless, the Virgin is depicted in the act of turning, for her two feet are seen frontally, facing the viewer, while the upper part of her body is moving to the right toward Theodore and Christ. On her scroll is written her request on behalf of the worshiper: "Supplication. Lord God, harken to the voice of my prayer, for I pray for the world."[61]

In addition to the differences in the poses of the two saints, there is a distinction in the modeling of the figures. The face of Saint Theodore shows little shading in contrast to that of the Virgin, and the pleats of his cloak are simply treated by black vertical lines, while the Virgin's robe is more delicately highlighted with yellow stripes. The contrast between the two saints in this mosaic demonstrates the relativity of the comparisons made by Byzantine artists between the saints. It was a binary system in which the signs were not invariably fixed but acquired their forms and their meanings only in pairs of oppositions. The soldier saint Theodore, as we have seen, was given substance and movement in contrast to monks, but in contrast to the Virgin he appears rigid and two-dimensional.

An even more striking distinction can be observed between the two dedication pages of the tenth-century Bible of Leo the Patrician, which is now in the Vatican Library. On the first page Leo, a eunuch, is shown offering the book that he has commissioned to the Virgin, who again mediates between him and Christ (fig. 76). The epigram that frames this miniature on all four sides expresses Leo's wish that the gift of this Bible will increase his chances of salvation:

> I make my good but humble offering
> out of faith, only this book, to God
> with the Mother who gave birth, the Mother of God,
> . . . in requital for the indictments against me.[62]

In the painting, the Virgin makes gestures of acceptance, leaning down on her right side to acknowledge her suppliant, while at the same time raising her left hand upwards to Christ in heaven. Another inscription at the top of the page reads: "The all-holy Mother of God with Christ receiving the book from Leo, praepositus, patrician and sakellarios."[63] In other words, the image provides reassurance to the donor that his gift is accepted. On the facing page of the manuscript is another dedicatory miniature (fig. 77), this one showing Saint Nicholas flanked by two kneeling suppliants who are identified by inscriptions as the abbot Makar, on the left, and as Leo's brother Constantine, on the right. It can further

76. Rome, Vatican Library, MS Reg. gr. 1B, fol. 2v (Bible of Leo the Patrician): The Virgin receiving the book from Leo

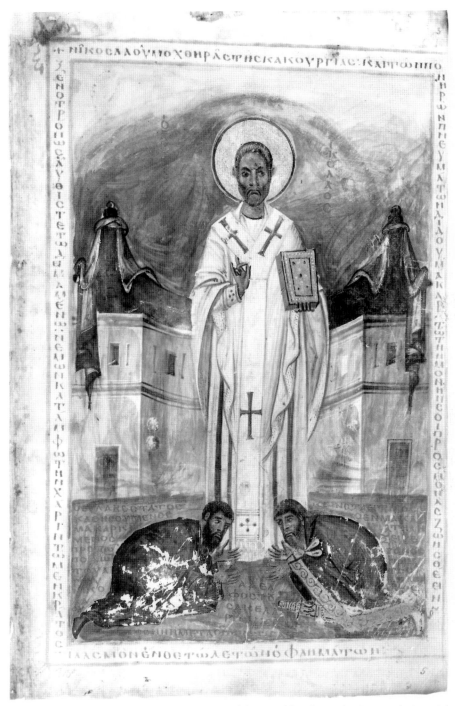

77. Rome, Vatican Library, MS Reg. gr. 1B, fol. 3r (Bible of Leo the Patrician): St. Nicholas receiving the supplications of the abbot Makar and Constantine the *protospatharios*

be deduced from the inscriptions that Constantine was the deceased founder of the monastery for which Leo had commissioned the Bible. The poem that runs around the miniature records the prayer of the two suppliants to Saint Nicholas:

> Victory of the people over wicked malice
> and the evil spirits, give [this] o blessed one. . .
> dispensing to both grace, to the one strength,
> to the other remission of his debts thereafter.[64]

In contrast to the Virgin, the image of Saint Nicholas that accompanies this prayer is completely disengaged from the kneeling figures at his feet. While the saint does make a gesture of speech with his right hand, in other respects he does not acknowledge the presence of Makar and Constantine at all. His image floats straight and unbending behind them, a specter in white vestments, drained of life and substance.

It may have been the special responsive character of images of the Virgin, in comparison to those of other saints, that gave rise to legends recounted in the saints' Lives of the Virgin reaching out of her images and, as it were, coming to life. For example, in the Life of Anthony the Younger, the monk of the mid-ninth century, we read that this saint repeatedly petitioned an icon of the Virgin on behalf of his protégé Petronas. He began his prayer as follows: "My lady, compassionate one, who holds God, the Word, your son, in your maternal arms, receive my entreaty and bring it before your son and God." Saint Anthony received confirmation of the acceptance of his prayer in a miraculous fashion: "One night, as he [the saint] stood before that holy icon, stretching out his hands, the image of the Mother of God bent towards him and touched his hands. And it [the icon] was restored again to its former appearance."[65] Here, then, the Byzantine viewer of an icon of the Virgin looked to the human bond between mother and son as a support for her intercession on his behalf; he was rewarded by the icon coming to life, so that it displayed in actuality the movement and interaction that he had expected to see in the image.

A more dramatic intervention by an icon of the Virgin is recorded in the biographies of Saint John of Damascus. According to the version written by John Merkouropoulos, a twelfth-century patriarch of Jerusalem, Saint John had his arm cut off by the ruler of Damascus, who had accused him of treason. After the amputation, he came into a chapel and prayed before "a divine icon bearing the face of the Mother of God." He then fell asleep and saw in his dream the icon of the Virgin telling him that he was healed; when he woke up, his severed arm was

totally restored. The more remarkable part of the story is that according to Merk-
ouropoulos, John's adopted brother, Kosmas, saw the "picture of the icon" step-
ping down from the wood and curing the sleeping saint. Merkouropoulos adds
that the panel itself remained bare, "deprived of the image."[66]

Thus, images of the Virgin frequently were given a higher degree of corporal-
ity and movement than those of other saints. In her icons the Byzantine viewer
sought motion, emotion, and responsiveness, and the artists responded with
forms that matched the viewer's expectations. These forms were not realistic in
our sense of the word, but they were sufficient to clearly define the Virgin's role
in relation to the roles of other saints. The viewer's imagination could do the rest.

CONCLUSION

By way of summary, it is useful to look more closely at the mosaics in the
monastery Church of Hosios Loukas, for here the formal logic governing the por-
trayal of saints in Byzantine art is expressed with particular clarity. The logic is
clear precisely because the overall style of these mosaics is relatively unclassical and
schematic; thus the distinctions are drawn more sharply. The images in the church
construct a hierarchy of intercession that began with the mortal remains of Holy
Luke, the monastery's founder, the miraculous doctor, and the center of a healing
cult.[67] His relics, and the holy oil associated with them, worked many miraculous
cures; they were housed in a special shrine placed under an arch set into the east
wall of the northern arm of the church (under the right-hand arch in figure 78).
Opposite the relics, in the mosaic on the west wall of the northern arm, the saint
himself raises his two hands in prayer (figs. 60, 78), while above the relics, facing
the portrait of Holy Luke, the Virgin holds her Child in her arms (figs. 78, 79).
One could imagine that suppliants who were sick would address their prayers to
the image of Holy Luke, following the logic expressed in the biography of another
saint, Nicholas of Sion: "Father, God listens rather to you. You pray for us."[68] The
prayers of Holy Luke were deemed effective because of his special closeness to
God, a closeness won by asceticism and expressed by the formal characteristics of
his image (fig. 60). His portrait is almost entirely frontal; there is a marked bilateral
symmetry governing all aspects of the icon, from the positions of the upraised
hands to the radiating folds of the cloak. Only in the direction of the saint's eyes,
turned to the left, toward the center of the church, is there a hint of movement.
The prayers of the local saint on behalf of the viewer were mediated by the Virgin,
whose image appears opposite (fig. 79). She is shown according to the type of the

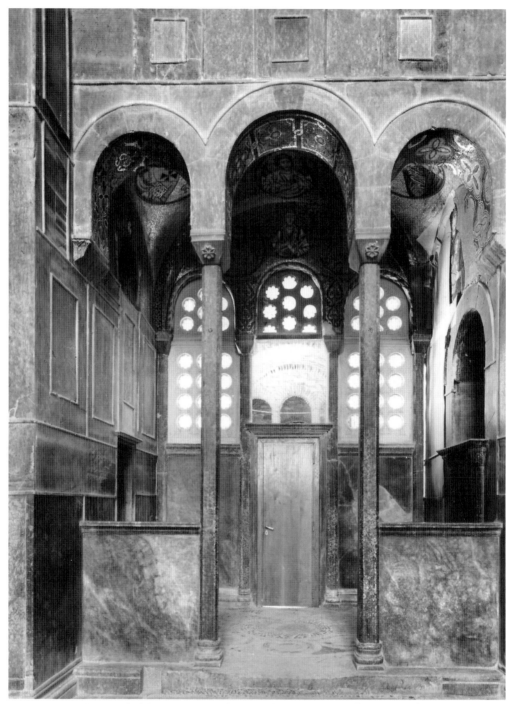

78. Hosios Loukas, Katholikon, east side of the north arm: Shrine of St. Luke of Stiris

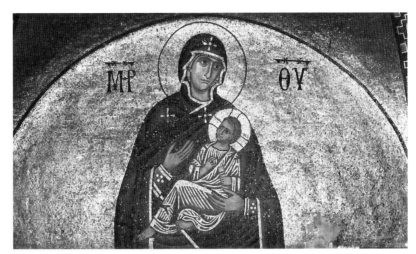

79. Hosios Loukas, Katholikon, mosaic above the shrine of St. Luke: Virgin and Child

80. Hosios Loukas, Katholikon, mosaics in the vault over the north arm: Christ with the Archangels Michael and Gabriel, and St. James the Brother of the Lord

Hodegetria; that is, unlike Holy Luke, she is in motion, cradling Christ and turning to him, inclining her head and looking upon her child. This demonstration of maternal closeness proves the effectiveness of an intercession which, in her case, comes not from emotional distance but from emotional attachment. At the top of the hierarchy, on the east side of the vault directly above the mosaic of the Virgin, is a half-length portrayal of Christ in a medallion, flanked by his heavenly court of archangels (fig. 80); here, then, is seen the ultimate recipient of the prayers. The saint in the medallion on the west side of the vault, immediately above Holy Luke, also has a special significance in this context, for he is James, the Brother of the Lord, who was invoked especially in prayers for the sick. His presence in this context is a reference to the Epistle of James 5:13-16: "Is anyone among you in trouble? . . . He should send for the elders of the congregation to pray over him and anoint him with oil in the name of the Lord. The prayer offered in faith will save the sick man, the Lord will raise him from his bed, and any sins he may have committed will be forgiven. . . . A good man's prayer is powerful and effective." At the shrine of the saint, therefore, Holy Luke and the Virgin intercede with Christ on behalf of the suppliant, each bearing the formal signs of a distinct status that renders their intervention effective.

The portrait of Holy Luke, flattened, frontal, and motionless, resembles the mosaics of the other monastic saints who are represented on the walls and arches of this church (compare Saint Nikon in figure 3 and Saint Theodore of Stoudios in figure 16). But the individual portraits of the apostles, on the arches between the vaults in the narthex, are quite different. As can be seen from the mosaic of Saint Paul (fig. 81), they are shown in three-quarter view, in motion. Their garments are less symmetrical than those of the monks, conforming to the movement of the body. The focus of the apostles' motion is Christ, whose image appears above the central doorway leading from the narthex into the nave; the apostles are depicted in the action of turning toward their master. At the same time, they are integrated into the historical scenes of Christ's life, which are depicted between them, in the niches of the narthex. Thus, the portrait of Thomas flanks the mosaic in the southern niche, in which he is shown again, putting his finger into the wound in Christ's side (fig. 82). The apostle portraits here bear witness to the incarnation, and their formal character proves it.

These distinctions go beyond the abstractions of theology because they also concern the practical functions of images in society. Prayer to Christ was effective on account of the message of redemption and salvation brought by the incarnation, and especially by the ability of Christ to sympathize with human troubles

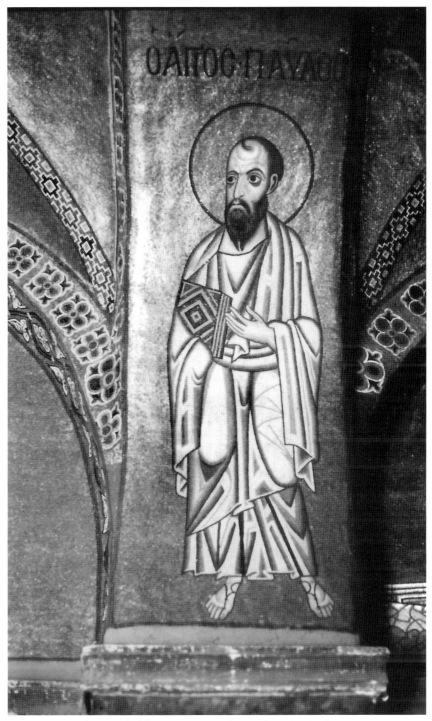

81. Hosios Loukas, Katholikon, mosaic in the narthex: St. Paul

82. Hosios Loukas, Katholikon, mosaics in the narthex: St. Thomas and the Doubting of Thomas

and weakness and to be moved by the pleas of those most near and dear to him, such as the Virgin. Since it was desirable to have images in church which reinforced that idea, those classes of saints who most closely participated in and bore witness to Christ's life on earth, in particular the apostles and the evangelists, were endowed with an appropriate degree of movement and corporality. Above all, artists sought to distinguish the humanity of the Virgin and the emotive ties that bound her to her son. But in the case of monastic and clerical saints, it was not their *humanity* that made them effective as helpers, but their *super*human qualities. Accordingly, their images were characterized by relative immobility and lack of substance, which proved that they were nearer than ordinary mortals to God; they had *presbeia*, a special closeness and intimacy with Christ, won not through ties of kinship or earthly association, as was the case with Christ's contemporaries, but through their passionless way of life. In functional terms, their disembodiment was a like a badge, a sign of their special status. The formal qualities of their images—their flatness, their symmetry, and their rigidity—were not incidental features but were an important part of their message, more important, even, than iconographic features such as costume or gesture. It was not Holy

Luke's monastic habit that caused him to heal nor even his gesture of prayer; there were plenty of praying monks who were not healers. Rather, it was his special status as a holy man that enabled Luke to cure people, and this status was defined by the formal features of his portrait in relation to other images in the same church. This is what gave to his icon its special power in the eyes of the Byzantine beholder. The formal qualities of the portrait—its bilateral symmetry, its frontality, its lack of modeling—are not simply to be seen as the generic mode of icons; on the contrary, they indicate that this was a particular type of holy image, one that occupied a particular place within a logical system of visual communication, and served particular social needs.

From the perspective of twentieth-century viewers, Byzantine art combines elements that we would call schematic, or abstract, with those that we would call illusionistic. To our perception, the latter elements appear more "realistic" than the former. But to Byzantine viewers, both modes of representation were equally true-to-life. Just as we do today, they saw the twin aspects of Byzantine art, but they considered both of them to be real and responded to them accordingly. Their world was both material and immaterial, one in which saints could be not only strong enough to be compared to Hercules but also insubstantial enough to levitate themselves and make themselves invisible. The Byzantine saints could be bent with emotion, or rigid and passionless, like columns of stone. The art of Byzantium evokes all of these realities.

3

NAMING AND INDIVIDUALITY

In the last two chapters we have seen that after the ninth century Byzantine artists always defined each saint closely, both as a member of a category and as an individual. The category to which a saint belonged was indicated by his or her costume, attributes, and formal characteristics. As an individual, the saint was defined almost invariably by an inscription giving the name, often by the portrait type, and occasionally by an attribute. In this chapter we consider the origins and causes of this post-iconoclastic system of portraiture and suggest some reasons for its development.

The essential purpose of the portraiture system was recognition, which was required by the theory of the icon. This theory had been developed in response to the iconoclastic controversy of the eighth and ninth centuries, which had demonstrated that the church needed to exert a greater control over access to the supernatural through images. The question of how people were to make contact with supernatural powers was partly linked to Byzantine ideas about the operation of demonic evil and about the ways in which images could be used to combat it. Because the Byzantines believed that all kinds of physical misfortunes could be caused by demons motivated by envy, who were permitted by God to wreak their mischief in order to test or to punish humans, there were two possibile remedies. First, there was a short, and for the most part unofficial, route, which engaged directly with the demons and blocked their work; this might be called a symptomatic treatment of the physical problems. Second, there was an indirect, but officially sanctioned, route, which appealed for relief to God through his intermediaries, the church on earth and the saints in heaven; this was a treatment which engaged with the underlying spiritual context of the misfortune and addressed the health of the supplicant's soul. As a means of access to the supernatural, images played an important part in each type of remedy, but their forms were adapted to fit the intended route, whether direct or indirect.

In this chapter we will first highlight the changes that took place in the portrayals of the saints between the early centuries of Byzantium and the period after iconoclasm. Then we will consider the problem of demonic envy as a background to Byzantine conceptions of the functioning of images in the immaterial world.

Following the discussion of envy, we will look at the employment of portraits of the saints as direct remedies against demons, especially in the domestic arts of the early period. Finally, we will see how post-iconoclastic images of the saints were designed to work indirectly, by the intercession of the depicted intermediaries with God, so that the forms of the icons themselves changed to match the perceived ways in which the images were functioning. Before iconoclasm there was greater ambiguity; there were fewer consistent portrait types, and frequently saints in art were not accompanied by inscriptions. Furthermore, in the early Byzantine period, it was not uncommon to find two or more identical portrayals of the same saint in the same context, such as on a dish or a piece of clothing, or even within a single commission of images in a church. After the iconoclastic controversy, such repetition of the saints' images was generally avoided. There might be the repetition of similar images in one context, but the icons were rarely identical.

The following series of juxtapositions highlights the changes that took place in the ways that saints were incorporated into the decoration of both churches and smaller-scale art objects. We may, for example, contrast the sixth- and seventh-century mosaics of the Church of St. Demetrios in Thessaloniki with those of the eleventh century in the pilgrimage Church of Hosios Loukas. We have already seen that many of the images in the earlier church were not identified by inscriptions (figs. 34, 36, 37), whereas all the images in the later building were named (figs. 3, 4, 12, 16, 18, 29, 30, 38, 39, 60, 79–82). The two churches also display different attitudes toward repetition. The Church of St. Demetrios is unlike any surviving post-iconoclastic church with mosaics. It is decorated with a series of *ex voto* images of the patron saint, which were given by individuals in exchange for his favors. Saint Demetrios was portrayed at least ten times in the mosaics, and probably more frequently, since our knowledge of the original decoration of the church is only fragmentary. Even within a single *ex voto* commission, the saint's portrait might be repeated several times. For example, on the wall of the inner north aisle of the church, there was a sequence of mosaics dating to the sixth century which were all made as part of one donation for the benefit of a child named Maria (figs. 83-85). This cycle of scenes, which is now lost but known from drawings, shows a three-fold presentation of the girl to the saint, at different times in her life. Presumably the mosaics were given by her parents, who, as may be deduced by an inscription under the last scene, were asking for some favor on her behalf. In the first of the scenes, a woman presents Maria as a child in arms to Saint Demetrios, who is portrayed seated in front of his shrine in the church (fig. 83). In the second scene the child, now walking but still an infant, offers candles

83. Thessaloniki, St. Demetrios,
mosaic: Presentation of Maria to St.
Demetrios

84. Thessaloniki, St. Demetrios,
mosaic: Maria offering candles
to St. Demetrios

to a standing image of Saint Demetrios that is set in front of a curtain, perhaps
representing the interior of his church (fig. 84). In the last scene, the child, now
bigger, offers doves to the saint, who is shown standing in a garden (fig. 85).
While the age of the child is different in each scene, and each setting differs, in
every case the focal point of the composition is a frontal portrait of the saint. By
contrast, at Hosios Loukas, as in all other post-iconoclastic churches decorated
with mosaics, the portraits of the patron saint were far fewer, and they were
incorporated into a single coherent program of images comprising both narrative
scenes and portrait icons of other saints. Holy Luke occurs only once in the
extensive program of mosaics in the main church (fig. 60), being shown, as we
have seen, directly opposite the shrine that held his relics (fig. 78). Although
three additional portraits of the saint can be found among the wall paintings of
the subsidiary northwest chapel and of the crypt, there can be no doubt that the
monastery's founder, and the well-spring of its healing cult, played a much more
confined role in the art of his church than did Saint Demetrios at Thessaloniki.

Contrasting attitudes toward naming and repetition can also be found in the
manufacture of ceramic tiles for the decoration of churches during the early and
later Byzantine periods. A number of sixth-century tiles bearing Christian sub-
jects, including saints, have been found in North Africa. These tiles were produced
in molds, with the result that the same design was repeated several times over, not

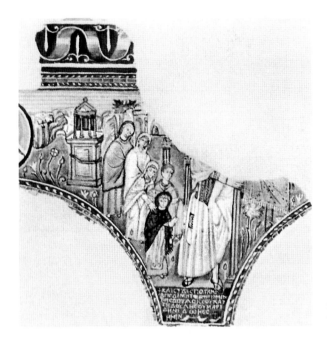

85. Thessaloniki, St. Demetrios, mosaic: Maria offering doves to St. Demetrios

only on separate tiles, but sometimes even on the same tile. For example, the tile shown in figure 86, which was found at Bou-Ficha in Tunisia, repeats two identical reliefs side by side. Although there are no inscriptions, the subject can be recognized as the Virgin enthroned with the Christ Child on her lap. A similar tile, portraying the Virgin and Child, was found at the basilican Church of Dermech in Carthage.

Architectural tiles decorated with religious subjects were also produced in Byzantium after iconoclasm, especially during the tenth and eleventh centuries, but now there was the important difference that the designs were painted, not produced by molds. Therefore, it would have been difficult for the post-iconoclastic artists to reproduce exactly the same design on separate tiles, for the technique of hand painting under glaze did not encourage exact repetition. The tenth- and eleventh-century tiles seem to have been made up into sets, with each set presenting a gallery of different saints. There is no evidence that individual saints were repeated in any one context. Moreover, in the post-iconoclastic period each saint was named by an inscription, as can be seen in the painted tile illustrated in figure 87, which came originally from the region of Constantinople. Here the Virgin was identified as Mētēr Theou, or "Mother of God."

The need to define and to name that differentiates post-iconoclastic Byzantine portraiture from earlier practice is apparent in every medium and type of object. It can be found, for example, in the decoration of liturgical objects such as chalices.

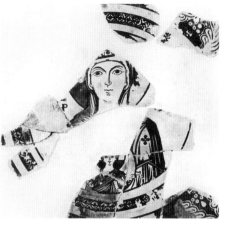

87. Paris, Louvre Museum, ceramic tile
(AC 83): Virgin and Child

86. Tunis, Bardo Museum, ceramic tile from Bou-
Ficha: Paired reliefs of the Virgin and Child

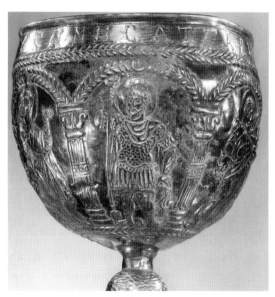

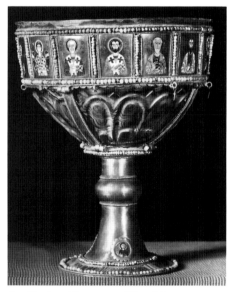

88. New York, Metropolitan Museum of Art,
Attarouthi treasure, chalice (1986.3.1): Saints

89. Venice, Treasury of San Marco,
chalice of Romanos (65): Saints

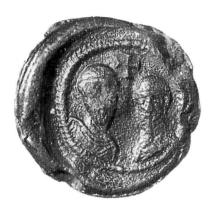 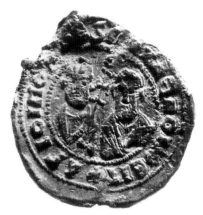

90. St. Petersburg, Hermitage Museum, lead seal (M-4281): Saints Peter and Paul

91. Cambridge, Massachusetts, Fogg Museum of Art, lead seal (1306; DOC 53.5): Saints Peter and Paul

The ten sixth- or seventh-century silver-gilt chalices preserved in the Attarouthi treasure from northern Syria are encircled by figures of saints in shallow relief, created by means of the repoussé technique (fig. 88). These saints are differentiated from each other by costume according to their category, for example, as bishops, deacons, or soldiers, and to some extent they are also distinguished by their facial features. However, the saints are not named by any inscriptions, so that it has proved difficult for modern scholars to identify them. These early Byzantine vessels may be contrasted with the tenth-century silver-gilt and rock-crystal chalices preserved in the Venetian Treasury of San Marco (fig. 89). Here each of the bust-length saints portrayed in the enamels on the metal mounts is carefully identified by an inscription.

The same change is apparent in the small-scale portraits of saints on lead seals. These objects, which survive in great numbers since they were extensively used by the Byzantines to protect and authenticate their written documents, provide a very good index of changing attitudes toward images. Before iconoclasm, the saints were frequently left unnamed by inscriptions.[1] An example is provided by figure 90, illustrating a seventh-century seal in the collection of the Hermitage Museum in St. Petersburg, which was acquired in Constantinople. It shows the busts of two men who can be recognized, by the styles of their beards and hair, as Peter, on the left, and Paul, on the right. However, there is no legend on the seal to secure the identification of the saints. This seal may be contrasted with another now in the Fogg Museum of Art, which probably dates to the turn from the ninth to the tenth century (fig. 91). It belonged to Demetrios, the metropolitan

bishop of Herakleia, on the European coastline of the Sea of Marmara. Here again there are two busts, portraying Saint Peter on the left and Saint Paul on the right. But in this case there is also an inscription that surrounds the portraits and continues on the back of the seal: "Saints Peter and Paul, help Demetrios the metropolitan of Herakleia." After the ninth century, the saints depicted on Byzantine seals were almost invariably identified, either by the invocation or by separate legends flanking the portrait.

Why did this change come about, from images that were repeated and unnamed to images that were identified and presented singly? And why did the Byzantines develop a larger repertoire of consistent portrait types after the ninth century? To understand the causes, we have to consider the system of belief within which the portrayals of the saints were called upon to operate. In particular, we must examine Byzantine ideas about the operation of evil, exemplified by demonic envy, and about the different ways, sanctioned and unsanctioned, through which believers could use images of the saints to combat its malice.

THE PROBLEM OF ENVY

From antiquity until even the present day, belief in the power of the evil eye, the malevolent glance of an envious neighbor, has been a widespread force in Mediterranean society. In the late Roman world, it was thought that the evil eye might fall on any aspect of one's good fortune, on one's house, possessions, health, or children. It was a constant danger and potential source of harm, which called for continuous protective measures. Papyri surviving from Egypt show that it was standard procedure for letter writers, whenever they referred to their correspondents' children, to add the formula "May the evil eye [or enchantment] not touch them." This hope was expressed by Christians as well as by pagans.[2] The danger posed by envy was fended off by a variety of protective measures, the most specific being the device of the "much-suffering eye," which was depicted on the floors of private houses, in wall paintings, and, above all, on amulets worn on the body.[3] This design shows an eye, sometimes explicitly identified by an inscription as "envy," being attacked by a variety of enemies, both animate and inanimate, including daggers, spears, tridents, scorpions, snakes, birds, and wild beasts. A good example of the device appears in the mosaic pavement of a house at Antioch (fig. 92). Its name, the "much-suffering eye," is derived from the *Testament of Solomon*, a popular Byzantine magical treatise which incorporated both Jewish and Christian elements. According to this text, the Archangel Michael

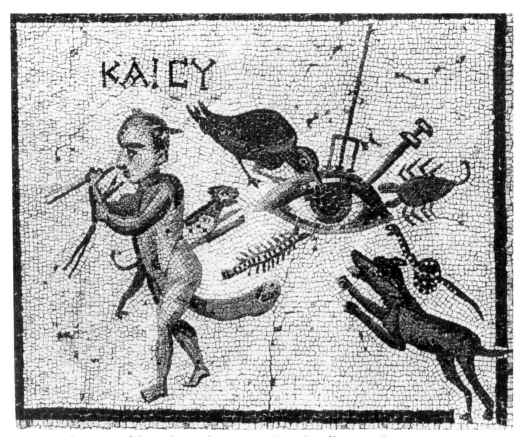

92. Antioch, House of the Evil Eye, floor mosaic: "Much-suffering eye"

gave King Solomon a ring with an engraved stone. This seal gave the king power over all the demons; with its aid, he summoned thirty-six of them before him in turn, giving to each evil spirit an interview and forcing it to reveal its name and the measures that were effective against it. The thirty-fifth demon to be called forth was responsible for the evil eye. It said: "My name is Rhyx Phthenoth. I cast the glance of evil at every man. My power is annulled by the engraved image of the much-suffering eye."[4]

In some cases, merely the shape or the outline of an eye was sufficient to repel the power of envy. There are eye-shaped bronze amulets from Palestine and Syria, for example, which show a rider slaying a demon with a cross-headed staff (fig. 93). As we shall see, the rider in this case might be Solomon himself, or else a Christian saint, such as Theodore or Sisinnios. Protective eyes were also woven into the designs of clothing, as in the collar of a tunic of the sixth or seventh century which was found in Egypt (fig. 94). The narrow bands of tapestry weave that descend

93. University of Chicago, bronze amulet: Rider slaying
a demon

from the neck at the front and back of the tunic (*clavi*) are decorated with eye shapes containing circular pupils, in the center of which are small crosses. Even today, in modern Greece, it is possible to buy eye-shaped amulets which are sometimes combined, as on the early Byzantine textile, with crosses (fig. 95).

These beliefs in the powers of envy and the evil eye had origins that were pagan and pre-Christian, yet they were adopted by Christians, both in their written and in their visual culture. But how was it possible for such ideas to be fitted into the framework of an orthodox Christian theology? The problem was one that challenged the fathers of the early Christian church who, eventually, arrived at an acceptable solution. Essentially, the orthodox view was that envy proceeded from the devil, who had envied Adam right from his creation as king of the earthly world. The devil tempted Adam to fall and so brought death into the world, but even after the Fall his envy of humanity continued and was thought to cause physical and spiritual harm.[5] In the words of the biographer of Saint Thomaïs of Lesbos: "The demon envies our race, and cast an evil eye upon it from the beginning, and has inflicted harm upon us from the earliest time of our forefathers."[6] In some cases, the devil was believed to cause physical misfortunes directly, but in other cases he operated indirectly, making use of human beings. The latter concept, of the devil working indirectly through humans, was a christianization of the old pagan notion of the evil eye. The orthodox Christian view was that it was not the envious people themselves who caused harm with their

94. Geneva, Musée d'art et d'histoire, fragment of a tunic (12 741): Protective eyes and other motifs

eyes—that belief was condemned as a superstitious relic of paganism; rather, it was the demons who caused the harm, when they took advantage of malevolent humans. The classic statement of this doctrine is that of the fourth-century father Saint Basil the Great (fig. 20). He said that the belief that the "eyes" of a jealous person cause harm on their own is an "old women's" superstition; instead, "the

95. Twentieth-century amulet from
Greece: Cross and protective eyes

good-hating demons, whenever they find someone with intentions that are
familiar to them, make use of these intentions in every way for their own pur-
pose, so that they employ the envier's eyes in the service of their own will."[7] In
some ways this doctrine made the power of human envy more dangerous than it
had been before, because it was now allied to the far greater power of demons.

Byzantine literature, from the imaginative saints' Lives to the more sober histo-
ries, is crowded with illustrations of how the devil could cause misfortunes to peo-
ple through the envy of others. Envy, according to one saint's Life, was the "work-
shop of evil."[8] A special focus of trouble was the administration of justice, where
much harm was caused by sycophancy (*sykophantia*), the false testimony of the envi-
ous.[9] A dramatic account of sykophantia due to envy can be found in the biography
of Gregory, the bishop of Agrigentum, a saint who ostensibly lived in the sixth
century, in the time of Justinian. The devil, we are told, saw the bishop's pure and

unstained habits, and was transported with envy. He provoked hostility against the saint, using as his agents a priest and a deacon, named Sabinus and Crescentius. These two men bribed a young prostitute to testify that the bishop had slept with her. They brought their charge before the governor, who summoned the girl in the presence of the two accusers to confirm the story. But when the woman testified that Bishop Gregory had indeed been with her, she was immediately possessed by a demon, so that she began to foam at the mouth and to roll on the ground at the feet of the saint; whereupon all those present were seized by fear and called out to God, saying that they believed her accusations to be false.[10]

An eleventh-century psalter from Constantinople contains marginal paintings of this vivid episode, which here illustrate a passage from Psalm 26:12: "Do not deliver me to the appetite of my enemies: false testimonies are raised against me which incite violence" (fig. 96). The artist portrayed the story in four scenes. At the bottom of the page, the envious priest Sabinus, in the presence of witnesses, is shown leading the bribed prostitute out of the bishop's cell, where Sabinus had hidden her. At the top of the page, Sabinus and Crescentius lead the bishop out of his palace. In the middle of the page, the woman, dressed in an eye-catching long-sleeved gown, makes her false accusation against the bishop; beneath this scene appears the dénouement of the story, when she is seized by the demon and cast to the ground.

Byzantine writers of political history, as well as the authors of saints' Lives, saw envy and the evil eye as a moving force in events. The early-thirteenth-century *History* by Niketas Choniates gives a striking account of the evil effects of envy and sykophantia in a passage concerning Theodore Styppeiotes, who fell from his position of high favor with Emperor Manuel I. In this case it was another palace official, the *logothete of the dromos*, John Kamateros, who envied Styppeiotes his good fortune, especially after the emperor had presented him with a golden inkwell encrusted with gems. Kamateros, says Choniates, was tormented by envy even in his dreams. He could not rest until he had successfully framed Styppeiotes on a charge of treasonable association with the king of Sicily. As a result of the slanders of Kamateros and the discovery of a forged letter, the emperor had Styppeiotes blinded. At the conclusion of this story, Choniates gives a lament on the subject of envy: "Envy, which ever looks askance, not only at the great rulers of nations and cities, but also at those of more modest rank, and which is forever near at hand nurturing traitors, . . . in the end overthrew [Styppeiotes] and caused him to suffer a most piteous fall."[11] These sentiments are not just literary convention; they represent real fears among the Byzantines of instability and uncertainty in the administration of justice.

96. London, British Library, MS Add. 19.352, fol. 29v (psalter): The slandering of St. Gregory of Agrigentum

The devil's envy also caused people to fall sick, although here he often operated directly, rather than through the agency of malicious people. The devil's role in provoking ill health can be seen in a story told in the seventh-century collection of *Miracles* of Saint Demetrios composed by John of Thessaloniki. John writes that there was a certain Marianos, a senator of high birth and great wealth, who administered justice as an eparch at Thessaloniki with such integrity and piety that he won the favor of God and the people, but at the same time he excited the envy of the devil. The devil first tried to attack Marianos spiritually by tempting him to sin, but to no avail. Then the devil decided to attack him physically, making him paralytic, so that he could not even feed himself. The treatments of the doctors were useless, and Marianos refused any recourse to magic. Instead, he prayed to Saint Demetrios (fig. 36) and was eventually cured through the saint's intercession.[12] The saint's intervention, therefore, cured the sickness that had been caused directly by the devil's envy.

In the minds of the Byzantines, misfortunes in the spheres of health and justice could be linked, because both had the same source, namely, the envy of the devil. Likewise, both could have the same solution, the intervention of the saints. Thus, in the Life of Saint Luke of Stiris (fig. 60), there is a story of a certain general called Pothos, who found himself put in a difficult situation on the occasion of an investigation at Constantinople into a conspiracy against the emperor. At this time, he received a letter from his wife saying both that the emperor desired his presence in the capital and that his son had fallen ill and was near to death. This put Pothos in a terrible dilemma: he wanted to return home because of the impending death of his child, but he was afraid of being suspected of complicity in the plot. He turned for help to Holy Luke, who was able to solve both problems at the same time. The saint predicted that if Pothos went to the capital, he would be well received by the emperor and that he would find his son cured. And so, of course, it turned out.[13]

Other disasters, also, were caused by the devil's envy. Sailors who went to sea had to contend with diabolical interference with the processes of nature, as was well known from a story of Saint Nicholas, one of the most popular saints in Byzantine art. According to his biographers, Saint Nicholas took a ship on his way to the Holy Land. But during the journey the devil caused a violent storm; Saint Neophytos the Recluse (fig. 62), in his encomium of Nicholas, specifies that it was Satan's envy that caused the tempest. Nicholas actually saw the devil flying around the boat with a knife, trying to cut the rigging that controlled the sails and to overturn the ship. The desperate sailors asked Nicholas to help them, and

97. Mount Sinai, Monastery of St. Catherine, panel painting, detail: St. Nicholas calms the storm

he calmed the sea with his prayer.[14] This story was often illustrated in art, the earliest portrayal being a vignette on a twelfth-century icon in the collection at Mount Sinai (fig. 97).[15] Here we see a mass of rolling waves on which is perched a small boat containing a sailor holding onto two oars; two black devils attack the rigging while Saint Nicholas prays in the stern.

Even in more mundane matters such as agriculture and husbandry, envy was a cause of misfortunes. For example, in the life of Peter of Atroa, a ninth-century saint who lived in Anatolia, we read of a wealthy landowner in Lydia, who had flocks composed of many kinds of animals which were dying prematurely, having succumbed to "an envious one and a sorcerer." In this case, because the biographer uses the word "sorcerer" (*goēs*), it is evident that the devil did not operate on his own but that there was also some human involvement in the bewitchment. The solution was for the landowner to obtain some holy oil from the saint's tomb and to sprinkle this substance over his whole house and his flocks, a remedy which put an end to the problem.[16]

Envy, therefore, was a major cause of misfortunes for the Byzantines, whether caused by the devil acting on his own or making use of jealous humans. Before we look in more detail at the role of the saints in combatting this force, it is nec-

essary to consider the Byzantines' overall conception of the places of malice and justice in the universe, or of what we would call the problem of evil.

The Byzantines believed that in the final order of things, divine justice ultimately prevailed. Eventually the demons were going to be put in their proper place, an outcome that can be seen in the Byzantine scheme of the Last Judgment as it is portrayed in the famous eleventh- and twelfth-century mosaic in the Cathedral of Torcello (fig. 98). Here the demons are confined to the lower right corner of the composition, to the left hand of Christ, where they are allowed to inflict their harm only on the wicked who have been assigned to them. Ultimately, heavenly justice was not flawed and not subject to envy; but it was slow, and therein lay the problem. Byzantine faith in ultimate justice was expressed by the concept of the "Eye of Justice," or the all-seeing eye of God. Demons operated only because God allowed their activities, either to test and prove the righteous, like Job, or else to punish the wicked. The orthodox view of the matter was set out by John Chrysostom (fig. 23), in a letter of consolation to Olympias, after she had been sent into exile from Constantinople. He explained that the attacks against her were provoked by the devil but permitted by God in order to augment the virtue of her soul.[17] Elsewhere he used the metaphor of sailors who are trained by storms not to become seasick.[18] Likewise, Abbot Theodore of Stoudios (fig. 16), the steadfast defender of icons during the second period of iconoclasm, declared in one of his letters to his persecuted followers: "Thoughtful servants [of God] do not say 'Until when?'. . . For the Sleepless Eye knows what is good in each case."[19] In the final analysis, the suffering caused by demons was beneficial, even though this might not be apparent to their victims at the time.

It is not surprising that there were complaints about this system. One of the most striking laments is the outburst of Niketas Choniates on the subject of Styppeiotes, who, as we have seen, was framed by the envy of Kamateros and blinded by Manuel Komnenos. Choniates exclaimed: "O unerring Eye of Justice, that sees all things, how is it that you often overlook such transgressions and even other more wicked deeds of men? Neither do you hurl forthwith the lightning and the thunderbolt, but, by delaying, you defer retribution. Inscrutable is your judgment and beyond human comprehension! But yet you are wise, and you know perfectly what is good for us!"[20]

In art, the concept of the "Eye of Justice" was embodied in the figure of Christ looking down from the central dome of a Byzantine church, to judge those below. Often in these images, the eyes of Christ are enlarged, as may be seen in the thirteenth-century fresco in the dome of the Church of the Panagia at

98. Torcello, cathedral, mosaic: Last Judgment

Trikomo, on Cyprus (fig. 99). Here the imposing painting of Christ is ringed by a poem clearly specifying the image's judgmental role:

> He who oversees all things from the distant place,
> sees all who enter here;
> he examines their souls and the movements of their hearts.
> Mortals, be terrified at the judge.[21]

The gaze of the divine judge is also evoked in a famous description of the mosaic in the central dome of the Church of the Holy Apostles in Constantinople, which was written by Nicholas Mesarites around the year 1200. Of this image, Mesarites says: "His eyes, to those who have achieved a clean understanding, are gentle and friendly and instill the joy of contrition in the souls of the pure

99. Trikomo, Church of the Panagia, fresco in the dome: Christ the Judge

in heart. . . . to those, however, who are condemned by their own judgment, they are scornful and hostile and boding of ill."[22]

In sum, the old pagan concept of the "evil eye," the damage caused by envy, was in the Byzantine period overarched by a new concept, that of the "Eye of Justice," according to which divine justice would eventually be done, even if its coming might be inconveniently slow. It was the slow pace of heavenly justice that gave a place for interim supernatural interventions, to provide a quicker remedy for the harm inflicted by demons. These interventions were of

two kinds, those which were unofficial and involved magic, and those which were sanctioned by the ecclesiastical authorities. The unofficial remedies took a short cut, by blocking the operations of demons. The sanctioned remedies involved an appeal for help to God, the ultimate source of justice. Images of the saints could play a role in both types of remedy, that is, they could either be used in magic to manipulate supernatural forces directly, or else they could be used as a regular channel for appeals to the supreme Judge. We shall see that the icons of the saints assumed different forms according to the roles that they were called upon to play.

THE SAINTS AND HOUSEHOLD MAGIC

With Christianity came strong new defenders against the force of envy, namely the saints. Their images were viewed as effective protection against this evil, as the tenth-century poet John Geometres explicitly states in a poem written to accompany an icon of Saint Demetrios:

> The chief of Thessaloniki stands here armed.
> But he conquers without arms; how can that be when he takes up arms?
> It is not by conquering with arms that the martyr was chief of wisdom.
> But defending with both, scatter envy to the winds.[23]

In other words, by virtue of his martyrdom, Saint Demetrios can conquer the invisible strength of envy, just as he can overcome visible opponents with his weapons.

The saints' images, therefore, were a powerful source of security against a constant threat. But how and when were they to be used? In the Byzantine world, not only was there dispute between the proponents and opponents of Christian images, but there was also controversy even among those who accepted images over the legitimate and illegitimate *contexts* of their use. The question was resolved only after iconoclasm, when the relationship between the saints' icons and divine power was finally defined in such a way as to exclude, or largely exclude, practices that had previously been considered suspect or deviant by many church authorities. The role of the saints was at first ambiguous, for in the early centuries their images were not only seen in churches; they were also incorporated into the apparatus of household magic. Their cult lay in between official church art and the unofficial remedies of the home. After iconoclasm, both the cult of the saints and their role in art were much more closely regulated by the

ecclesiastical authorities. These changes had important effects on the design of the images themselves.

Since the early portrayals of the saints took on certain characteristics associated with magical devices, it is necessary to look more closely at the forms of magic in the early Byzantine world.[24] The definition of magic was a vexed question in Byzantium, just as it is today.[25] For the purposes of this discussion, the word "magic" will be used to describe relations with the supernatural that were outside the regular channels of the church. According to this definition, the boundaries of magic were not fixed but involved a certain ambiguity. As the church sought to dictate more closely which practices were orthodox, and which were not, the parameters of magic tightened. In the early period there was considerable overlap between what some churchmen condemned as magic and what other Christians were willing to practice. After iconoclasm the marginalization of the questionable practices became increasingly effective.

At the core of magic, both as it was defined by early Byzantine churchmen and as it is understood by scholars today, are the "magical" papyri surviving from Egypt. Typically, they contain charms intended to ensure good health or success in various endeavors, such as lawsuits or love. The texts of the charms, specifying the aims of the user, frequently are accompanied by supporting devices characterized by obscurity and repetition. These devices include various configurations of repeating letters and also ring signs, which resemble a form of writing but are unintelligible. Very often the groups of letters and the signs are without apparent meaning or reference to the external world as known by the user of the charm. They are thus self-contained, in that their only meaning was their supposed effect. They were "mighty signs", able to act in their own right, without recourse to assistance and intervention from outside forces. The directness of their operation is made clear by one papyrus of the fifth century, intended to cure a sickness, which accompanies its text and associated ring signs with the following command: "Holy inscription and mighty signs, chase away the fever with shivering from Kale, who wears this protective charm" (fig. 100).[26] In addition to their obscurity and unintelligibility, another characteristic of the charms in the magical papyri is their use of repetition.[27] Various tricks were employed to convey the idea of endless reiteration of letters in series. One such device is illustrated by a fourth-century papyrus at Leiden, where the vowels alpha, epsilon, eta, iota, omicron, upsilon, and omega are repeated in different, but always senseless, permutations in three columns (fig. 101).[28] In the second column one extra letter is added to the series, an omega after the omega, and in the third column two extra

100. University of Copenhagen,
Institut for Klassisk Filologi, papyrus
(P. Haun. III 51): Holy inscription
and mighty signs

letters are inserted, an omicron and an upsilon between the two omegas. This
pattern implies that the series of columns could be extended indefinitely to the
right by adding an increasing number of letters to each column. The desire for
endless repetition expressed by such devices corresponds to the verbal texts of
the charms, which often call for continuous protection with formulas such as
"protect him for the entire time of his whole life"[29] or "heal her for all of her
lifetime."[30]

When Christian imagery was incorporated into the household, it tended to
take on some of the characteristics of the magical charms of the papyri. In the
first place, the Christian images became ambiguous and obscure, rather than well
defined.[31] And second, because the images worked directly, it was effective to
repeat them; for the greater the number of devices, the greater was their effect on
unseen forces.

The clearest examples of the incorporation of images of saints into house-
hold magic occur on amulets of the early Byzantine period. For example, a
bronze amulet, which was perforated for wearing, shows Saint Sisinnios, the
guardian of infants, as a mounted horseman spearing a woman, who represents
a child-killing demon (fig. 102). The saint is invoked as "Holy Sisinnios" by

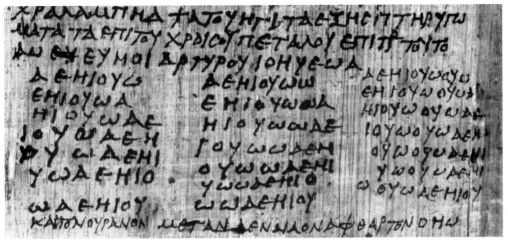

101. Leiden, National Museum of Antiquities, papyrus (P. Leid. J 395): Repeated vowels

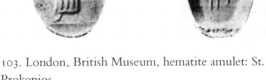

102. Bronze amulet, location unknown: St. Sisinnios on horseback accompanied by magical signs

103. London, British Museum, hematite amulet: St. Prokopios

the inscription surrounding the image.[32] In the field between the victorious horseman and the legend there are various magical signs: a star, a crescent, a circle with six spokes, and an eye. Another amulet (fig. 103) on which a saint is appealed to by name is made of hematite, or bloodstone, a material believed to have the magical property of preventing hemorrhages. On one side of the stone Saint Prokopios, a martyr of Caesarea in Palestine, is portrayed standing with his hands raised in prayer, while the other side contains the text of the invocation: "Holy Prokopios!"[33] More frequently, the holy figures on the amulets are not identified. We have already seen an example of a bronze

104. Ann Arbor, Kelsey Museum of
Archaeology, bronze amulet, reverse
(26115): "Much-suffering eye"

105. Ann Arbor, Kelsey Museum of
Archaeology, bronze amulet, obverse
(26115): Holy rider, demon, and lion

amulet from Syria or Palestine which shows an unnamed haloed rider spearing
an adversary (fig. 93). Since this horseman wields a cross-headed spear, we
know that he is Christian, but we noted also that the amulet as a whole takes
the outline of an eye, which shows clearly that the pendant was intended to
ward off envy. There is a series of bronze amulets from the same region which
show the "much-suffering eye" under attack from a variety of creatures and
offensive weapons (fig. 104). On the reverse sides of these pendants a nimbed
rider appears, with a recumbent demon and a roaring lion under the hooves of
his horse (fig. 105). The identity of this rider is uncertain; it is possible that he
represents a conflation of several powerful heroes, both saints and non-saints.
Such an interpretation is suggested by the inscription that surrounds a rider
with a cross-headed spear on an amulet found at Smyrna (fig. 106): "Flee O
Detested one!" it commands, addressing the demon, "Solomon, Sisinnios,
Sisinnarios pursue you."[34] Here, then, Solomon and the two saints Sisinnios
and Sisinnarios are all associated with the powerful sign of the rider, in an

106. Bronze amulet from Smyrna: Holy rider

107. Ann Arbor, Kelsey Museum of Archaeology, bronze bezel of a ring (KM 26165): Holy rider with unintelligible inscription

image that was ambiguous and multivalent. Finally, on one amulet, which served as the bezel of a ring, the rider motif is framed by a totally meaningless inscription: "*ogyrdkmapeotufzezouzerbe*" (fig. 107).[35] We have seen that such unintelligible words were characteristic of the magic of the papyri; in this case the identity of the rider was intentionally obscured.

Domestic textiles from the early Byzantine period also show how the images of saints were incorporated into magical or semi-magical contexts. Both figured drawloom silks and the cheaper tapestry weaves illustrate this phenomenon. The production of textiles bearing Christian iconography for household use is known from literary sources and from extant examples. Although the surviving silks with Christian subjects are not now very numerous, having been preserved for the most part only in the dry climate of Egypt, they were once common enough to draw the ire of a late-fourth-century bishop, Asterius of Amaseia, who in a famous passage specifically attacked wealthy lay people who wore episodes from the Gospels woven into their garments, citing especially scenes showing Christ's miracles.[36] Another author, Theodoret, who wrote in Syria during the fifth century, spoke of textiles decorated with figures of men in prayer.[37] There is also a famous portrayal of the Empress Theodora in a mid-sixth-century mosaic at S. Vitale in Ravenna, which shows the empress wearing a silk robe with a depiction of the three Magi on the hem (fig. 108).

It is clear from the character of the Christian subjects on early Byzantine household textiles that they were primarily amuletic. It is significant that the

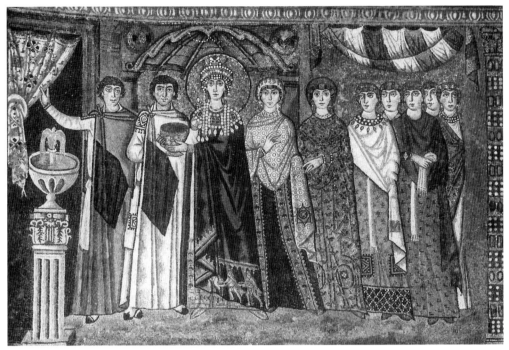

108. Ravenna, S. Vitale, mosaic: Theodora and her retinue

woven Gospel scenes attacked by Asterius of Amaseia were depictions of Christ's miracles. The wearers must have hoped for similar benefits themselves. When Christian images appeared on garments, they were usually placed in hard-to-see locations, such as hems or sleeves, which would have made them difficult to use as educational or devotional aids (fig. 108). Furthermore, the portrayals were often unspecific, so that it is unclear which holy figure is being represented. Like the bronze amulets, these images were not directed at human viewers but at unseen forces. They were not representations of individual holy persons, but they were self-sufficient devices that were powerful in and of themselves. Like the "mighty signs" of the papyri, they functioned directly and in their own right.

The amuletic character of the domestic weavings is shown most clearly by a group of silks having repeated images of a holy warrior killing a dragon (figs. 109, 110). The hero stands in military dress of tunic and cloak and pierces the beast with a cross-headed spear. Originally, these silks decorated the sleeves of tunics, each sleeve band repeating the identical motif four times over. The repetition was the result of the drawloom technique of manufacture which, with its mechanical sequences, encouraged the repetition of designs in series. Figure 109

109. Lyon, Musée Historique des Tissus, silk sleeve band (910.III.1): Holy warrior killing a dragon

110. Philadelphia, Museum of Art, fragment of silk sleeve band (33.83.1): Holy warrior killing a dragon

illustrates a complete sleeve band of this type, while figure 110 shows a fragment of another sleeve band that preserves only one figure. Above each of the repeated warriors is an eagle with its prey, a motif which translates the action of the human hero into animal imagery. The eagle was a well-known device on magical gems, whose supposed apotropaic powers were attested to by the Roman naturalist Pliny.[38] Some difficulty has been caused to modern scholars by the lack of inscriptions on these silks: the warrior has been identified variously as Saint Michael, Saint George, Saint Theodore, or even as Christ himself.[39] However, the absence of a name was probably no problem to the original wearers of the garment, who cared only whether the motif worked. In summary, then, this group of sleeve bands exhibits two of the salient features of household magic: the signs are autonomous, and they repeat.

Another group of images on early Byzantine domestic weavings depicts men in prayer. As we have seen, Theodoret in the fifth century describes such images on clothing. He speaks of garments woven with silken or woolen threads so as to depict images of trees and all kinds of animals, as well as figures of men, some hunting, and others in prayer.[40] The combination of motifs recorded by Theodoret can be found on surviving textiles. For example, a band of wool-and-linen tapestry weave now in Prague depicts a nimbed figure with hands raised in the orant pose, framed on either side by lions, dogs, and treelike designs (fig. 111). As is usually the case, the praying personage on this textile is anonymous. Only very rarely is it possible to identify an orant saint on a textile from a written name or from some associated attribute. One of these exceptions is an eighth-century medallion now in the Vatican Museums (fig. 112). Here the praying man is flanked by two humped camels; he can thus be identified as the soldier martyr Menas, whose cult was centered near Alexandria in Egypt.

The mounted riders that were featured on magical amulets were also portrayed on domestic textiles. There is a fine series of seventh-century tapestry-weave medallions decorated with this motif, which were probably made in imitation of more costly fabrics in silk.[41] As in the case of the amulets, the horsemen are often unnamed. However, on a pair of medallions from a tunic, now in the Textile Museum of Washington, D.C., and in the Cleveland Museum of Art, the rider is identified by a legend as "Alexander of Macedon" (figs. 113, 114). As we shall see, images of Alexander were thought to have magical properties. In this case, it may be noted that the sign of the horseman Alexander was repeated several times on the same piece of clothing. Not only was this rider repeated twice in each medallion in imitation of the bilateral symmetry characteristic of drawloom

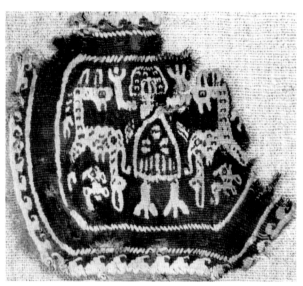

111. Prague, Arts and Crafts
Museum, tapestry-woven band
(2245): Figure in orant pose

112. Rome, Vatican Museums, tapestry-woven
medallion (T. Grassi 2): St. Menas flanked by camels

textiles, but the roundels themselves were repeated on the same tunic. More
often, the rider was left nameless, as can be seen in another medallion in the
Textile Museum of Washington (fig. 115). Here the horseman, who is marked
only by a halo, rides triumphantly over a large lion, an image that can be
related to the engravings on the bronze amulets directed against the evil eye
(fig. 105). As on the amulets, this defender could be associated with a number
of powerful riders, be it Alexander, Solomon, or even a Christian saint such as
Sisinnios, who in a sixth- or seventh-century wall painting at the Monastery of
St. Apollo at Bawit was shown on horseback surrounded by demons and wild
beasts (fig. 116).

The decoration of domestic textiles with unnamed and repeated holy figures was
echoed in other household artifacts, such as pottery bowls and dishes. There are
examples in the sixth-century red slip ware that was manufactured in North Africa
and widely exported in the Byzantine world. Among the motifs stamped into the
floors of these vessels are standing men holding crosses on long staffs (figs. 117-
119). None of the men are identified by inscriptions, and since the figures were
impressed into the fabric of the bowls by means of stamps, they were frequently

113. Washington, D.C., The Textile Museum, tapestry-woven medallion (11.18): Alexander of Macedon

114. Cleveland, Cleveland Museum of Art, tapestry-woven medallion (59.123): Alexander of Macedon

115. Washington, D.C., The Textile Museum, tapestry-woven medallion (11.17): Unnamed rider with lion

repeated, not only on separate bowls but sometimes on the same vessel. Modern researchers generally identify some of these figures as saints, others as Christ. Those figures thought to portray Christ correspond to one of his portrait types, with long hair falling down over the shoulders, and they are distinguished by haloes (fig. 117). It is possible that a saint is portrayed in the bowl illustrated by figure 118, which was found at the Egyptian town of Karanis. The man stamped at its center has no nimbus, his hair is short and curly, and he wears a long tunic ornamented with circles (fig. 119). He holds the cross-headed staff in his left hand, while he raises his right in a gesture of speech or blessing. Figure 120 shows a fragment of a bowl

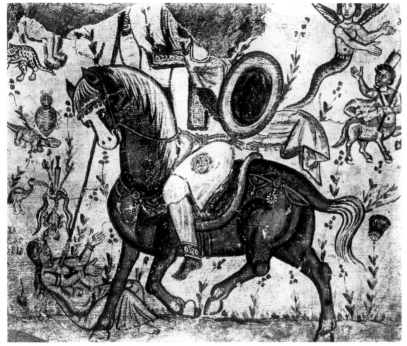

116. Bawit, Monastery of St. Apollo, fresco: St. Sisinnios with demons and wild beasts

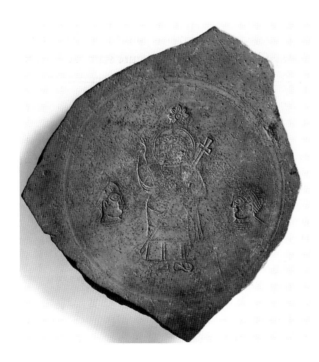

117. London, British Museum, bowl of North African red slip ware (1963.7-4.1): Christ(?) holding a cross

118. Ann Arbor, Kelsey Museum of Archaeology, bowl of North African red slip ware (20024): Saint(?) holding a cross

119. Ann Arbor, Kelsey Museum of Archaeology, bowl of North African red slip ware, detail (20024): Saint(?) holding a cross

found in southern Anatolia but now in the Archaeological Museum at Istanbul. The vessel had a large cross stamped at its center, which was flanked on the left by a nameless man holding a cross-headed staff; he resembles the figure stamped into the bowl from Karanis, except that he is distinguished by his hairstyle, which is straight rather than curly. An identical figure probably stood on the right of the large cross, creating a symmetrical composition. Such a pairing of identical holy men is still preserved on a similar bowl from Delos, which is decorated with two "saints" from the same stamp set side by side (Delos, Archaeological Museum, inv. B 1094/7808).

These portrayals of holy men, somewhat crudely stamped into the floors of pottery vessels, imitated finer works in silver. An example of the latter is a fine bowl discovered on Cyprus and dated by the control stamp on its base to the years 641-651 (fig. 121). It has a central medallion portraying the bust of an unnamed nimbed figure in low relief. Like some of the men stamped into the pottery bowls, he has curly hair and holds a cross-headed staff. Without the inscription, the identification is uncertain; however, the torque worn around the man's neck (the *maniakion*) suggests that he may be either Saint Sergius or Saint Bacchus, high court officials whose later portraits exhibited this attribute.

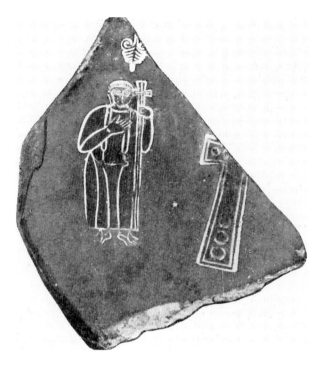

120. Istanbul, Archaeological
Museum, fragment of bowl of
North African red slip ware (561):
Saint(?) holding a cross

In conclusion, it can be said that the saints played an obscure and ambiguous role in the domestic arts of the early centuries of Byzantium. Rarely did they reveal their names or identities, and often they allowed themselves to be repeated several times over as identical images on the same object. They kept company with magical signs and symbols, not only on amulets but also on textiles. All these characteristics were sufficient to attract the deepest suspicions of the church authorities.

OFFICIAL OPPOSITION TO HOUSEHOLD MAGIC

The incorporation of Christian elements into household magic did not go unnoticed by the church, and it provoked considerable opposition. In their attacks on domestic magic, the early church fathers singled out several objectionable features, all of which were characteristic of the images that we have examined. In the first place, they disliked the unofficial nature of domestic defenses against demons, which were neither controlled nor sanctioned by the church. Second, they complained on theological grounds that these remedies were aimed directly at the physical well-being of the body rather than at the health of the soul; in other words, because their effect was direct, the images were a shortcut to the receipt of

121. London, British Museum, silver bowl (M and LA 99.4-25.2): Unnamed saint, perhaps Sergius or Bacchus

benefits. In the third place, they were ambiguous and obscure; their content was not unambivalently Christian. And, finally, in addition to being ambiguous, they were characterized by repetition, a sign of their autonomous, non-intercessory operation. We will look briefly at each of these complaints in turn.

There is no doubt that the church authorities, despite their frequent diatribes from the pulpit, were able to exercise very little control over the imagery of domestic art during the early Byzantine period.[42] The production of drawloom silks bearing Christian subjects, for example, was not regulated by church or state.

Such textiles could be purchased and used by all who could afford them. Asterius of Amaseia, in his attack on the silk clothes figured with Christian subjects, highlighted the domestic origins of the imagery, saying that it was the wearers themselves who chose the scenes to be depicted and specifying that this power was exercised by women as well as by men: "The more religious among rich men and women, having picked out the story of the Gospels, have handed it over to the weavers."[43] For the less wealthy, a large number of small workshops made figured textiles in wool and linen tapestry weave. Therefore the imagery on the tapestry weaves, also, would have been very difficult for the authorities to control. It may be noted that Asterius of Amaseia, unlike his contemporary Epiphanios of Salamis, did not object to seeing Christian subjects shown in churches; he composed a moving description of a painting of the martyrdom of Saint Euphemia that he saw depicted in her shrine.[44] He did, however, object to Christian subjects portrayed on clothing, in a context that was unregulated by the ecclesiastical authorities.

A common image used by the church fathers to express the unofficial nature of domestic magic was that of the "drunken old woman," a character who for them exemplified the margins of society.[45] For example, John Chrysostom complained repeatedly of the drunken old women who provided incantations and claimed to be Christian because they uttered the name of God, but who in truth introduced the devices of demons.[46] Elsewhere he included other categories of women in his criticisms, as when he attacked nurses and maids who made a mark on a child's head while bathing it, in order to avoid the evil eye, fascination, and envy. He complained that by this action they compromised the sealing with the cross provided by the priest at the child's baptism;[47] in other words, the marginal ritual conducted by women at home nullified the official ritual performed by the male at church.

The directness of household remedies also came under considerable attack. At worst, they could be seen as a form of coercion of the demons, and at best as an easy way to favors and benefits which did not involve an effort to improve the user's soul. Again, we turn to the sermon by Asterius of Amaseia for the official views on the subject. The bishop said that people who wore depictions of Christ's miracles woven into their garments did so because they thought that they were wearing "garments pleasing to God." They were wrong, he said, because one should not simply sketch the Raising of Lazarus but rather prepare one's defense well for one's own resurrection. One should not have miracles depicted on one's clothes, but one should go out and do good works oneself.[48] The advice of Asterius, to cultivate

God in the spirit and not to wear him depicted on the body, echoed the strictures of Saint Jerome. The Latin father criticized "superstitious little women" who, like the Pharisees with their phylacteries, tied onto themselves little Gospel books or such relics as pieces of the wood of the cross. Like the Pharisees, he said, these women wore the scriptures on their bodies, rather than in their hearts.[49] Thus the church fathers were suspicious of all objects, such as weavings of Gospel scenes or even the Gospels themselves, that were used for direct physical benefits rather than as sources of instruction and edification. The true Christian should not be concerned with short-term security on earth but rather with his or her standing at the court of heaven.

From the perspective of the ecclesiastical authorities, the marginal character of the Christian paraphernalia employed in the household would have been accentuated by its tendency to ambiguity and obscurity.[50] It has been seen that in many cases, such as the unidentified riders, it is not clear whether the images on amulets and textiles are Christian or profane. The church fathers saw such ambiguity as an especially insidious feature of magic. For example, John Chrysostom, in his attacks on amulets and other apotropaic devices, repeatedly stressed that only the cross is acceptable as an explicitly Christian protection. Only the sign of the cross, he said, can be put on a child's forehead, not some other sign made in mud by its nurses and maids.[51] The child should not be guarded by amulets tied to it, nor by bells hung from its hand, nor by scarlet thread, but only by the sign of the cross.[52] The woman who ties on an amulet inscribed with the name of a river is not making a simple incantation but is falling for a device of Satan; for the Christian's only weapon should be the cross.[53] In John Chrysostom's writings we see that any protective device that was not unambiguously Christian was suspect. We can find similar sentiments expressed in the sixth century by the monastic writer Barsanufius, not, however, with respect to amulets, but to images received in dreams. In answer to the question, "How can the devil dare in a vision or in a dream-fantasy to show the Master Christ?" Barsanufius replies, "[The devil] cannot show the Master Christ Himself. . . , but he lies and presents the image of some man. . . . Nevertheless he cannot show the holy cross, for he does not find a way to depict it in another form. Inasmuch as we know the true sign and image of the cross, the devil does not dare to use it [for our deception]. . . . When, therefore, you see in a dream the image of the cross, know that this dream is true and from God."[54] Barsanufius, therefore, felt that human images received in uncontrolled circumstances, such as in dreams, were uncertain and inherently dangerous. Under such conditions, only the cross was explicitly Christian and safe.

Similar warnings about the dangers inherent in uncertain and obscure signs and images are found in the popular saints' lives and collections of miracles. The story told in the seventh-century *Miracles* of Saint Demetrios concerning the eparch Marianos is especially interesting in this regard. We have seen that this high official excited the envy of the devil on account of his integrity, and as a consequence he was afflicted with paralysis. Hoping to cure Marianos, one of his close associates approached him with a risky proposal, which he whispered into the sick man's ear: "There is a certain man who said to me that he could make you healthy, Master, if you wished to tie around your neck and wear the inscribed parchment that he is giving to you." Marianos was immediately suspicious; he asked: "And what is it that he says is written on the parchment?" His servant replied: "When I inquired [about this matter] a little more carefully, on account of my extraordinary care for you, O Master, he did not conceal it from me, but he said that he had written certain letters there, and stars, and half circles, and certain other formulas with Hebrew letters, and names of angels unknown to the many, written inside and outside. But," added the servant, "what need is there to know the force and the forms of what is written there? For there is but one concern for all of us your servants, namely that you should gain your health." But the pious eparch was not to be deceived. He responded indignantly: "First . . . from what is it manifest that I will escape the disease, having worn the parchment; but rather, since its writer did not wish to make clear the force of what was written, is it not plain that nothing good has been inscribed upon it? For 'whatsoever doth make manifest' according to the apostle, 'is light.'"[55]

The servant of Marianos, then, did not care whence the amulet derived its power; for him it only mattered that it worked. In the same manner, the users of household objects bearing anonymous images did not care whom they represented, so long as they were effective. But for the official, Marianos, the obscurity and ambiguity of the signs and formulas were a matter of grave concern, a source of danger for the unwary, for he did not wish to save his body while losing his soul. If the content was not crystal clear, it was tainted.

Ecclesiastical writers also referred to the repetition characteristic of magical devices. For example, John Chrysostom inveighed against those who used charms and amulets and who made chains around their heads and feet with coins of Alexander of Macedon.[56] We know that such "coins" were manufactured as amulets in the fourth century, at the time when John Chrysostom preached, because one of them, a circular gold pendant bearing a profile head of Alexander, is now preserved in the Walters Art Gallery of Baltimore (fig. 122).[57] We have

122. Baltimore, Walters Art Gallery, gold pendant (57.526): Head of Alexander of Macedon

seen, also, that images of "Alexander of Macedon" were repeated on tunics (figs. 113, 114). A passage in the biography of Saint Andrew the Fool speaks of the magical repetition of knots. It tells the story of a woman of Constantinople who engaged the services of a magician to help her with her marital problems. The sorcerer tied four knots in her girdle and advised her to wear it. By such means he bound a demon to her, from which she was released only after she had been advised to burn the garment.[58] This tale is an accurate reflection of late antique and early Byzantine magical practices. The written instructions for a charm, for example, may specify that three knots should be tied in the cord employed to suspend it from the user's neck.[59]

THE TAMING OF THE SAINT'S IMAGE

The incorporation of Christian imagery into household magic gave an easy avenue of attack to the iconoclasts who wished to ban Christian icons altogether, allowing only the unambiguous sign of the cross. In their polemics, the iconoclasts made use of quotations from the earlier church authorities, such as Asterius of Amaseia, who had condemned the domestic use of Christian images.[60] The iconoclasts charged, among other things, that the proponents of images showed reverence for icons and inanimate substances in and of themselves, rather than for the saints that had empowered them. In response, the defenders of images reiterated the old doctrine

of Saint Basil that "the honor paid to an image passes to its prototype"[61] and insisted that the icons did indeed work their benefits by the intercession of the prototype with God, and not directly.[62] The debate is illustrated by a late-eighth- or early-ninth-century sermon attributed to the iconophile writer Constantine of Tios. Referring to the iconoclast emperor Constantine V, the homilist complains:

> Not only did he [the emperor] extend his wickedness against the holy icons [by destroying them], but also . . . he set at naught the *hagiasmata* [i.e., holy water shrines] that flowed on account of God's providence toward men, and he called those who made use of them worshipers of water, thus taking the glory away from the intercessions of the saints, even renouncing the help and intercession of Mary, the all-holy Mother of God.[63]

In other words, the iconoclast emperor accused the image worshipers of believing that icons and substances related to the cults of the saints operated directly, on their own, and not by intercession. In reply, the champions of icons had to point to the intercessory role played by the saints in miracles that had apparently been achieved through the agency of inanimate objects. For example, at the Second Council of Nicaea, which met in 787 to reinstate icons, a passage from the sixth- or seventh-century *Miracles* of Saints Kosmas and Damian was quoted in defense of the cult. It told of a woman with the colic, who was cured by scraping plaster from the images of the saints painted upon the walls of her bedroom and drinking the resulting powder with water. Such a story might suggest that the images were acting directly, as a powerful substance in their own right, like a medicine or a drug. But the passage concludes with a significant disclaimer. It adds that the woman "immediately became healthy, her pains having ceased by the *intervention* (*epiphoitēsis*) of the saints."[64] Somewhat later, Theodore of Stoudios stressed that "it is not the material [of the icon] that is venerated, but the prototype."[65]

As a result of the debate over images, there was less ambiguity after iconoclasm concerning their status. Christian icons were seen as intermediaries between the suppliant and the invisible power rather than as powers in themselves. In theory it was no longer possible for icons of the saints to have the ability to act on their own; icons could only facilitate access to the prototypes in the hope of their intercession with the supreme Judge. This distinction between icon and proto- type was emphasized in the Life of the ninth-century saint Theodora, which was written in the early tenth century. The text describes how Theodora's kinsman, Anthony, the archbishop of Dyrrachion, made a defense of icons before the icon- oclast emperor Leo V. "All people who are taught of God in the Spirit," said

Anthony, "are familiar with this distinction of reverence and what sort of veneration we should render to Christ our God; and they know how to render the proper reverence to holy icons, and how to offer *through* them [i.e., through the icons] honor to the archetype."[66]

The importance of intercession in the functioning of icons is emphasized in many post-iconoclastic saints' Lives. There are, for example, many stories which reverse the usual pattern of prayer to an icon being followed by miraculous intervention, so that the appeal for help and the miraculous intervention take place before the icon is even mentioned. We have already encountered a story of this type, concerning the relative of Saint Irene of Chrysobalanton, whom she saved miraculously from execution.[67] In this tale, the role of the saint's portrait was not to bring about her aid but only to confirm that it had taken place. Other stories in the post-iconoclastic saints' Lives were still more explicit in reinforcing the dogma that images did not work directly on their own, but that any benefits were bestowed only through the intercession of the archetype with God. For example, in the ninth-century Life of Saint Stephen Sabaites, a tale is told of a certain Leontios, who suffered from demonic assaults. This man was released from his affliction only after he *stopped* looking at icons for a certain period.[68] Such a cure could work, of course, only if the real source of power was outside of the icons themselves.[69]

The post-iconoclastic concept of the functioning of images had important consequences for the design and presentation of the portraits of the saints. In the first place, it was now ineffective to have multiple identical copies of the same image in one context, in one area of a church, or on one garment, because the individual viewer could reach the prototype only through one image at a time. In this respect, a distinction should be made between visual images and verbal prayers such as were recited in the liturgy. The repetition of verbal appeals could still be compatible with the idea of intercession, but repeated identical images were useless to the individual worshiper, who could look upon only one picture at a time. For this reason, it is unusual to find a repetition of the same image within one program of decoration in a post-iconoclastic church. We have seen, for example, that even Holy Luke appears just once in the mosaics of his church; there are many similar images among those mosaics, but none are identical. It could be said, of course, that post-iconoclastic Byzantine artists came close to the repetition of images in cases such as the two Theodores, who could almost be taken as twins of each other (figs. 10, 11). But even here, as we have seen, artists were careful to observe the distinctions between the two saints, portraying them as two individuals, not as an exactly repeated type.

The post-iconoclastic change in the status of icons had its most significant impact on the domestic arts. According to the Acts of the Iconoclastic Council of 754, the iconoclasts banned Christian images from private dwellings.[70] But even after the end of iconoclasm, the depiction of saints all but disappeared in some domestic media, such as textiles and pottery. In household ceramics, only the old motif of the nimbed rider piercing a foe occasionally survived, but it was relatively rare after the ninth century. In textiles, the greatest change took place in the decoration of drawloom silks. As we have seen, the drawloom technique encouraged the repetition of identical motifs, but such a presentation was now no longer suitable for Christian images. The iconoclastic dispute of the eight and ninth centuries had caused a break in the production of textiles with Christian images within the Byzantine Empire. We know from the Acts of the Council of 754,[71] as well as from the eighth-century biography of Anthousa of Mantineon,[72] that the iconoclasts seized and defaced textiles bearing Christian figures; even the altar cloths were in danger of desecration. Therefore, the production of drawloom silks decorated with Christian subjects must have ceased in the Byzantine Empire during the iconoclastic period. But once iconoclasm was finally over, in the ninth century, the drawloom silks woven with Christian figures seem never to have returned. Surviving Byzantine drawloom silks from the centuries after iconoclasm are woven only with repeated profane motifs, especially with animals. It is true that the *Liber Pontificalis* does mention two ninth-century papal donations to Roman churches of textiles decorated with Christian scenes that may have been Byzantine in origin, since the subjects are designated with Greek names ("*Cheretismon*," or "Salutation," and "*Ypopanti*," or "Presentation").[73] However, it is not clear that these were drawloom silks with repeating woven designs; very possibly they were embroideries. Certainly, post-iconoclastic representations of Byzantine lay persons wearing silks invariably show that their garments were decorated with animal or plant motifs rather than with religious imagery. Two examples may be drawn from manuscripts. First, there is the the famous portrait of the eleventh-century emperor Nikephoros Botaneiates, which serves as one of the frontispieces to a copy of the homilies of Saint John Chrysostom now in Paris (fig. 123). Here one of the courtiers standing to the left of the emperor wears a white silk robe decorated with repeating medallions containing lions executed in gold and red. His costume can be compared with a surviving silk from the reliquary of Saint Siviard at Sens, which is woven with medallions containing gold griffins on a white ground (fig. 124). Second, a fourteenth-century manuscript of Hippocrates, now in Paris, portrays the owner, Alexios

123. Paris, Bibliothèque Nationale, MS Coislin 79, fol. 2r (Homilies of St. John Chrysostom): Nikephoros Botaneiates with courtiers

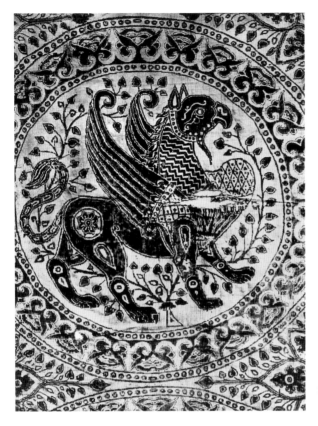

124. Sens, cathedral treasury, silk
from the reliquary of St. Siviard
(B8): Griffins

Apokaukos, wearing a drawloom silk decorated with identical medallions, each
containing two lions set back to back (fig. 125).

The surviving evidence suggests, therefore, that after the ninth century,
repeating drawloom silks were no longer a suitable medium for portrayals of the
saints because the prevailing image theory discouraged repetition. A second con-
sequence of the new concept of images was that all sacred icons had to be
sufficiently detailed, complete, legible, and precise for the prototype to be recog-
nized, for now it was not the icon, but the holy person portrayed, that possessed
the power. The importance of the name and the features of the image as pointers
to the prototype was stressed in the Acts of the Second Council of Nicaea: "The
image resembles the prototype not with regard to essence, but only with regard
to the name and to the position of the members which can be characterized."[74]
Recognition was an important part of the experiencing of icons, as the stories of
dreams and visions in the saints' Lives reveal. For this reason, post-iconoclastic
artists, to a much greater extent than their predecessors, developed a standard sys-
tem for clearly identifying the saints by means of category, and in many cases also

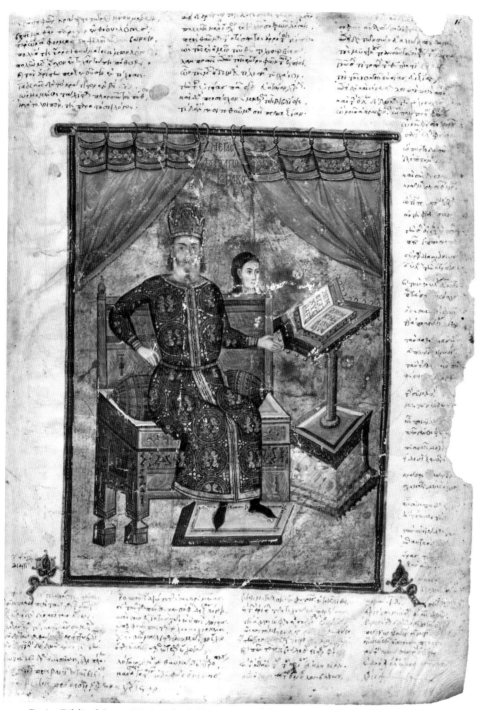

125. Paris, Bibliothèque Nationale, MS gr. 2144, fol. 11r (Hippocrates): Alexios Apokaukos

126. Washington, D.C., Dumbarton Oaks, enamel plaque (57.9): St. Demetrios

by portrait type. Most importantly, the addition of identifying inscriptions eventually became standard practice after iconoclasm, as the contrast between the mosaics in the churches of St. Demetrios and Hosios Loukas has shown (figs. 34, 60). Even for small-scale images on domestic jewelry, it became the general rule for the saints to be identified by inscriptions, as can be seen, for example, on a tiny fingernail-sized enamel plaque of the eleventh century which portrays St. Demetrios (fig. 126). In the post-iconoclastic period, the effectiveness of icons depended on their accuracy and specificity, not on their obscurity and ambiguity.

In conclusion, it may be said that portrayals of saints and other holy figures on early Byzantine domestic clothing and furnishings were decentralized in their production and not standardized in their iconography. Many images were ambiguous, portrait types were few, and often identifying inscriptions were lacking. Especially in textiles, but also in other media, there was frequent repetition of identical images. Even in churches, *ex-voto* images such as those of Saint Demetrios took on some of the characteristics of domestic art. These early images were operating in a different way from those in post-iconoclastic art. To a large extent, they were not icons serving as avenues of appeal to an individual saint, but rather they were direct and powerful signs in their own right, intended, especially, to counter the ill effects of demonic envy. The character and function of Christian images in domestic art shared several features in common with devices and practices that the church condemned as deviant or magical, and therefore these images posed problems, both for opponents and for supporters of Christian images.

After iconoclasm, however, the church was able to recontextualize and channel Christian imagery, so that it no longer was able to play a role in customs and belief systems that the church could not reconcile with the theology of the icon. This restriction had important effects on the design and presentation of Byzantine images of the saints. Post-iconoclastic art responded to the theory of intercession that had been developed by the church, that is, to the demand that each image should relate directly to an individual holy figure, to whom prayers could be addressed, in order to persuade the saint to intercede with the divine Judge. There was no longer any room for ambiguity. The iconography of the saints was standardized, with the different classes of saints being clearly distinguished from each other, and with individual portrait types being created for each of the more

important saints. Most significantly, all saints were now identified clearly by inscriptions. These changes affected both domestic and church art. Furthermore, after iconoclasm, the repetition of identical images within a single context, on one object, or within one space of the church, was usually avoided, except in some special cases such as the images of a patron saint. For the individual worshiper, repeated individual images were at best useless, and at worst suspect, for only if the images were devices that had power in and of themselves did it make sense to repeat them. In other words, the images of the saints lost the status of powerful signs and became instead portraits of powerful individuals.

The change from a more open to a more defined iconography of the saints and the disappearance of their images from several categories of domestic furnishings—especially from weavings—signalled a tightening of church control over access to the supernatural. We have seen that in the early Byzantine period, lay people at home, including women, were able to exercise choice over the selection of images and instruct their artists accordingly. They were able to use the images that they had commissioned as devices that worked directly; there was no necessity to go through the regular intercessory channels prescribed by the church in order to seek alleviation of their problems. After iconoclasm, however, the ecclesiastical authorities could monitor lay access to supernatural power more effectively, both through the theology of the icon and through the forms of the icons themselves.

4

DETAIL AND DEFICIENCY

MODES OF NARRATION IN ART AND LITERATURE

One of the homilies attributed spuriously to the fifth-century theologian Hesychius of Jerusalem, but in fact composed some centuries after his death, is devoted to the Passion of Saint Longinus the Centurion. The sermon opens with an interesting contrast between images of cities, as created by painters, and images of martyrdom, as described by writers:

> Just as the images of the painters represent certain appearances of cities, and show the sizes of their towers, and the forms of men and women, now young, now old, now imperial, now nuptial, now sad-looking, now joyous, so also those who compose accounts of the trials of the martyrs make plain to their hearers the firmness of the [martyrs'] spirit, the courageousness of their attitudes, and their fearless, brave-spirited, and imperturbable comportment in the face of dangers.[1]

The comparison made here between painting and oratory is a conventional opening gambit for encomia of the saints, but what is unusual and striking about this passage is the Byzantine author's careful distinction between two modes of narration. That is, the writer distinguishes between a picturesque mode on the one hand, showing the temporal accidents of youth and age, particular social occasions, and passing emotional states, and a more rigid mode on the other hand, showing firmness, an avoidance of emotions such as fear, and a general imperturbability. It is with such distinctions that this chapter is concerned, for here it will be shown that Byzantine artists after iconoclasm created similar differentiations between the narrative lives of the saints, making them either full of incident and particularity or else rigidly schematic and impassively abstract. We shall see that in narrative scenes, art and literature followed different rules with respect to their treatments of the saints' lives, for in some cases the hagiographic scenes in art emulated, or even exceeded, the drama of the written biographies, but in others they fell far short of the texts, being more stripped down and reduced. The visual biographies of the saints, like their portraits, showed varying formal characteristics that reflected differences both in the salvific roles of their subjects and in the devotional expectations of their viewers.[2]

In this chapter the lives of three saints are selected for examination, namely, the Virgin, Saint Nicholas, and Saint George, because their biographies were the most frequently illustrated in Byzantium. Byzantine artists illustrated the narrative of each saint in a distinct mode, which can be defined as either more or less detailed and earth-bound in comparison with the life of Christ. We begin with the life of the Virgin, where the relationships to the life of Christ are particularly complex, inviting interpretation on several levels.

THE LIFE OF THE VIRGIN

Already in the early Byzantine period, christological scenes involving the Virgin were set in opposition to those in which she was not present, in order to create a meaningful juxtaposition. A particularly interesting pre-iconoclastic example is the gold ring illustrated in figures 127 to 130, which is now in the Byzantine Collection at Dumbarton Oaks. We will look at this ring briefly, before moving on to depictions of the life of the Virgin in the eleventh to fourteenth centuries, because it makes an instructive contrast with the later works of art. In spite of superficial similarities to the post-iconoclastic monuments, the images on the ring juxtapose the Virgin and her Son in a different way and with a different purpose. The ring was made for a marriage that took place in the late sixth or seventh century. We know the names of the couple, for around the edge of the bezel is written the following inscription: "Lord, help thy servants, Peter and Theodote."[3] The bridal pair are portrayed on the bezel, on the top of the ring, by means of niello that has been set into the gold (fig. 127). On the right of the photograph we see the bride, Theodote, who is being crowned by the Virgin. On the left stands the groom, Peter, who is being crowned by Christ; he was given the more honored position, to the right hand of the Lord. The composition, however, is perfectly symmetrical, with the males on the left and the females on the right. This idea of balance is reinforced by the inscription underneath the figures, which reads, simply, "*Omonya,*" or "harmony."

On the faceted hoop of this eight-sided ring there are seven episodes from the life of Christ, one episode to each facet. These christological scenes are remarkable for their small size and detail, but it is perhaps more remarkable that they, too, are symmetrically divided, with the male-centered subjects on the left of the bezel as seen in the photographs, and the female-centered subjects on the right. If we take the scenes in the chronological order of Christ's life, we have, on the right, three scenes involving the Virgin Mary: the Annunciation of Christ's birth,

127. Washington, D.C., Dumbarton
Oaks, gold marriage ring (47.15):
The Virgin and Christ crown the
bride and groom

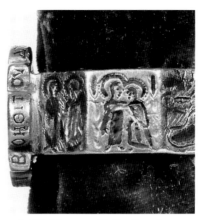

128. Washington, D.C., Dumbarton
Oaks, gold marriage ring (47.15):
Annunciation, Visitation, and
Nativity

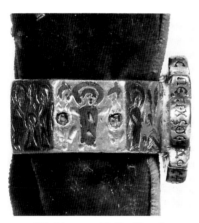

129. Washington, D.C., Dumbarton
Oaks, gold marriage ring (47.15):
Baptism, Crucifixion, and
Resurrection

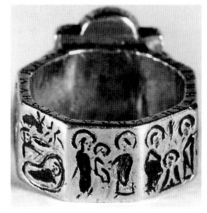

130. Washington, D.C., Dumbarton
Oaks, gold marriage ring (47.15):
Nativity, Presentation of Christ, and
Baptism

the Visitation, in which Mary embraces her cousin Elizabeth, and the Nativity of
Christ (fig. 128). Then, on the other side of the hoop, the male side, we have the
Baptism of Christ, his Crucifixion between two thieves, and finally his Resur-
rection, which is portrayed by his appearance to the women in the garden (fig.
129). These two sequences of scenes are ingeniously linked by the engraving of
the Presentation, at the back of the hoop, where we see the Virgin giving the
Christ Child into the arms of the prophet Symeon, the Virgin being on the

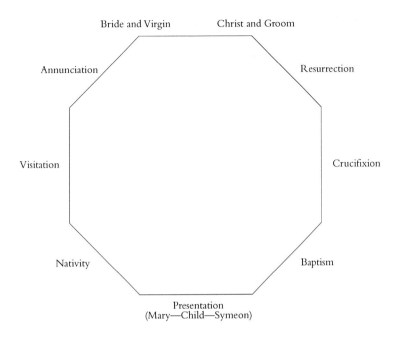

131. Washington, D.C., Dumbarton Oaks, gold marriage ring: Diagram of images

female side, on the left, the prophet on the male side, on the right (fig. 130). The gender symmetry is absolutely consistent, as can be seen from the diagram of the images on the ring shown in figure 131.

The marriage ring at Dumbarton Oaks belongs to a group of four similar pre-iconoclastic rings with octagonal hoops decorated with episodes from the life of Christ, but it is unique in the consistency and precision of its division of the scenes by gender. The purpose of this symmetry was more than a simple expression of the union of male and female in marriage; it also had to do with the content of the inscriptions on the ring, the "harmony" invoked on the bezel, and also the twin inscriptions that run around the two edges of the hoop: "My peace I leave with you," and "My peace I give unto you."[4] These inscriptions refer to the verse in the Gospel of John, that reads in its entirety: "Peace is my parting gift to you, my own peace, such as the world cannot give. Set your troubled hearts at rest and banish your fears (14.27)." Scholars have recognized that early Byzantine rings of this type are amuletic; not only does the inscription on the edge of the bezel invoke Christ's help for the couple, but even the shape of the ring may have been benificent, for rings with octagonal hoops were thought to have medicinal

properties, promoting good health.⁵ But in this case the amulet is designed not only for the physical health of the wearer but also for the health of the marriage itself. The Byzantines were as well aware as we are today that marriages could be marred by strife and discord—perhaps more aware, because divorce for them was much more difficult. For the Byzantines, marital discord was not just due to problems of personality; it was caused also by demons. From the Byzantine magical textbook, the so-called *Testament of Solomon*, we even know the names of the malevolent spirits responsible for marital conflicts, names such as Modabeel and Katanikotaeel.⁶ A ring such as this one would work its benign influence to repel these evil spirits and to insure peace between wife and husband. The careful pairing of images by gender complements the inscriptions by invoking harmony; the two genders form a kind of magic circle, held in a perpetual balance that is insured by the life of Christ himself.

The marriage ring at Dumbarton Oaks and its relatives are among the earliest known objects containing a closed christological cycle, that is, a self-contained sequence of biographical scenes from the life of Christ. As such, these rings have been seen as important precursors of the mosaics and frescoes that were to appear in Byzantine churches after iconoclasm.⁷ For in Byzantine churches that were decorated after the ninth century, that is, after end of the iconoclastic period, we commonly find a sequence of scenes from the life of Christ encircling the church, like a greatly expanded version of the images on the ring. Such images of the life of Christ were called by the Byzantines "feast" icons, with the implication that they imaged the year-long sequence of the liturgy.⁸ In many post-iconoclastic churches the cycle of the feasts was expanded by the addition of scenes portraying the birth and early life of the Virgin.⁹ These images from the life of the Virgin formed a kind of female counterpoint to the scenes from the life of Christ, setting up a division by gender, just as the scenes were divided by gender on the marriage ring.

To illustrate this counterpoint of the feast scenes, female and male, we may look at the mosaics preserved in the church at Daphni, outside Athens, which date to the late eleventh or to the early twelfth century. With one exception, the scenes of the early life of the Virgin were portrayed in the narthex, or porch of the church, while the scenes of the infancy of Christ were displayed in the naos, or nave, high up in the four squinch vaults under the dome. In the narthex, the life of the Virgin starts with the Annunciation to her father Joachim (fig. 132). According to the apocryphal Gospel, the *Protevangelium* of James, which was the principal source for the iconography of the Life of the Virgin, Joachim was a rich and pious man but also sterile. On account of his inability to beget a child, his

offerings were refused by the high-priest at the temple. Following this rebuff, he went into the desert to fast and to pray. After an interval of forty days and forty nights an angel came to him to announce that his wife, Saint Anne, would now conceive.[10] So this scene appears as a gender reversal of the Annunciation of Christ's birth, which is portrayed in the naos (fig. 133). That is, here the angel comes not to the woman but to the man.

The Birth of the Virgin is given special prominence at Daphni (fig. 134), where it is taken out of the narthex, the location of the other scenes of the infancy of the Virgin, and presented instead in the naos, as a pendant to the visit of the three Magi to Christ (fig. 135). The Nativity of the Virgin is shown on the eastern wall of the north arm of the naos, while the visit of the wise men is in the corresponding position on the east wall of the south arm. In the Nativity of the Virgin, we see at the left Saint Anne sitting up on a bed in order to receive two women who bring gifts in golden containers. Below, a third woman pours water for the first bath of the child from a gold and silver pitcher which she cradles on a towel. On the other side of the church, in the pendant position, we see the three Magi bringing their offerings of gold, frankincense, and myrrh to the Christ child, who is enthroned upon his mother's lap. Thus, on the left we see women bringing gifts in golden containers to a female child, on the right men to a male.

The pairing of the images in these mosaics had its counterpart in real life, in the ceremonies of the imperial palace in Constantinople, where there were parallel receptions for the emperor and the empress. We know a certain amount about these imperial rituals from the official *Book of Ceremonies*, which was compiled by the tenth-century emperor Constantine Porphyrogennetos. According to this treatise, when the emperor received foreign ambassadors in the throne room of the Magnaura, the legates were led before him by an official carrying a golden rod, who was known as the *Ostiarios*. Once the ambassadors reached the throne of the emperor, they fell on the ground to pay him respect.[11] In the mosaic of the Magi at Daphni, we see that the role of the Ostiarios is taken by an angel, who carries a golden rod and introduces the Magi to Christ as they bow before him (fig. 135). There was also a reception involving the empress on the occasion of the birth of a male child. Here the instructions from the *Book of Ceremonies* state: "Know well that on the eighth day after the birth the bed-chamber of the Augusta [the empress] is beautified with veils interwoven with gold and with chandeliers . . . the child . . . is placed in the crib and he and the Augusta are covered with spreads woven with gold." These spreads can be seen covering the couch in the mosaic of the Birth of the Virgin (fig. 134). *The Book of Ceremonies* continues: "Then the *praepositi* are

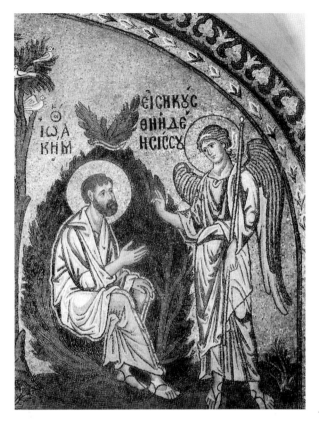

132. Daphni, monastery church, mosaic in narthex: Annunciation to Joachim

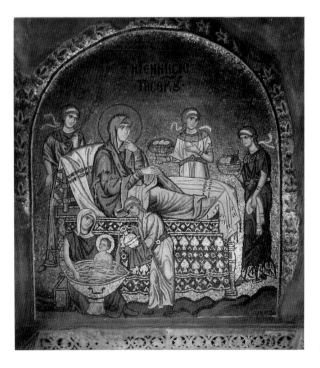

134. Daphni, monastery church, mosaic in naos: Birth of the Virgin

133. Daphni,
monastery church,
mosaic in naos:
Annunciation of
Christ's birth

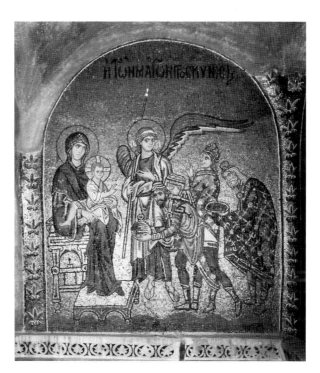

135. Daphni, monastery church,
mosaic in naos: The three Magi
before Christ

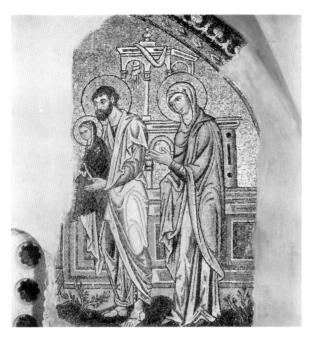

136. Daphni, monastery church, mosaic in narthex: Blessing of the Virgin

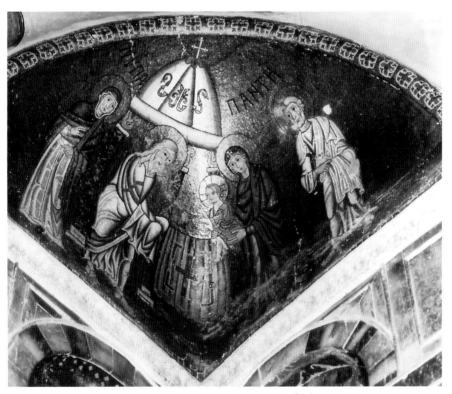

137. Hosios Loukas, Katholikon, mosaic: Presentation of Christ

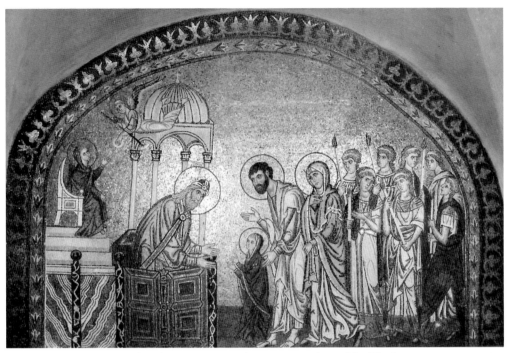

138. Daphni, monastery church, mosaic in narthex: Presentation of the Virgin

summoned . . . and then are led in [the wives and widows of the court officials], one after another, from the New Palace dining room. . . . And they pray in thanksgiving for the Augusta, and acclaim her, and they give fitting respect, each one bringing in a gift of her own choice."[12] In the mosaic this great crowd of visitors has been reduced to two, but there is no doubt of the image's resonance. The Virgin and her mother are honored here with an imperial reception, similar to the one accorded to Christ. We may note, however, that the mother of the Virgin is cooled by the feathers of an earthly fan, held by a servant on the left, while the adoration of Christ is overshadowed by the wings of an angel.

The next episode to be portrayed from the life of the Virgin is located in the narthex and takes place on her first birthday, when she was given by her parents to be blessed by the priests (fig. 136). The visual counterpart to this episode is the Presentation of Christ in the temple, a scene that at Daphni was originally portrayed in one of the squinch vaults of the naos but is now lost. However, there is a well-preserved mosaic of the Presentation in the somewhat earlier Church of Hosios Loukas, which may be used for comparison (fig. 137). In both images, the parents, on the right, carry the child to be presented to the priest, who was

shown on the left—at Daphni the figure of the priest who was blessing the Virgin is lost. Again the sexes are reversed: in the Blessing of the Virgin, it is the father who holds the daughter; in the Presentation of Christ, it is the mother who holds the son. In addition to the switch in gender roles, we may observe in the Presentation of Christ that the man, Joseph, follows at a respectful distance, for he is not really the father, of course (fig. 137). Here again there is a message about the status of the child, a point to which we shall return later.

The last event from the infancy of the Virgin that was depicted in the narthex at Daphni was her Presentation in the temple, an event that took place when she was three years old (fig. 138). On this occasion, she was received into the temple by the priest Zacharias and left there by her parents until she was old enough to be betrothed. Once in the temple, she was taken into the holy of holies and fed in the sanctuary by an angel, a miracle that can be seen on the left.[13] This angelic feeding was regarded by Byzantine commentators as a foreshadowing of the eucharist.[14] Once more, if we make the comparison with the Presentation of Christ (fig. 137), we find the same gender reversal: the Virgin is presented by her father, while Christ is offered by his mother.

On the surface, therefore, it appears that the artists of Daphni attempted to create pairings of scenes by gender, which in some respects seem to echo the gender symmetry of the episodes on the early Byzantine ring. But are the two cases really similar? In the marriage ring, which was a domestic object with a quasi-magical intent, the dialectic is relatively simple and straightforward; the division is equal, and the message is harmony between the sexes. But the pairings in the later Byzantine churches are more complex. The messages are presented in a sophisticated manner, and they reflect not the unregulated views of laywomen and men but the official dogmas of a male clergy. The echoing of the scenes in the church may at first look symmetrical, but closer scrutiny reveals significant differences which carry a message of profound asymmetry. The designers at Daphni were employing a technique that was frequent in Byzantine churches, namely, the use of paired images to emphasize contrasts in content. The play of the life of the Virgin against the life of Christ was intended to convey distinctions that were not only gendered, but also theological, concerning humanity and divinity.

The relationship between the infancy of the Virgin and the infancy of Christ was discussed extensively by Byzantine preachers, in sermons which were read out each year on the appropriate feast days. Among the most popular of these sermons, to judge from the frequency with which they were copied in liturgical manuscripts, were the homilies on the infancy of the Virgin by George of Nicomedia.

This preacher was an ecclesiastic of the ninth century, who spent part of his career as archivist of the Church of St. Sophia in Constantinople. George of Nicomedia saw each of the events of the early life of the Virgin as predictions of the much more wondrous life of Christ. "It is not the mysteries of the Virgin that are honored," he preached in a sermon on her Presentation, "but rather the events of the future that are foreshadowed by them."[15] In another sermon, on the conception and birth of Mary, he made an involved comparison between the Nativity of the Virgin and the Nativity of Christ; his language is difficult and rhetorical, for this is the kind of writing that the Byzantines admired, but the main point of his juxtapositions is clear: the lesser event foreshadowed the greater. In the words of George of Nicomedia:

> Through the miracle that happened to [the Virgin's] parents, we are taught about the mysteries of the more ineffable miracle. This earlier [Nativity] was indeed the prediction of that [Nativity], and through what was fulfilled it forecast the certainty of what was announced. There, a woman who was sterile was debarred from what was appropriate for her nature, but here a Virgin is walled by an inviolable chastity. There the binding [i.e., sterility] was long-lasting, but here the purity of character is immortal. That birth was the fruit of virtuous actions and prayer, but here the inexplicable conception is instituted anew on account of surpassing virtue and boundless purity. There it was an angel who was the herald of the promised childbirth; here it is an archangel who is the announcer of the supernatural conception.[16]

Other Byzantine preachers drew a similar contrast between the infancy of the Virgin and that of Christ. The learned Byzantine emperor Leo VI, for example, wrote a passage in a homily on the Nativity of the Virgin which is more compressed than the rhetoric of George of Nicomedia but essentially says the same thing:

> Now the philanthropic God on account of his pity . . . brings forth from a sterile womb the womb that he will occupy in a supernatural fashion. For it was fitting that the miracle should be preceded by a miracle; the miracle that is greater and transcending nature by the miracle that is lesser; and the one that is above nature by the one that is above hope.[17]

Thus Leo VI, who was given to pithy formulations of complex dogmas, characterizes the Nativity of the Virgin as only above hope but the Nativity of Christ as above nature.

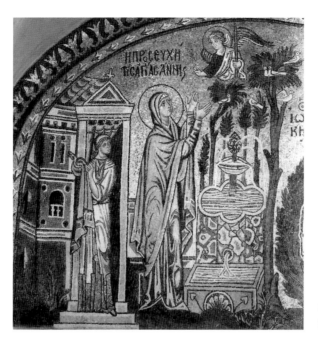

139. Daphni, monastery church,
mosaic in narthex: Annunciation to
St. Anne

Such ideas were expressed also by Byzantine artists, not in verbal rhetoric but
in the language of forms. We may consider, for example, symmetry and asymme-
try in the Annunciation scenes at Daphni. In this church, the mosaic of the
Annunciation to Joachim in the wilderness (fig. 132) is set beside a second annun-
ciation scene, showing the appearance of the angel to his wife, Saint Anne (fig.
139). The two episodes are seen by the visitor immediately on entering the
narthex, somewhat above eye level on the right-hand wall. In contrast, we have
seen that the mosaic of the Annunciation to the Virgin is within the church
proper, in the naos, and it is not low down but displayed high up in one of the
squinches beneath the dome (fig. 133). Comparing the images in more detail, we
see that the mosaic of the Annunciation to Saint Anne is full of picturesque inci-
dent (fig. 139): following the text of the *Protevangelium*, the artist has shown Saint
Anne standing in a garden, where she sees a birds' nest in a laurel tree and where
she indulges in a long lament, complaining that she alone of all creatures is unable
to reproduce. To the left, she is witnessed from the door of her house by her ser-
vant Judith, who had earlier reproached her for her sterility. Above and to the
right, an angel at long last announces to Saint Anne the forthcoming birth of a
child.[18] The artist has emphasized the details of daily life that bring the story
down to earth. We see the many-storied architecture of Saint Anne's house, for
the *Protevangelium* says that she and Joachim were wealthy. We are shown the

embroidered curtain at the doorway and the fountain in the garden, with its pine-cone finial spouting water and its basin of colored marbles. All this is in striking contrast to the mosaic of the Annunciation to the Virgin, which is reduced to a simple confrontation of the two protagonists (fig. 133). Even though the Gospel implies that the Annunciation of Christ's birth took place indoors, in the Virgin's house, the scene is presented against an absolutely plain gold ground. Thus, the mosaic in the narthex is seen by the visitor on entering, low down in the building, and rich in details of daily life; it is a preparation for the greater mystery that is to be seen within, high up under the dome, shorn of earthly trappings and silhouetted against gold. Through the contrasts in their formal design, the parallel Annunciations reveal profound differences in status.

A very striking illustration of this distinction between the two mysteries, the one that was above hope and the one that was above nature, can be found in two famous manuscripts of the twelfth century which contain the illustrated sermons of a writer known as James of Kokkinobaphos.[19] The two manuscripts are now preserved in the Bibliothèque Nationale in Paris (ms. gr. 1208) and in the Vatican Library (ms. gr. 1162), and they each contain six sermons devoted to the life of the Virgin, from her Conception to the Visitation, together with nearly identical cycles of illustrations. The homilies are written in an exceedingly florid style, more rhetorical, even, than the homilies of George of Nicomedia. The miniatures in the two manuscripts follow the sermons quite closely, but the artist changed his manner of illustrating the text according to the status of the subject matter. Just as at Daphni, the life of the Virgin evoked a more detailed and more down-to-earth telling than the life of Christ. We may compare, again, the two Annunciations, to Saint Anne and to the Virgin. Figure 140 illustrates the Annunciation to Saint Anne from the manuscript in the Vatican. As at Daphni, the story is given the picturesque treatment: at the lower left we see Saint Anne and Judith walking in the garden; the servant turns toward her mistress, in order to point out the birds who are feeding their nestlings in the trees. Then, on the lower right, Saint Anne laments beside an elaborate fountain, which has waterspouts in the shape of serpents' heads. Here an angel tells her that she will conceive. The scene shown above provides an emotional contrast. Saint Anne, waiting in her house for Joachim to come back from his vigil in the wilderness, has just heard from her servant that he is returning, whereupon she springs up eagerly from her chair and runs to meet him. On the left she greets her husband with an impetuous embrace, which is also a discreet reference to the natural conception of the child. Thus, the division of the miniature into two registers in effect creates an emotional contrast between the two stages of the story. Below is the lament in the garden, in

σιπ ά ι ε λ οι τ ημ ιμι τ μο ψιμ ρό οβωσ
ωρο αμα φωρ οισ ωυ λλημ /ιμ· ι λ ουσ αρ
φη σ λ λ ο υσ η σ, ά π π λ ο σ κ ύ η λ θ ε λ έ τ ωμ
ά υ τ ή :-

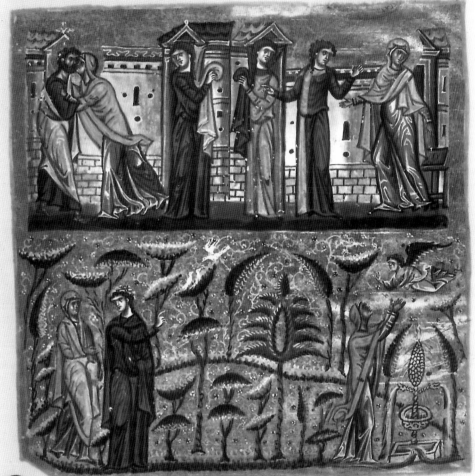

ⲉ ωή Κ ο υ σ ὁ μ ό · θ῀υ τ ῀η σ δ ε ή ο β ω ό σ ο υ·
Κ ω ι σ υ χ λ ή ψ η κ α ι έ τ ι μ ή σ τ ι σ· Κ α ι λ α
λ η θ ή σ ε σ ται το σω β έ ρ μ α σ ο υ ὑ μ ό λ η · τ ἡ

140. Rome, Vatican Library, MS gr. 1162, fol. 16v: Annunciation to St. Anne

which Saint Anne complains, in the words of the homily, that she is less fit than any creature that can give birth.[20] The upper register portrays her joyful receipt of the news of Joachim's arrival and her greeting of him. In some ways the miniature of the Annunciation of the Virgin's birth goes beyond the text of the homily in dramatizing the story, for the sermon does not refer to the servant announcing Joachim's return; it was a detail inserted on the initiative of the artist.

The same painter, when he came to illustrate the sermon devoted to the Annunciation of the nativity of Christ, produced miniatures of a completely different character, even though they are in the same manuscript (figs. 141–145). Here the text by James of Kokkinobaphos gives a very extended description of the Virgin's emotions as she received the message of the archangel Gabriel; first she was fearful, then hesitant, and only after feeling these emotions did she joyfully give her acceptance to her heavenly visitor. This long passage of writing is accompanied in the manuscript by a sequence of five miniatures of the Annunciation, which take no account whatsoever of the emotional shifts experienced by the Virgin; in fact, the five illustrations are very similar, although the artist was careful not to make them identical. We will look at them in more detail, to see just how far they fall short of illustrating the text to which they are attached.

The first miniature (fig. 141), comes on folio 118 of the manuscript in the Vatican; it is headed "*O Chairetismos*" or "The Salutation." It shows the angel approaching from the left, and, on the right, the Virgin sitting and spinning in front of a domed building that represents her house. She sits in a pose that may express her initial alarm at Gabriel's approach, for she has her body facing away from the angel, while she turns her head to look at her visitor over her shoulder. This miniature comes immediately after a passage in which the homilist describes how the Virgin was first startled by the angel when she was outside her house, fetching water from the well. She fled indoors and tried to compose herself with her spinning. The homilist continues:

> With her heart still trembling and palpitating, with pallor draining her cheeks, and with all of her limbs trembling violently, she was intent on her work. Whereupon the archgeneral [of the heavenly host], presenting himself in human form, appeared before her face to face through the door. And then the angel uttered those blessed words . . . "Hail thou who art highly favored, the Lord is with thee."[21]

The second miniature of the Annunciation occurs four folios later, on folio 122 (fig. 142). Here the poses of both the Virgin and the angel resemble the

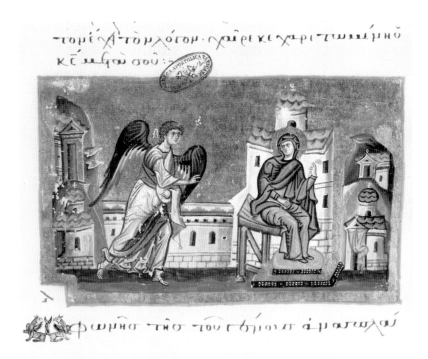

141. Rome, Vatican Library, MS gr. 1162, fol. 118r: Annunciation, "The Salutation"

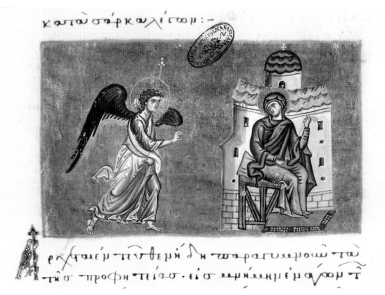

142. Rome, Vatican Library, MS gr. 1162, fol. 122r: Annunciation, "Exposition of the truth of the Gospels"

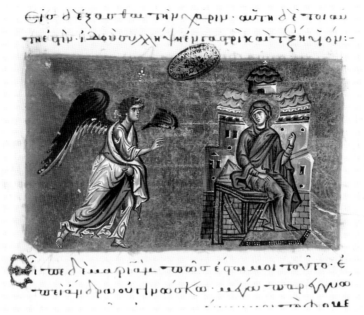

143. Rome, Vatican Library, MS gr. 1162, fol. 124r: Annunciation, "The doubts of the Virgin as to how she is to conceive the Lord"

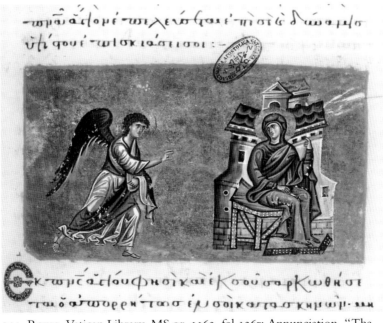

144. Rome, Vatican Library, MS gr. 1162, fol 126r: Annunciation, "The Virgin is released from her doubts"

first miniature, but the architectural background has been simplified. The painting is headed "Exposition of the truth of the Gospels." It follows a text which includes a discussion of why the Virgin was so fearful of the angel. The homilist says:

> Before we proceed any further, it is proper that we should at this point raise the question of how that most immaculate one took so much fear at the sight of the archangel, when she formerly had been habituated to the company of angels [through being fed] in the temple. . . . Why was she panic-stricken, disturbed, and at a loss at the sight of the angel? . . . In truth, it was not on account of the [appearance of the angel], but on account of the newness of what the angel said that she was disturbed within herself.[22]

The third miniature of the Annunciation follows after two more folios of text (fig. 143); once again, the poses of both protagonists strongly resemble the preceding miniature, but there are slight variations in the design of the house. The painting is headed "The doubts of the Virgin as to how she is to conceive the Lord" and it accompanies a further dialogue between Gabriel and Mary, in which the angel seeks to allay her fears and doubts.[23]

The fourth Annunciation miniature comes two folios later (fig. 144). It is headed "[The Virgin is] released from her doubts," but we would hardly know this from the poses of the figures, which are virtually identical to those in the last composition. There is, however, another change here in the architecture of the Virgin's house, for the dome at the top has given way to a gabled roof. This miniature accompanies a passage in which we are told of the Virgin's joy once her fears have been allayed:

> By such means the archgeneral buoyed the all-lucid understanding of the Virgin, setting it above the heavens. Wherefore, he prepared her to submit to the mystery with ineffable joy. . . . And so what had been a cause of fear and uncertainty to her, became a cause of greater joy.[24]

The depiction of the joy has to wait until the fifth miniature of the Annunciation, which is found on the next folio (fig. 145). It illustrates a passage in the homily which describes what happened when the Virgin finally gave her assent to the conception. In the words of James of Kokkinobaphos: "All the intelligible powers leaped [for joy] when this response reached their ears; heaven above rejoiced, and the clouds received these words like a joyful dew."[25] In the miniature, though, it is only the angels on the right who show their enthusiasm, by

※ ΤΗΣ ΑΚΟΙ ΕΝ ΧΗ ΚΑΙ ΕΝ ΚΑΤΑΒΘ ΘΣ Ε ΠΙ ΤΗΣ ΕΝΑΛΗ ΨΕΙ:-

Πήραμα καλεα όριομ ός η ρεύξατο λόγομ. Τό
πολυ θαίμα ιατρομ. τα μάι τι λαομη δι η γη
και ιδούφη σιμ η δούλ η κύ. τή μοι τό
και και ατα. τό έ μαι σου:-

σκιρ ΤΗσαμ παθ σαμ ρο θραι δικο αμειο

145. Rome, Vatican Library, MS gr. 1162, fol. 127v: Annunciation, Joy in heaven

pirouetting and waving their hands in the air. The Virgin and Gabriel are still frozen in the same poses that they have adopted in all the other Annunciation scenes; only the architecture of the house behind the Virgin has changed again, as it is now topped by an open ciborium. We see, then, that the sequence of scenes is against earthly logic. One would expect that the actors would change their positions over time, while the architecture, the set, would stay the same. In fact, it is the reverse.

How are we to explain this uniformity of posing? We cannot ascribe it to a lack of originality or invention on the part of the artist, because many of the compositions in this manuscript are unique, including the scene that we looked at earlier of Saint Anne receiving the news of her husband's arrival (fig. 140). A more satisfactory explanation lies in the status of the imagery; the one scene, the Annunciation of Christ's birth, was above nature, sacred, and immobile, even when the text of the sermons provided a series of elaborations on the Gospel text. The other scene, the Annunciation of the Virgin's birth, was more mundane; it could be elaborated by the painter even beyond the requirements of the sermon. Paradoxically, the less important the imagery, the richer it could be in detail, and conversely, the higher its status, the more it should be deficient.

Similar observations can be made if we turn from the Annunciations of the births to the Nativities themselves. Here, too, Byzantine artists found ways to express the contrasting status of the scenes, the antithetical content that underlay the pairs of images. Figures 146 and 147 illustrate the two Nativities as they are portrayed in the early-fourteenth-century frescoes of the so-called King's Church at Studenica. The two scenes are set one above the other on the south wall, the birth of Christ in the higher position (fig. 146) and the birth of the Virgin below (fig. 147). On first viewing, the pair of compositions at Studenica exhibit a kind of symmetry. In each fresco, the mother is at the center, sitting up on a bed. Below her, in the front plane of the picture, is the first bath of the child, while beside her are her visitors—the women with gifts attending the birth of the Virgin, the three Magi and the shepherds at the birth of Christ. But there is one very significant difference between the two scenes, which is literally at their core. We see that Saint Anne has to be supported after the childbirth; she cannot sit up on her own but has to be helped by two midwives. The Virgin, on the other hand, can lean forward without assistance, to embrace the head of her child as he lies in his crib. This is not an insignificant detail, for it was noted by Byzantine writers themselves when they described works of art. As early as the sixth century, the orator Choricius, describing a mosaic of the Nativity of Christ in the Church of

146. Studenica, King's Church, fresco: Nativity of Christ

147. Studenica, King's Church, fresco: Nativity of the Virgin

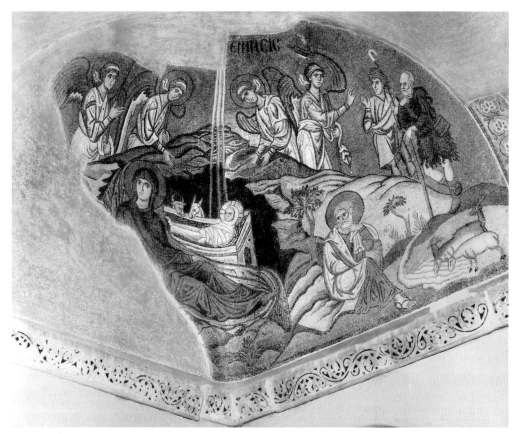

148. Daphni, monastery church, mosaic: Nativity of Christ

St. Sergius at Gaza, said that the image showed a Virgin who "has given birth to a child without recourse to union with a man. Her face," he went on, "is not altered with the pallor of one who has just given birth, and, indeed, for the first time; deemed worthy of a supernatural motherhood, she was justly spared its natural pains."[26] This passage was repeated, virtually verbatim, by a writer of the twelfth century, the monk John Phokas, who made a pilgrimage to Palestine and afterward wrote up a description of a mosaic of the Nativity of Christ that he saw in the grotto underneath the church at Bethlehem. According to John Phokas, not only did the Virgin in the mosaic show no signs of pain, but she was, in his own words, "looking toward the Babe, and displaying her inner discretion in her smiling form, and in the color in her cheeks."[27] So the contrasting depictions of the two mothers at Studenica—with and without the signs of earthly labor—clearly show the contrasting natures of the two Nativities, even while their overall compositions are symmetrical. In other Byzantine works of art the same contrast was

expressed in a more subtle manner. Thus, in the mosaic of the Birth of the Virgin at Daphni, Saint Anne raises her left hand to touch her chin, a gesture which in Byzantine art was a sign of grief or pain (fig. 134). The Virgin in the mosaic of the Birth of Christ makes no such sign of earthly travail (fig. 148).

We have seen, then, that there were profound differences between the ways in which Christian scenes were paired on the early Byzantine marriage ring and in post-iconoclastic art. The images on the ring exemplified an unofficial, domestic art that presented the male and the female sides of the life of Christ as a semi-magical equation, designed to insure marital harmony. The post-icono-clastic images, on the other hand, represented an art that was now more tightly controlled by the male clergy; its message was one of profound inequality between the two scenes in each pairing, an inequality whose implications involved theology, status, and gender. The images of the Virgin's infancy were more detailed and dramatic, and thus more temporal and earth-bound; those of Christ were more stripped down and hieratic, and thus more eternal and closer to heaven.

THE LIFE OF SAINT NICHOLAS

While the infancy of the Virgin was portrayed with some frequency in Byzantine art, the biographies of other saints were less common. Among the few saints whose lives were illustrated by Byzantine artists, the narratives of Nicholas and George were by far the most widespread. The relative popularity of Saint Nicholas may be ascribed to his being something of a generalist. Whereas other saints tended to specialize in their miraculous activities, as healers of the sick, for exam-ple, or as protectors of soldiers, Saint Nicholas provided help in a variety of situa-tions. He watched over travelers, he provided money to the needy, he expelled demons, and he helped people in trouble with the law. The range of his miracles, their frequently mundane character, and his indefatigable opposition to the force of envy in all its operations help to explain the effectiveness and popularity of his biographical scenes in Byzantine art.[28] The expectations that were placed upon the images of Saint Nicholas may be gauged from a poem attributed to Manuel Philes, in which a donor dedicates a church to this saint. The verses describe the church, which was probably painted with scenes from the saint's life, as "a common rem-edy of safety" and as "a sea of miracles flowing without envy."[29]

The role of Nicholas in solving earthly problems was linked to his role as an intercessor at the heavenly court, for the Byzantines believed that saints who had

a good record in solving problems in this world, who were known to have interceded with God successfully to block the machinations of demons, could also be expected to be effective at the Last Judgment, when the stakes were higher. Because the Byzantines believed that Saint Nicholas was an especially successful advocate at the court of heaven, the scenes from his life were often painted in association with tombs or penitential inscriptions.[30]

There are several extant written Lives of Saint Nicholas, the most important of which was the version by the tenth-century writer Symeon Metaphrastes. According to some surviving monastic liturgical rule-books, or *typika*, this version of the Life was recited at the morning service, or *orthros*, on the saint's feast day, which took place on the sixth of December. For example, the Metaphrastian Life is prescribed as a reading by the *typikon* of the Evergetis monastery, which was founded in the mid-eleventh century in the suburbs of Constantinople.[31] This typikon in its turn became the model for the liturgical instructions of several other Byzantine monasteries in the twelfth century.[32] Thus, the foundation typikon of the Monastery of St. Mamas in Constantinople, which was composed in 1159, requires that the liturgical calendar of the Evergetis monastery should be followed "completely" and without abbreviation.[33]

As was his custom, Symeon Metaphrastes wrote his biography of Saint Nicholas in a strongly rhetorical style, full of vivid and emotional detail. Metaphrastes described the settings of the various episodes at some length, giving a full account of the emotions of the participants as expressed through their dramatic gestures and speeches. When it came to the visual lives, however, Byzantine artists did little to emulate the drama of the text. In a conventional rhetorical introduction to his life of Saint Nicholas, Symeon Metaphrastes claimed that speech is more vivid than painting in presenting the accomplishments of the saints;[34] in this case at least, Byzantine art certainly confirms his observation. Although the contrasts between word and image are particularly striking in the Metaphrastian biography, the lives of Saint Nicholas written by other Byzantine authors also differ markedly from works of art. As a group, the written lives of Saint Nicholas are more detailed and more vivid than the visual.

Several comparisons illustrate the contrasts between the written and the painted versions of the saint's life. We may start with the well-known story of the saint saving three men who were victimized by envy and were consequently unjustly condemned to be executed. Symeon Metaphrastes precedes his account of these events by relating that the Emperor Constantine sent three generals to put down a revolt in Phrygia. On their way, the generals landed at a port near

Myra named Andriake, where Saint Nicholas entertained them. They were about to depart when

> certain of those in the city approached the saint and, falling headlong at his feet, heatedly begged him to defend those who had been wronged and demanded that he release them from their present misfortunes. "For the Governor Eustathios," they said with wailing and tears, "has been corrupted in his soul by money, by the slaves of envy and evil, and [now] punishes with death three men of the city who have done no wrong whatsoever. For these men, therefore, the city is piteously beating its breast and grieving, and in much sorrow calls for your presence. For had you been there, the sun would not have looked down upon such an abomination in the city."

When he heard this impassioned plea, the saint, followed by the three generals, hurried to the place of execution. There he discovered the following scene:

> He saw a big crowd standing around, and the [three] men, alas! with their hands tied behind them and with their eyes covered, already bent toward the ground, with their necks bare and stretched out waiting for the cut. A pitiful sight! A sight of suffering not to be borne! He saw the executioner himself with his sword already drawn, looking murderous and wild and showing the harshness of his impulses by the mere sight of him.

When Nicholas saw this situation, we are told, he acted swiftly and decisively. Approaching the executioner, he took the sword from his hands, threw it on the ground, and released the men from their bonds. Symeon Metaphrastes then describes the reactions both of the condemned men and of the spectators:

> As for those who had been saved, their joy moved them to warm tears, and they joyfully and repeatedly shouted aloud on account of their change of circumstances. The whole plain was a theater, and all shouted praises and broke out into loud cries on account of the sight that they had beheld.[35]

This text is remarkable for its recording of dramatic detail and especially of psychological reactions. To increase the vividness of the account, Symeon Metaphrastes tells how the saint reached the three men in the nick of time, and he records the emotional states of all the actors in the play, even of the executioner. The scene in the text is crowded with people: "The whole plain was a theater." Byzantine artists, on the other hand, drained this story of its drama and specificity, presenting only the barest outline of the events, as may be seen, for

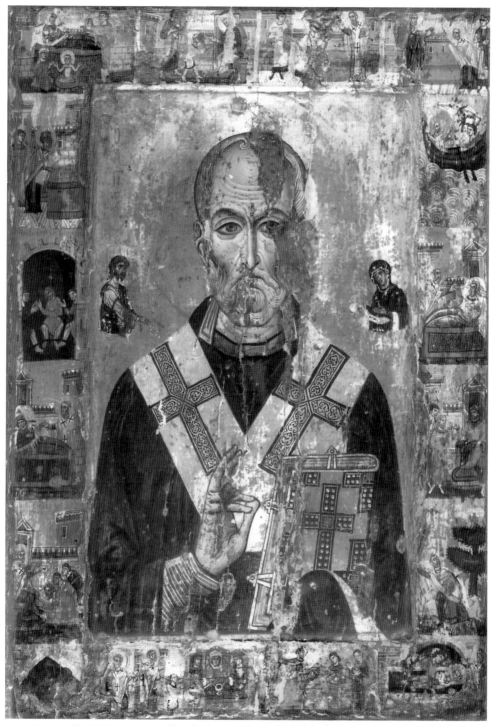

149. Mount Sinai, Monastery of St. Catherine, icon: St. Nicholas with scenes from his life

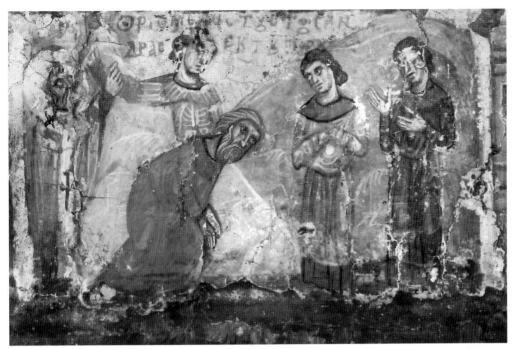

150. Mount Sinai, Monastery of St. Catherine, icon, detail: St. Nicholas saves three men from execution

example, in a painting of the scene which borders an early-thirteenth-century icon now preserved at Mount Sinai (fig. 149). This icon is of the so-called "biographical" type, which surrounds a central portrait of the saint with small scenes from his life. Here the story of the condemned men is reduced to only five participants (fig. 150). We see just the three victims, the executioner raising his sword to strike one of them, and the saint staying his hand. Some hills in the background hint that the action is taking place outside of the city, but in other respects the setting is generic and vague. The witnessing crowd and the three generals, who play such a prominent part in the texts, are completely absent.

The omission of these details is not simply due to the small scale of the painting on the icon, for there is a similar lack of specificity in large-scale paintings of the scene. Even in the Palaiologan period, when styles of Byzantine painting were more illusionistic and richer in detail, the episodes from the life of Saint Nicholas retained their spare and stripped-down quality. For example, the early-fourteenth-century frescoes at Staro Nagoričino present a striking contrast between the scene of Nicholas saving the three men, portrayed in the diaconicon (fig. 151), and the Crucifixion of Christ, shown in the nave (fig. 152). Once

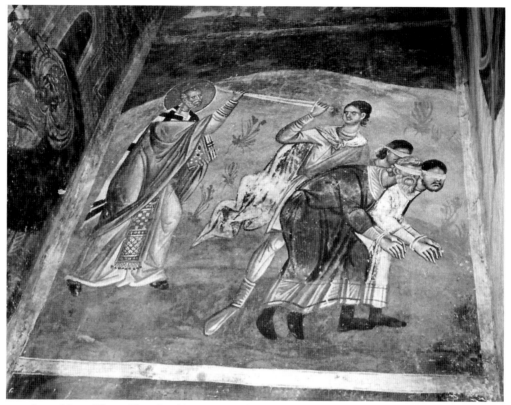

151. Staro Nagoričino, Church of St. George, fresco: St. Nicholas saves three men from execution

again, in the narrative from the life of the saint, only the five principal characters are shown, against the simple backdrop of a hill. In the painting of the Crucifixion, on the other hand, large crowds of subsidiary players throng the stage alongside the principal actors, including Jews, disciples, holy women, and soldiers. Moreover, the fresco clearly indicates the setting of the Crucifixion on a hill outside the walls of the city. In this painting we truly see what Symeon Metaphrastes described as a "theater," whereas in the fresco of Saint Nicholas we are given only a diagram.

For another opposition of text and image, we may consider the episode of the three generals in prison, which follows the story of Saint Nicholas saving the three men from execution at Myra. Again, the Metaphrastian life tells the tale with a great deal of drama and emotion. It relates how the three generals, having left Myra, went on to Phrygia to settle affairs there, and then returned to Constantinople, where they were extravagantly received by the grateful emperor

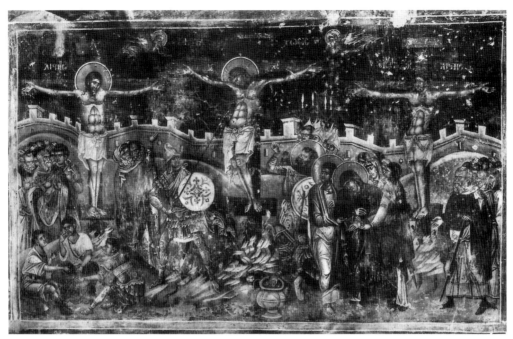

152. Staro Nagoričino, Church of St. George, fresco: Crucifixion of Christ

Constantine. But, as in the case of the the three condemned men, the evil eye of
envy struck again: "Envy did not intend to put up with this (good fortune), or
allow that it should be tolerated by the eyes of the envious." Certain men, says
the text, approached Ablabius, the eparch of the city, and told him that the three
generals had been plotting against the emperor. They reinforced their story with
bribes, with the result that the eparch went to the emperor and persuaded him to
throw the three generals into prison. After a while, the eparch, yielding to further
pressure from the envious men, persuaded Constantine to order the execution of
the generals. There followed a touching scene in the prison:

> It was determined, then, that they should die on the following day. The
> decree had been given in the evening. And the unlucky messenger of the
> judgment had come to the jailer and had made known to him everything
> concerning his prisoners. But the jailer, having earlier lamented much at
> their fate by himself—for he was, it seems, much softer-hearted than the
> eparch, and besides had become friendly and familiar with them—grieved
> for the men, and went to them and said: "Would that I had never started to
> speak with you, nor that you had spent so much time with me, nor that I
> had shared your table and your food. For then more easily would I submit to

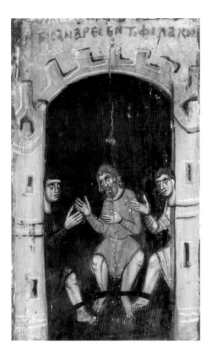

153. Mount Sinai, Monastery of St. Catherine, icon,
detail: The three condemned generals in prison

my ill fortune, and less would I feel pain at our separation, nor would suffer-
ing so touch my soul. For tomorrow we are parted from each other—the
bitter, alas! and final separation. Nor will I see any more the longed-for sight
of you, nor will I hear your voices, nor will I have set before me our com-
mon bread. For you have been ordered to be killed. . . ."

He spoke thus, lamenting, and bitterly mourning their death. But as for
them—how would a soul react to this when it was conscious of nothing
worthy of death? They tore off their clothing and wretchedly pulled out
their hair. "Which demon," they said, "envied us our life? To what end will
we submit to the death of criminals? What have we done to merit death?"
They called on their kinsmen by name, they called on God to witness their
present situation, they imagined their death already before their eyes.[36]

Fortunately, one of the generals, Nepotianus, collected himself sufficiently to
remember how Saint Nicholas had saved the three men from execution at Myra.
The three generals called for aid to the saint, who appeared to Constantine that
night in a dream and ordered their release.[37]

Once again, we may observe that Byzantine artists illustrated very little of the
theatrical detail provided by the texts. The painting on the early-thirteenth-century
icon from Mount Sinai simply shows three men sitting in prison, their feet bound

154. Rome, Vatican Library, MS gr. 1754, fol. 6r *(Penitential Canon)*: Penitent monks

by iron fetters (fig. 153). The supportive guard of the written lives is nowhere to be seen. The condemned generals raise their hands in what may be interpreted as a sign of appeal and their faces are doleful, but they make none of the gestures of grief and despair so vividly described by Metaphrastes; there is no ripping of garments, no tearing of the hair. Yet such gestures were certainly part of the vocabulary of contemporary Byzantine artists in other contexts, as is proved, for example, by the depictions of penitent monks in an illuminated copy of the *Penitential Canon* preserved in the Vatican Library. One of the paintings in this manuscript shows the penitents pulling at their hair and clothes in a demonstration of despair equivalent to that described by Symeon Metaphrastes (fig. 154).

If we turn from the small-scale painting of icons to the monumental art of frescoes, we find that here too Byzantine artists were singularly undemonstrative in their portrayal of the three condemned generals. For example, in the early-fourteenth-century fresco in the Church of the Koimesis at Gračanica (fig. 155), the three generals sit passively in jail, making little display of mourning other than to cup one hand against the cheek (the prisoner on the right) or to spread the palms (the prisoner in the center). Although the fresco at Gračanica is now incomplete, it is very likely that originally the guard was omitted, because he almost never appears in this scene in Byzantine art. In contrast, the contemporary fresco of the Lamentation over the dead Christ in the same church (fig. 156) depicts a large crowd of mourners abandoning themselves to their grief, throwing their arms up into the air or tearing at their hair, while the Virgin Mary herself succumbs to a swoon. Thus the Lamentation over Christ is thronged with dramatic actions, while the three generals sit passively in their prison cell. Since the Lamentation is not described in the Gospels themselves, but only in the hymns, sermons, and apocrypha of the Byzantine church, we see that this scene provides more actors than the canonical story requires, while the painting from the saint's life provides less.

A similar lack of detail is found in the illustration of other stories from the life of Saint Nicholas. A particularly striking example is the well-known episode concerning the poor man with three daughters. According to the saint's biographers, this man could not afford dowries for the maidens and was about to put them to work as prostitutes. Saint Nicholas came to the man's aid by stealthily throwing a bag of gold through the window of the pauper's house as he slept, thus providing a dowry for the first of the daughters. He repeated this act of kindness for the second and the third maidens.[38] It is remarkable that in some of the visual versions of this story, the three daughters are completely omitted. For example, on an eleventh-century icon

155. Gračanica, Church of the Koimesis, fresco: The three condemned generals in prison

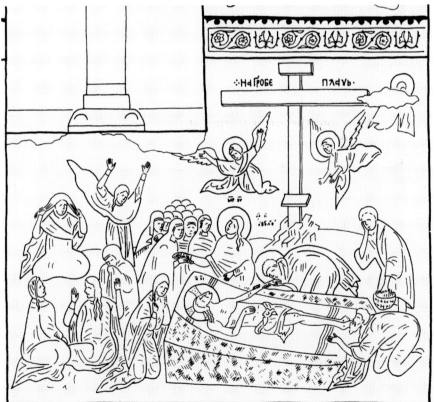

156. Gračanica, Church of the Koimesis, fresco: Lamentation over Christ

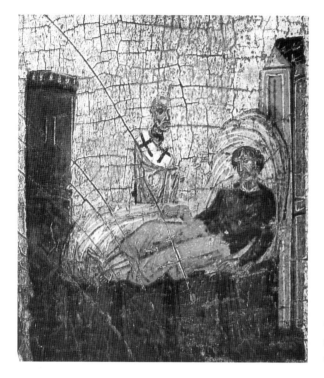

157. Mount Sinai, Monastery of St. Catherine, icon, detail: St. Nicholas aiding the pauper with three daughters

at Mount Sinai, which preserves some of the earliest surviving illustrations of the life of Saint Nicholas, we simply see the pauper lying in bed, with Saint Nicholas standing beside him holding out a bag of money (fig. 157). Although the poverty of the sleeper is indicated by the fact that he has no shoes, the three young women are nowhere to be seen. Again, the omission of some of the major actors in the story is not due merely to the small scale of the painting, for in the mid-thirteenth-century fresco in the Church of St. Nicholas at Bojana in Bulgaria, the daughters are also left out of the picture (fig. 158).

Another story that received a minimalist treatment from artists, while it was told in much greater detail in the texts, is that of Saint Nicholas felling the cypress tree. The biographies relate that near the village of Plakoma, in Lycia, there was a big cypress tree that harbored a dangerous devil. The villagers pleaded with Nicholas to cut down the tree. He came and began to chop at the tree with his axe, while a large crowd watched. Moved by the devil, however, the tree started to fall on the spectators, and disaster would have ensued had not the saint grasped its trunk and made it fall in the opposite direction.[39] In some Byzantine works of art, this story is reduced to the lone figure of the saint cutting down the tree. On the early-thirteenth-century icon at Mount Sinai (fig. 159) the crowd is completely omit-

158. Bojana, Church of St. Nicholas, fresco: St. Nicholas aiding the pauper with three daughters

ted; the saved spectators are also absent from the fresco at Staro Nagoričino (fig. 160), although here the artist has added the devils fleeing from the upper branches of the tree.

It can be seen, then, that in Byzantine art the lives of Saint Nicholas and the Virgin stood in opposite relationships to the life of Christ. Whereas the infancy of the Virgin was portrayed as more detailed and more earth-bound than that of her son, the life of Saint Nicholas was less detailed and more schematic. As was the case with the portraits of the saints, these distinctions between their biographical narratives carried messages about the scheme of salvation and the relative positions of the saints within it. The narrative of Christ's birth, in contrast to that of his mother, showed his divine and superhuman nature. Compared with Saint Nicholas, however, Christ's humanity was revealed, and thereby also was demonstrated the superhuman nature of the saint.

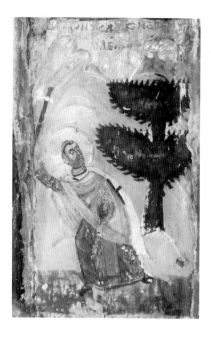

159. Mount Sinai, Monastery of St. Catherine, icon,
detail: St. Nicholas felling the cypress tree of Plakoma

In addition to this binary coding of status, the distinctions between Christ and
his saints also had an important psychological dimension. The visual lives of
Christ and of Saint Nicholas had very different demands put upon them by the
viewer, and accordingly they took different forms. We have seen that the mortal
nature of Christ was emphasized in Byzantine art through the creation of dra-
matic scenes of Christ's passion (figs. 152, 156). Such scenes reached their full
development in the early fourteenth century. The purpose of these theatrical por-
trayals of Christ's death was both theological and functional. In theological terms,
they conveyed the dogma of Christ's humanity, while in functional terms their
vivid emotional content served to make the incarnation more accessible to view-
ers, thus bringing Christ closer to them as a focus for prayers. A poem in a four-
teenth- or fifteenth-century manuscript in the Vatican Library shows how a
painting of the Passion of Christ could engage the emotions of the Byzantine
viewer as an assurance of the mercy of Christ. The epigram, which is entitled
"On the Entombment," is in the form of a question from the viewer and of
Christ's response. The viewer asks:

Alas! What is this [event]?
Do even You die, my Christ,
You who have given breath and the measure of life to all?

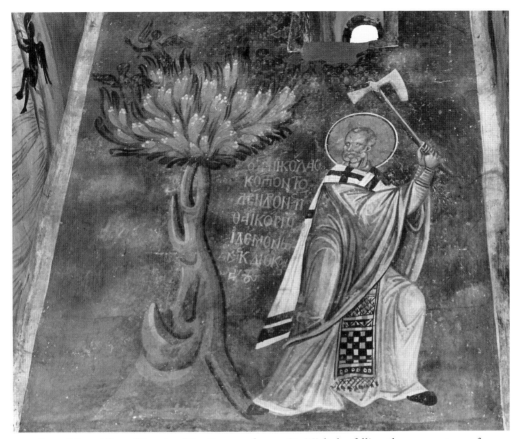

160. Staro Nagoričino, Church of St. George, fresco: St. Nicholas felling the cypress tree of Plakoma

Christ replies:

I die as a man, but willingly.
But let me raise Adam from decay and corruption,
and let me come once more to the breadth of Paradise.
Praise, therefore, my compassion.[40]

In other words, the viewer has empathy with the death of Christ ("Alas! . . . Do even You die?"), and, at the same time, Christ's condescension to mortality proves his compassion.

From other sources, we know that the reenactment of Christ's death in the Byzantine liturgy increasingly became a focus for personal penance and contrition.[41] Thus, in the early fourteenth century the Patriarch Athanasios I encouraged the people of Constantinople to assemble at the Holy Saturday ceremonies "with

appropriate contrition and fear and love and tears, so that we may quench tears with tears."[42] In another letter on the same subject, addressed to the emperor, he compares the congregation to the holy women at Christ's tomb, saying:

> Your subjects . . . will witness with compassionate soul what was done by the men of that time through an inhuman and murderous impulse, and share the sorrow of the ever-Virgin mother of God . . . and they should not simply depart, just as a spectator interested in watching divine spectacles, but should rather remain and "bring precious ointments," in the hope that they may [themselves] see the stone rolled away.[43]

Here, then, the patriarch insists that the people should attend the services not just as observers but as participants; they should share the sorrow of the Virgin; they should come with their own tears of remorse. As in the liturgies celebrating the life and death of Christ, so also in the visual narratives Byzantine artists sought more and more to engage the viewer in the passion of the moment, through scenes that were dramatic and full of feeling.

The engagement of Byzantine beholders with images of the life of Saint Nicholas, however, took a completely different form. We can discover how fourteenth-century viewers reacted to these scenes from a poem attributed to Manuel Philes, which was probably inscribed upon an icon of Saint Nicholas to which a gilt silver revetment had been added. The poet declared:

> Let anyone who wishes boast simply
> in abounding possessions, money, and glory.
> But I, O blessed one, am fortunate in your image,
> in which, being all but alive, you work wonders without envy. . . .
> Therefore, receive from us the golden adornment,
> together with the stones set in it.
> For with the invisible ring of your prayers,
> and with the spiritual stones of your miracles,
> you force away from us the hidden wolves.[44]

The gilded revetment that had been donated to this icon of Saint Nicholas, therefore, was studded with jewels, which the poet compares to an invisible ring of the saint's prayers and also to an implied ring of his miracles. The writer claims that Saint Nicholas works his wonders without envy; the ring of his prayers and his miracles have the power to ward off invisible dangers.

The language of the poem helps us to see how an early-fourteenth-century

viewer might have regarded the circle of abbreviated biographical scenes sur-
rounding Saint Nicholas on the panel at Mount Sinai (fig. 149), as well as on later
biographical icons of the saint. These scenes were not so much narratives, designed
to engage the emotions of the beholder, but rather reiterated assurances of protec-
tion from a saint who was a powerful recourse against envy and the evil eye. As
such, the generic quality of the scenes made them more useful because, to put it
simply, the less specific the image was, the greater the number of situations it could
apply to, and the more people could relate to it. The generalization of each mira-
cle scene expanded its range of reference and thus its relevance to viewers.

As we have seen, Saint Nicholas specialized in getting people out of mundane
troubles, and the visual scenes of his life were paradigms of such situations, rather
than illustrations of specific events. In the case of the poor man with three daugh-
ters, for example, one could say that many people might lie in bed at night wishing
that they had more money, but not everyone had three daughters. Therefore, the
painting had wider relevance for the average viewer if the three young women
were omitted (figs. 157, 158). The explanatory inscriptions accompanying this
scene in Byzantine art often bear out the generic nature of the image. For exam-
ple, on a biographical icon of the fifteenth century at the Monastery of St. John
on the island of Patmos, we find a trenchant legend that reads, in its entirety:
"Bringing the money."[45] Likewise, in the scene of the three generals in prison, the
artists needed only to show enough detail to identify their overall circumstances,
namely that they had been badly treated by the law. But it was not necessary, or
even desirable, to engage the viewer's sympathies with these particular victims, for
very few of the beholders would be generals. It was only necessary to evoke the
overall circumstances of the miracle, which promised that anyone who found him-
self unjustly accused or in legal difficulties could be helped. Here, again, the
inscriptions attached to the scene were frequently nonspecific in character. On the
icon at Mount Sinai, for example, the three generals were described simply as
"The three men in the prison" (fig. 153).[46] As for the miracle of the cypress tree,
the main point of the story was not that the saint saved the particular crowd that
turned out to watch the spectacle, but that he was effective at driving out demons
wherever they might be. Accordingly, the inscription on the icon at Mount Sinai
reads: "The saint chasing the demons from the tree" (fig. 159).[47] On another bio-
graphical icon, at the Church of St. Nicholas tis Stegis at Kakopetria on Cyprus,
the legend accompanying the scene reads only: "The saint chasing away the
demons."[48] Like the images, the inscriptions got to the point.

In summary, the scenes from the life of Christ and of Saint Nicholas had differ-

ent demands put upon them, resulting in different modes of presentation. The scenes of Saint Nicholas were reiterated assurances of help in different mundane situations, to which a generic character was appropriate to insure the breadth of their appeal; hence these images were drained of their specificity. The scenes from the passion of Christ, in contrast, worked in the opposite direction. They were intended to engage the emotions of the viewer in contemplating the specific circumstances of the incarnation as an assurance of Christ's accessibility to human prayer and to the intercession of the saints. To achieve this end, Byzantine artists who illustrated the life of Christ created a more participatory art, which in many respects was more detailed than the Gospel text. The same artists, however, when illustrating the life of Saint Nicholas, ignored the dramatic details provided by his biographers.

THE LIFE OF ST. GEORGE

The life of Saint George, like that of Saint Nicholas, was depicted with relative frequency in Byzantine art.[49] In their manner of presentation, the two biographies shared some similarities, for both tended to be more schematic and less detailed than depictions of the life of Christ. But with respect to content, the lives of Saint George and Saint Nicholas had different characters. The emphasis with Saint Nicholas was placed on his mundane miracles, but with Saint George the stress was put on his repeated tortures and miraculous survivals. The miracles performed by Saint George in aid of others were not omitted from the visual record, but they were balanced by the reiterated scenes of his own suffering, which often echoed each other in their formal composition. It is this last aspect of the scenes from Saint George's life that concerns us here. How did their repetitious and formulaic nature benefit the Byzantine viewer?

As a martyr, Saint George was an imitator of Christ. Just as the Gospel related that Christ was resurrected on the third day from Hell, the biographies of Saint George reported that he was placed in a pit of caustic lime for three days but emerged from it alive.[50] Several writers claimed that like Christ, Saint George was finally put to death on a Friday.[51] In some instances, scenes of the tortures and martyrdom of Saint George were intentionally juxtaposed with the Passion of Christ. In the early-fourteenth-century frescoes of the church of St. George at Staro Nagoričino, for example, the two narratives were set in parallel, running around the walls of the nave, one beneath the other (fig. 161). Each biography concludes with the death of its protagonist, the beheading of Saint George being

161. Staro Nagoričino, Church of St. George, frescoes on the south wall: The Passion of Christ and of St. George

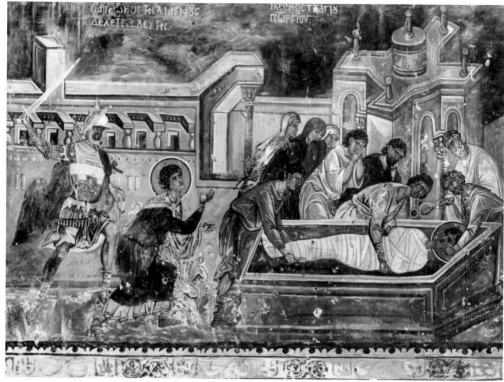

162. Staro Nagoričino, Church of St. George, fresco: Death and burial of St. George

shown at the eastern end of the north wall of the nave (fig. 162), directly beneath the Crucifixion of Christ, which appears in the register above (fig. 152).[52]

In spite of such juxtapositions, Byzantine artists portrayed the narratives of Christ and of his martyr in significantly different ways. A striking characteristic of the illustration of Saint George's tortures and martyrdom is the reiteration of similar, but not identical, schematic compositions. This effect of a litany can be found, for example, on a thirteenth-century biographical icon preserved at Mount Sinai, where several of the saint's tortures are presented according to the same formula, though they are carefully distinguished by the Greek inscriptions (fig. 163). If we read the scenes around the frame of the icon, starting in a clockwise direction from the top right-hand corner, we see that each torture of the saint follows a like pattern, with the saint in the center being flanked by two symmetrical executioners, whether he be beaten with whips, buried in a pit of caustic lime, scraped by iron hooks, crushed under a stone, broken on a wheel, or burned with torches. As in the case of Saint Nicholas, the artist omits many of the distinctive details given in the written Lives; thus he shows neither the angel who miraculously cured

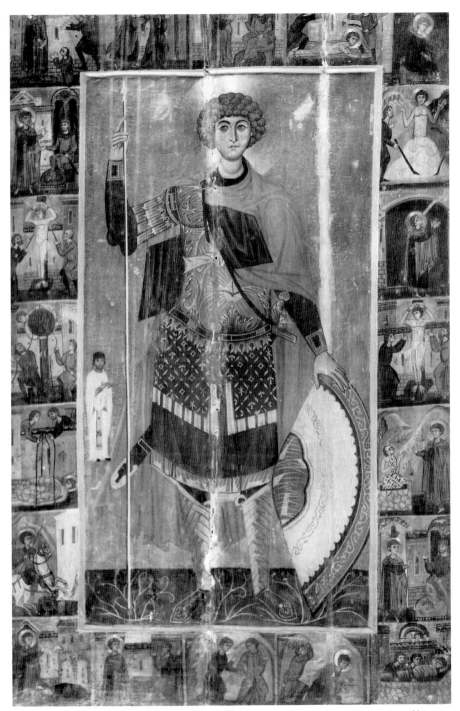

163. Mount Sinai, Monastery of St. Catherine, icon: St. George with scenes of his
miracles and martyrdom

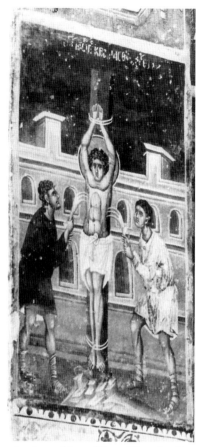

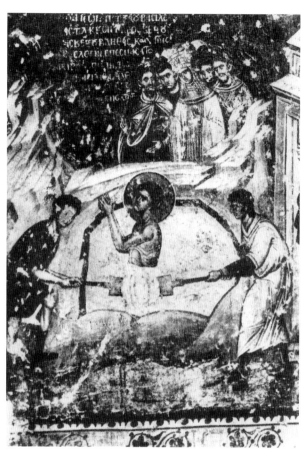

164. Staro Nagoričino, Church of
St. George, fresco: St. George being
scraped with iron claws

165. Staro Nagoričino, Church of St. George, fresco: St.
George being buried in a lime pit

George's wounds after he had been broken on the wheel,[53] nor the angel who
accompanied the saint and protected him while he was in the pit of lime.[54] Even
among the wall paintings in the Church of St. George at Staro Nagoričino, which
are much larger in scale and richer in detail, there is a tendency to repeat similar sim-
plified compositions. For example, the paintings of the scraping with iron claws and
of the burial in the lime pit both make use of the same basic symmetrical scheme,
showing the saint standing half naked between two executioners who attack him
from either side with matching instruments of torture (figs 164, 165). At Staro
Nagoričino, these two stark scenes from the life of Saint George make an especially
striking contrast with the Mocking of Christ, which is portrayed in the register
above. The latter episode, though it is also symmetrically composed, presents a

166. Staro Nagoričino, Church of St. George, fresco: Mocking of Christ

complete throng of jeering characters surrounding Christ, varied in pose, age, and costume, and including musicians as well as dancing boys with flapping sleeves (fig. 166). Simplified and formulaic images of the sufferings of Saint George can be found in several other Byzantine churches, the compositions being varied only by the substitution of different means of punishment.

On the icon at Mount Sinai, as at Staro Nagoričino, the scenes of George's tortures are accompanied by others which illustrate his helping miracles, such as the killing of the dragon (second from the bottom on the left side of the frame in fig. 163), the resurrecting of a dead man (third from the bottom on the right side of

the frame), and the restoring to life of a poor farmer's ox (second from the left at the bottom). Together, the portrayals of George's torments and of his miracles illustrate a principle of reciprocity that was fundamental to the Byzantine mentality but is alien to modes of thinking today. The repeated sufferings of the martyr, God's miraculous interventions on his behalf, and his own miracles performed on behalf of others were all assurances to the donor or the viewer of Saint George's closeness to God, and of the effectiveness of his intercessions. One preacher of the seventh century, Arcadius of Cyprus, begged the saint:

> Since, O martyr, soldier, attendant, and friend of Christ, you have enjoyed much grace and freedom to speak with Him (*parrēsia*), . . . all of us faithful now habitually beseech you: "Become priest for us sinners who do not enjoy the freedom to speak with the Lord, pray as our champion on behalf of the Christian folk who are piteously, but justly, chastised, do not cease to say continuously together with all the saints: 'Spare your people, O Lord.'"[55]

Hence at Staro Nagoričino, on the icon at Mount Sinai, and elsewhere in Byzantine art, the tortures of the saint were interspersed with his helping miracles, for the martyr's successful endurance of many trials assured the effectiveness and frequency of his interventions for the benefit of others. This equation of repeated tortures and repeated miracles, both already performed and anticipated, was expressed by a donor's inscription accompanying a life of Saint George painted in the church of the Anargyroi at Kastoria. Here the late-twelfth-century frescoes, which are in the north aisle of the church, depict the torments of the saint together with his miracles, such as the saving of the king's daughter from the dragon. The inscription, which is now incomplete, begins:

> You were already painted in my heart,
> much suffering martyr, with mystic tints of longing.
> And now with more material colors
> I paint the pictures of your miracles,
> through which you warded off many. . . .[56]

Many sufferings, therefore, meant many miracles. The reiteration of similar images of torture brought reassurance to the Byzantine viewer of repeated benefits.

The saints, of course, could not work their miracles without God. As in the case of Saint Nicholas, the abstraction of Saint George's biographical images was a demonstration of the saint's special closeness to the divinity. The lives and encomia of Saint George emphasized the constant and unchanging power of God

that enabled the repeated triumphs of the saint over his opponents, the power that preserved his body unharmed in the lime pit, that kept him uncrushed by the stone, and that sent an angel to rescue him from the wheel. The biography of the saint by Symeon Metaphrastes, after recounting his miraculous survival in the lime pit, has the saint address his tormenter, the Emperor Diocletian, with the following words: "Let it be plain to you, O emperor, that Christ himself, the Son of God, overshadows me, and all those who believe in Him, with His invisible wings, and saves us from every kind of harm."[57] At the end of the biography, Symeon Metaphrastes concludes that God's pledge of assurance was undying through all of the martyr's tortures, just as it will be for all believers:

> Wherefore he [Saint George] took the crown, not a mortal crown, extended by the right hand of a mortal, but an immortal crown from an immortal, a right hand that not only crowned him, but fought with him in his former trials, and participated with him in his contests. For the power and the glory is Christ's, with the eternal Father and with the life-giving Spirit, now and forever, for ages upon ages.[58]

The unchanging character of the saint's tortures in Byzantine art, the relative sameness and lack of detail in the compositions, and their lack of temporal specificity all carried a positive message for Byzantine viewers, for the power that sustained the saint was seen to be constant and eternal, for him as for them.

Nevertheless, even while the power of the martyrdom scenes was enhanced through the repetition of similar formulas and compositions, the artists took care not to reproduce images that were exactly the same, for each torture was clearly distinct. The visual narratives of the martyr saints, with their re-echoing scenes of trials and tortures, could function as recurring assurances of aid from the same saint, but they were not to be confused with identical magical signs, endowed with the ability to act in their own right.

CONCLUSION

In this chapter we have seen many of the factors that controlled the composition of the saints' lives in Byzantine art. The visual narratives of the saints were defined in relation to each other, and to that of Christ. Since Christ was portrayed as both divine and human, his life could play a double role in a series of binary oppositions. The life of the Virgin was shown as more detailed and earthbound, and thus in our terms more "realistic," than that of her son. Thereby

Byzantine artists simultaneously revealed the special divine status of Christ and also, by extension, his human nature, since the Virgin was, of course, his mother. The painted lives of Saints Nicholas and George, on the other hand, were less detailed than that of Christ; they were more "abstract," whether in terms of their relative lack of emotiveness, incidental detail, or variety of composition. By means of their deficiency, the superhuman status of these saints was revealed. At the same time, the paradigmatic and reiterative qualities of these hagiographic images enabled them to act more effectively as assurances of the beholder's safety in the perils of this world and of the next.

It is apparent, therefore, that narrative art and narrative literature followed different rules. In the realm of literature, a feast day, whether celebrating a saint or an important event in the life of Christ or the Virgin, called for a biography or a panegyrical sermon, elaborated with appropriate rhetoric and drama, to be read out once a year on the occasion that was being celebrated. In art, however, the images were potentially visible all at the same time and all year round. Consequently, they were coded according to the relative status of their subjects and adapted to the continuing devotional needs of their viewers. Thus, while the texts might in each case be rich with a variety of earthly incident and drama, the works of art depicting the same stories were not necessarily so. The texts always had the potential to provide artists with the inspiration for specific details, but the choice of whether or not to illustrate those details was both a theological and a functional one, dictated by the particular role played by the subject of the image in manifesting the doctrine of the church and in satisfying the expectations of the viewer.

CONCLUSION

The subject of this book has been the anatomy of Byzantine art, both in the literal sense of the saints' bodies and in the metaphorical sense of the logic that controlled their images. The first two chapters analyzed the Byzantine conception of sacred portraiture as it was developed in the centuries after iconoclasm. We saw that the aim of Byzantine artists was to define all the saints as closely as was necessary, in the first place by assigning every individual to a recognizable category, such as apostles, bishops, monks, and soldiers, each category being distinguished by means of the saints' attributes of costume and formal values. Second, within each category every important saint was further defined by portrait type, and all saints were identified by name. The Byzantine notion of true and lifelike portraiture did not correspond to our ideas of realism, for their purpose was only to define the saint sufficiently for recognition, not to create an optical illusion. The system of differentiation—between categories of saints according to their attributes and formal qualities, between individuals according to their portrait types—remained constant over the centuries, even while period styles changed. It was like a tune that could be transposed into different keys. The veracity of the portraits was constantly confirmed by dreams and visions, which in their turn were confirmed by the icons. Thus, both the visions and the paintings were artificial constructs, belonging to the domain of Byzantine art.

The second chapter argued that the formal characteristics that we associate with illusionism and spontaneity in portraiture, such as modeling and movement, were either employed or withheld by Byzantine artists in order to distinguish between the categories of saints according to their natures, whether corporeal, as in the case of soldiers and witnesses to the incarnation of Christ, or incorporeal, as in the case of ascetic monks and bishops. For the Byzantines, flatness and rigidity, signifying immateriality and immobility, composed a true and accurate definition of the natures of ascetic saints, while motion and roundness displayed either the vigor and strength of the holy warriors or the materiality of those who participated in the earthly life of Christ.

The third chapter showed how the post-iconoclastic conception of sacred portraiture, and the forms that icons consequently took, were conditioned by the perceived functions of the images. Earlier images of saints in Byzantine art, especially in domestic contexts, had been viewed and used by many people as potent

signs with powers to work in their own right; consequently, they did not need to be identified by inscriptions (that is, tied to any particular holy personage outside of the image itself), and they could be repeated for maximum effect. After iconoclasm, however, the images were seen only as channels of communication, so that now the powers were vested not in the images themselves but in the saints that they portrayed. Consequently, each icon had to be an accurate portrait of a particular saint, without ambiguity or superfluous repetition.

The fourth chapter moved from the portraits of the saints to their biographies, showing that there were also formal distinctions between the visual narratives of their lives, especially in relation to the life of Christ. The infancy of the Virgin was presented as a gendered counterpoint to the infancy of her son, the greater richness of earthly detail in Mary's life throwing into relief the divinity of Christ. Conversely, the lives of the popular Saints Nicholas and George were less detailed than that of Christ, as an expression of their superhuman status and of the multivalency and multiplicity of their interventions in human affairs. In the visual lives of the saints, as with their portraits, artists presented a series of binary oppositions, each pair of contrasts carrying messages for the viewer.

Both the forms of Byzantine icons and their roles in society have been the subject of this study. However, this has not been a book about art in society but about society in art. The objects themselves, their formal design, and their manner of presentation have been the focus; the surrounding matrix of beliefs and practices has been investigated only insofar as it throws light upon the appearance of the objects. If we have touched upon questions of theology, cult, magic, and gender, these have been ancillary to our main purpose, which has been to explain why Byzantine works of art took the particular forms that they did.

Nevertheless, our findings are not without relevance to the broader issues of art in society because there was always a two-way interchange between the artwork and the viewer. The distinctions that we have observed between different categories of saints with respect to the formal characteristics of their portraits and of their visual lives demonstrate that their images in art were intended to engage the beholder in different ways, and that there was a continuous dialogue between viewer and image. If the conversation had been only on the part of the viewer, that is, if it had been simply a monologue, there would have been no point in the artists varying the images. The paintings of all Byzantine saints could have shared exactly the same formal characteristics, and it would have been the task of the viewer to provide the variation through changes in his or her response. But in Byzantine society the role of images was more active; they themselves were var-

ied in their formal attributes, in order to *provoke* different responses from the viewer. The flattened images of the monks and the robust portrayals of the warrior saints evoked different responses, partly because of the viewer's expectations, and partly because of the design of the images themselves. Likewise, a Byzantine painting of the Lamentation over Christ would not engage the viewer in the same way as the lamentation of the three generals condemned unjustly to execution. The one scene, detailed and charged with emotion, was designed to involve worshipers as participants in the moment of Christ's death, to draw them into that particular drama, which was an assurance of their salvation. The other scene, the plight of the three generals, abstracted and drained of detail, was intended to lead viewers out of that particular situation, to reassure them of the help of Saint Nicholas in all cases of injustice, whatever the precise circumstances. The viewers' expectations conditioned the forms of the images, and the forms of the images, in their turn, encouraged the viewers' expectations.

The expectations of Byzantine viewers in front of their images went beyond emotional response to issues of power and control. The repeated, undefined, and anonymous images on an early Byzantine tunic or bowl worked for the beholder in ways that were completely contrary to the closely defined portraits of the post-iconoclastic period. Even though the viewer's hoped- for physical benefit might often be the same, whether it was health, safety, or success, the means of getting there was very different. In the former case, it was by the direct operation of the image, in the latter case, through the mediation of intervening powers, through the depicted saint, through his overlord Christ, and through Christ's earthly ministers in the church. In the case of the early Byzantine image, more control was retained by the user; in the case of the post-iconoclastic icon, the viewer was at the mercy of his or her intermediaries.

Thus, the change in artistic forms signaled an important shift from using to viewing and a significant loss of control for the individual who sought the benefits. The loss of control was especially significant for female viewers. In the domestic art of the early Byzantine period, women retained a significant degree of power over both the imagery and the results of its use. We have seen that in the mosaics of S. Vitale it was Theodora who was depicted wearing the Three Magi embroidered onto the hem of her robe (fig. 108), while on the early Byzantine marriage ring the two genders appeared balanced in a state of harmonious equality (figs. 127-131). In the later period, both the forms of the images and the channels of communication with the supernatural powers were more tightly controlled by the male clergy. In the final centuries of Byzantium, it was the clergy,

167. Moscow, Kremlin Museums: "Minor Sakkos" of the Metropolitan Photios

not the lay people, who wore the magnificent costumes elaborately embroidered
with Christian images and scenes, as can be seen from the richly figured "Minor
Sakkos" of the Metropolitan Photios, a Byzantine vestment of the fourteenth
century with later Russian additions (fig. 167). In the post-iconoclastic period of
Byzantium, Christian imagery played a reduced role in the decoration of house-
hold objects, and when it did appear there, as in jewelry, it tended to follow the
iconographic prescriptions of the church, including the adherence to established
portrait types and the provision of inscriptions (fig. 126). The later images of the
saints worked by intercession, not by coercion, a shift that did not so much mark
a change from "magic" to "religion" as a shift from lay to ecclesiastical control.
The church, therefore, was ultimately successful in monitoring the use made of

images, not only by the "foolish old women" about whom the early fathers complained, but also, in an important sense, by all laymen and women.

There is one final conclusion that emerges from the texts and images presented in this book. To understand both Byzantine art and its reception, it is necessary to look at its formal values. There can be no history of Byzantine art, nor of art in Byzantium, without an understanding of its forms.

ABBREVIATIONS

Acta SS: *Acta Santorum.* 71 vols. Paris, 1863-1940.

PG: Patrologiae cursus completus, Series graeca, ed. J.-P. Migne. 161 vols. Paris, 1857-1866.

PL: Patrologiae cursus completus, Series latina, ed. J.-P. Migne. 221 vols. Paris, 1844-1880.

NOTES

Preface

1. A. Kazhdan and H. Maguire, "Byzantine Hagiographical Texts as Sources on Art," *Dumbarton Oaks Papers* 45 (1991).

2. Paul J. Alexander, "The Iconoclastic Council of St. Sophia (815)," *Dumbarton Oaks Papers* 7 (1953), 62, no. 28.

Chapter 1

1. On portraiture in Byzantium, see, in general: H. Belting, *Bild und Kult: eine Geschichte des Bildes vor dem Zeitalter der Kunst* (Munich, 1990), and its English translation *Likeness and Presence: A History of the Image before the Era of Art* (Chicago, 1994); A. Cameron, "The Language of Images: The Rise of Icons and Christian Representation," in *The Church and the Arts*, ed. D. Wood, (Oxford, 1992) (= *Studies in Church History* 28), 1–42; G. Dagron, "Le culte des images dans le monde byzantin," in *Histoire vécue du peuple chrétien*, I, ed. J. Delumeau (Toulouse, 1979), 133–60 (repr. in G. Dagron, *La romanité chrétienne en Orient* [London, 1984], no. 11); idem, "Holy Images and Likeness," *Dumbarton Oaks Papers* 45 (1991), 23–33; idem, "L'ombre d'un doute: L'hagiographie en question, VIe–XIe siècle," *Dumbarton Oaks Papers* 46 (1992), 59–68; idem, "L'image de culte et le portrait," in *Byzance et les images*, ed. J. Durand (Paris, 1994), 121–50; R. Grigg, "Byzantine Credulity as an Impediment to Antiquarianism," *Gesta* 26 (1987), 3–9; A. Kazhdan and H. Maguire, "Byzantine Hagiographical Texts as Sources on Art," *Dumbarton Oaks Papers* 45 (1991), 1–22, esp. 1–9; E. Kitzinger, "Some Reflections on Portraiture in Byzantine Art," *Zbornik Radova Vizantološkog Instituta* 8 (1963), 185–93; J. Lowden, *Illuminated Prophet Books: A Study of Byzantine Manuscripts of the Major and Minor Prophets* (University Park, 1988), esp. 49–63; I. Spatharakis, *The Portrait in Byzantine Illuminated Manuscripts* (Leiden, 1976).

2. J. Noret, *Vitae duae antiquae S. Athanasii Athonitae* (Brussels, 1982), 122.

3. G. Galavaris, "The Portraits of St. Athanasius of Athos," *Byzantine Studies* 5 (1978), 96–124.

4. C. J. Stallman, "The *Life* of St. Pancratius of Taormina" (D.Phil. thesis, Oxford, 1986), I, 442.

5. J. O. Rosenqvist, *The Life of St. Irene, Abbess of Chrysobalanton* (Uppsala, 1986), 88–100.

6. A.M.J. Festugière, *Vie de Théodore de Sykéôn*, I (Brussels, 1970), 109–10.

7. D. F. Sullivan, *The Life of Saint Nikon* (Brookline, Mass., 1987), 44, 74, 154.

8. Ibid., 148–56.

9. PG 113, col. 425A.

10. *Acta SS*, Nov. IV, 699B–C.

11. *Antirrheticus* III; PG 100, col. 380B. See K. Parry, "Theodore Studites and the Patriarch Nicephoros on Image-Making as a Christian Imperative," *Byzantion* 59 (1989), 164–83, esp. 180.

12. PG 96, col. 352B.

13. *Homily on Gordios*; PG 31, col. 493A.

14. F. Drexl, *Achmetis oneirocriticon* (Leipzig, 1925), 106–107.

15. See Dagron, "Holy Images and Likeness," esp. 30–33.

16. PG 100, col. 1076B–D.

17. PG 105, col. 533C.

18. Rosenqvist, *Life of St. Irene*, 96.

19. F. Combefis, *Illustrium Christi martyrum lecti triumphi* (Paris, 1660), 276–78; M. Guidi, *Un Bios di Costantino* (Rome, 1908), 26–28; A. Kazhdan, "'Constantin imaginaire.' Byzantine Legends of the Ninth Century about Constantine the Great," *Byzantion* 57 (1987), 196–250, esp. 231–32.

20. F. Halkin, "Sainte Elisabeth d'Héraclée, abbesse à Constantinople," *Analecta bollandiana* 91 (1973), 261–62.

21. On this question, see especially: C. Mango, "Antique Statuary and the Byzantine Beholder," *Dumbarton Oaks Papers* 17 (1963), 55–75, esp. 64–67; R. Grigg, "Byzantine Credulity"; L. Brubaker, "Perception and Conception: Art, Theory and Culture in Ninth-century Byzantium," *Word and Image* 5, 1 (1989), 19–32, esp. 19–24; eadem, "Byzantine Art in the Ninth Century: Theory, Practice, and Culture," *Byzantine and Modern Greek Studies* 13 (1989), 23–93, esp. 80–81; H. Maguire, "Originality in Byzantine Art Criticism," in *Originality in Byzantine Literature, Art and Music*, ed. A. R. Littlewood (Oxford, 1995), pp. 101–14.

22. PG 111, col. 736A–C.

23. For an illuminating discussion of the princi-

ples upon which Byzantine portraits were con-
structed in art and literature, see the articles by
Dagron cited in note 1 above, especially "Holy
Images and Likeness," 26–27.

24. H. Delehaye, *Synaxarium ecclesiae Constanti-
nopolitanae*, in *Propylaeum ad Acta Sanctorum Novem-
bris* (Brussels, 1902), cols. 109–12.

25. PG 105, col. 536A.

26. On the portraits of St. Theodore in Byzan-
tine art, see L. Mavrodinova, "Saint Théodore,
évolution et particularités de son type icono-
graphique dans la peinture médiévale," *Bulletin de
l'Institut des Arts*, Académie Bulgare des Sciences,
13 (1969), 33–52.

27. *Acta SS*, Nov. IV, 52E–F.

28. PG 99, col. 313A.

29. PG 99, col. 216C.

30. D. Mouriki, "The Portraits of Theodore
Studites in Byzantine Art," *Jahrbuch der Österreichis-
chen Byzantinistik* 20 (1971), 249–80.

31. E. Schwartz, *Kyrillos von Skythopolis*
(Leipzig, 1939), 59; A.M.J. Festugière, *Les moines
d'Orient*, III, 1 (Paris, 1962), 113–14.

32. Schwartz, *Kyrillos von Skythopolis*, 20; Fes-
tugière, *Les moines d'Orient*, 73.

33. On monastic portraits in general, see S.
Tomeković, "Le 'Portrait' dans l'art byzantin:
exemple d'effigies de moines du Ménologe de
Basile II à Dečani," in *Dečani et l'art byzantin au
milieu du XIVe siècle*, ed. V. J. Djurić (Belgrade,
1989), 121–33.

34. On the three hierarchs, see H. Buchtal,
"Some Notes on Byzantine Hagiographical Portrai-
ture," *Gazette des Beaux-Arts* 62 (1963), 81–90; on
St. John Chrysostom, see O. Demus, "Two Palae-
ologan Mosaic Icons in the Dumbarton Oaks Col-
lection," *Dumbarton Oaks Papers* 14 (1960), 87–119,
esp. 110–19.

35. PG 116, col. 304A.

36. B. Leib, *Anne Comnène, Alexiade*, I (Paris,
1937), 111–12.

37. For a discussion of the type, see L. Hader-
mann-Misguich, *Kurbinovo. Les fresques de Saint-
Georges et la peinture byzantine du XIIe siècle* (Brus-
sels, 1975), 251–54.

38. *Acta SS*, Nov. IV, 235E.

39. S. A. Paschalides, *Ho Bios tēs hosiomyrobliti-
dos Theodōras tēs en Thessalonikē* (Thessaloniki,
1991), 74–76.

40. Ibid., 108.

41. Ibid., 152.

42. Ibid., 174. On the St. Sophia portrait, see S.
Pelekanidis, *Hellenika*, Supplement 9, 1 (1955), 404,
note 1, Fig. 83, 1.

43. D. Vojvodić, "The Cult and Iconography of
Saint Anastasia Pharmacolytria in Countries of
Byzantine Cultural Realm," (in Serbian) *Zograf* 21
(1990), 31–40, figs. 1–8.

44. On the attribute, see Hadermann-Misguich,
Kurbinovo, 235–40.

45. On underdrawings, see D. C. Winfield,
"Middle and Later Byzantine Wall Painting Meth-
ods. A Comparative Study," *Dumbarton Oaks Papers*
22 (1968), 61–139, esp. 80–96.

46. Sullivan, *Life of Saint Nikon*, 154.

47. Stallman, "Life of St. Pancratius," 11–12.

48. V. Laurent, "Une homélie inédite de
l'archevêque de Thessalonique Léon le Philosophe
sur l'Annonciation," *Studi e testi* 232 (1964), 301; R.
Cormack, "The Mosaic Decoration of St. Demetrios,
Thessaloniki: A Re-Examination in the Light of the
Drawings of W. S. George," *Annual of the British
School at Athens* 64 (1969), 17–52, esp. 50–51.

49. *Acta SS*, Nov. III, 886E–F.

50. A. Pamperis, *Logos dialambanōn ta peri tēs sys-
taseōs tou sebasmiou oikou tēs en Konstantinoupolei
Zōodochou Pegēs* (Leipzig, 1802), 53–54.

51. On the portrait type, see Hadermann-Mis-
guich, *Kurbinovo*, 243–45.

52. V. Laurent, *Les "Mémoires" du Grand
Ecclésiarque de l'Église de Constantinople Sylvestre
Syropoulos sur le concile de Florence (1438–1439)*
(Rome, 1971), 250; B. Zeitler, "Cross-cultural
Interpretations of Imagery in the Middle Ages,"
Art Bulletin 76 (1994), 680–94, esp. 680–82.

53. P. Bonifatius Kotter, *Die Schriften des
Johannes von Damaskos*, I (Berlin, 1969), 100–101.

Chapter 2

1. D. F. Sullivan, *The Life of Saint Nikon*
(Brookline, Mass., 1987), 154.

2. See D. Sheerin, "Lines and Colors: Painting
as Analogue to Typology in Greek Patristic Litera-
ture," *The 17th International Byzantine Congress,
Abstracts of Short Papers* (Washington, D.C., 1986),
317–18; H. L. Kessler, "Medieval Art as Argu-
ment," in *Iconography at the Crossroads*, ed. B. Cas-
sidy (Princeton, 1993), 59–70.

3. *Epistola* XLI; PG 77, col. 217C.

4. *De imaginibus oratio III*; PG 94, col. 1361D–1364A. The passage is a paraphrase of John Chrysostom, *In Epistolam ad Hebraeos, homilia XVII*; PG 63, col. 130.

5. A. Heikel, "Ignatii diaconi Vita Tarasii," *Acta Societatis Scientiarum Fennicae* 17 (1891), 416.

6. On the techniques of Byzantine painting, see D. C. Winfield, "Middle and Later Byzantine Wall Painting Methods. A Comparative Study," *Dumbarton Oaks Papers* 22 (1968), 61–139.

7. The following discussion builds upon the concept of "modes" in Byzantine art that was first proposed by Ernst Kitzinger and Kurt Weitzmann. See especially: E. Kitzinger, "On Some Icons of the Seventh Century," in *Late Classical and Mediaeval Studies in Honor of Albert Mathias Friend, Jr.*, ed. K. Weitzmann et al. (Princeton, 1955), 132–50, (repr. in E. Kitzinger, *The Art of Byzantium and the Medieval West* [Bloomington, 1976], no. 7); idem, "Byzantine Art in the Period between Justinian and Iconoclasm," *Berichte zum XI. Internationalen Byzantinisten-Kongress, München 1958* (Munich), 4,1 (1958), 1–50 (repr. in *The Art of Byzantium and the Medieval West*, no. 6); idem, *Byzantine Art in the Making: Main Lines of Stylistic Development in Mediterranean Art 3rd–7th Century* (Cambridge, Mass., 1977); K. Weitzmann, "The Classical in Byzantine Art as a Mode of Individual Expression," in *Byzantine Art, An European Art, Ninth Exhibition Held under the Auspices of the Council of Europe. Lectures* (Athens, 1966), 149–77, (repr. in idem, *Studies in Classical and Byzantine Manuscript Illumination* [Chicago, 1971]). See also H. Maguire, "Disembodiment and Corporality in Byzantine Images of the Saints," in *Iconography at the Crossroads*, ed. B. Cassidy (Princeton, 1993), 75–83.

8. On the iconography see, most recently, S.E.J. Gerstel, "Monumental Painting and Eucharistic Sacrifice in the Byzantine Sanctuary: The Example of Macedonia" (Ph.D. diss., New York University, 1993); eadem, "Liturgical Scrolls in the Byzantine Sanctuary," *Greek, Roman, and Byzantine Studies* 35 (1994), 195–204.

9. The distinctions were observed by O. Demus, *The Mosaics of Norman Sicily* (London, 1949), 230–31, pl. 64.

10. S. P. Lampros, "Ho Markianos kōdix 524," *Neos Hellēnomnēmōn* 8 (1911), 183.

11. *De divinis nominibus*, 3; PG 3, col. 681C–D.

12. W. Wright, *Journal of Sacred Literature* 6 (January, 1865), 419–48, and 7 (April, 1865), 129–60, esp. 131.

13. A monastic style was proposed by K. Weitzmann, "Byzantine Miniature and Icon Painting in the Eleventh Century," in *The Proceedings of the XIIIth International Congress of Byzantine Studies. Oxford. 5–10 September, 1966*, eds. J. M. Hussey, D. Obolensky, and S. Runciman (Oxford, 1967), 207–24, esp. 209–12 (repr. in idem, *Studies in Classical and Byzantine Manuscript Illumination* [Chicago, 1971], 271–313, esp. 271–81). Weitzmann postulated the creation of a general "abstract" style connected with the ideals of monastic asceticism in the second half of the eleventh century. In the following pages, however, we shall see how images of monks were differentiated from those of other saints *within* the style of a given period or painter, whether "abstract" or "classical."

14. Neophytos, *Laudatio Sancti Alypii Stylitae*; *Les saints stylites*, ed. H. Delehaye, Subsidia Hagiographica 14 (Brussels, 1923), 190.

15. Sullivan, *Life of Saint Nikon*, 66–74.

16. S. A. Paschalides, *Ho Bios tēs hosiomyroblytidos Theodōras tēs en Thessalonikē* (Thessaloniki, 1991), 114–26.

17. Sullivan, *Life of Saint Nikon*, 48.

18. Ibid., 78.

19. D. Z. Sophianos, *Hosios Loukas - Ho bios tou Hosiou Louka tou Steiriōtē* (Athens, 1989), 165.

20. Sullivan, *Life of Saint Nikon*, 106.

21. A. Papadopoulos-Kerameus, *Syllogē palaistinēs kai syriakēs hagiologias*, I (St. Petersburg, 1907), 214.

22. F. Halkin, "Sainte Elisabeth d'Héraclée, abbesse à Constantinople," *Analecta bollandiana* 91 (1973), 257.

23. Sullivan, *Life of Saint Nikon*, 56.

24. E. Miller, *Manuelis Philae carmina*, I (Paris, 1855), 387. The poem is one of a group devoted to the *Heavenly Ladder* of John Klimax.

25. On the career of St. Neophytos, see C. Galatariotou, *The Making of a Saint: The Life, Times, and Sanctification of Neophytos the Recluse* (Cambridge, 1991).

26. Miller, *Manuelis Philae carmina*, 460.

27. J. Bollig and P. de Lagarde, *Iohannis Euchaitorum Metropolitae quae in Codice Vaticano graeco 676 supersunt* (Göttingen, 1882), 11–12.

28. *Antirrheticus III*, 47 (PG 99, col. 412A); K. Parry, "Theodore Studites and the Patriarch Nicephoros on Image-making as a Christian Imperative," *Byzantion* 59 (1989) 164–83, esp. 176.

29. Bollig and de Lagarde, *Iohannis Euchaitorum Metropolitae quae in Cod. Vat. gr. 676 supersunt*, 3.

30. *Homilia XXXV*, 4; *Filagato da Cerami: Omelie per i vangeli domenicali e le feste di tutto l'anno*, I ed. G. Rossi Taibbi (Palermo, 1969), 240.

31. Hymn XV; *Syméon le Nouveau Théologien, hymnes*, I, eds. J. Koder and J. Paramelle, Sources chrétiennes 156 (Paris, 1969), 294.

32. PG 87, 3, col. 3705A.

33. Ibid., col. 3708D.

34. Ibid., col. 3721B.

35. Miller, *Manuelis Philae carmina*, I, 36.

36. A. Papadopoulos-Kerameus, "Epigrammata Ioannou tou Apokaukou," *Athena* 15 (1903), 476–77.

37. J. B. Aufhauser, *Miracula S. Georgii* (Leipzig, 1913), 8–12.

38. H. Delehaye, *Synaxarium ecclesiae Constantinopolitanae*, in *Propylaeum ad Acta Sanctorum Novembris* (Brussels, 1902), col. 627.

39. A. Atiya, Y. 'Abd al-Masīh, and O. Burmester, *History of the Patriarchs of the Egyptian Church, by Sawīrus Ibn al-Mukaffa bishop of al-Ašmūnīn*, II, Part 3 (Cairo, 1948), 226; cited by J. den Heijer, "Miraculous Icons and Their Historical Background," in *Coptic Art and Culture*, ed. H. Hondelink (Cairo, 1990), 94.

40. Atiya, 'Abd al-Masīh, and Burmester, *History of the Patriarchs of the Egyptian Church*, II, part 2, 77; cited by Heijer, "Miraculous Icons," 94.

41. Miller, *Manuelis Philae carmina*, I, 133.

42. R. Romano, *Nicola Callicle, Carmi* (Naples, 1980), 80.

43. E. Miller, "Poésies inédites de Théodore Prodrome," *Annuaire de l'Association pour l'encouragement des études grecques en France* 17 (1883), 46.

44. Miller, *Manuelis Philae carmina*, I, 80.

45. Ibid., 33.

46. Ibid., 33–34.

47. Ibid., 34.

48. Ibid., 36.

49. R. Browning, "An Unpublished Corpus of Byzantine Poems," *Byzantion* 33 (1963), 298.

50. Bollig and de Lagarde, *Iohannis Euchaitorum Metropolitae quae in Cod. Vat. gr. 676 supersunt*, 9.

51. Ibid.

52. Miller, *Manuelis Philae carmina*, I, 20.

53. *De Imaginibus oratio III*, 12; PG 94, col. 1333D.

54. *Homilia XXXIV*; *Leontos tou Sophou, Panēgyrikoi logoi*, ed. Akakios (Athens, 1868), 275–78; trans. by C. Mango, *The Art of the Byzantine Empire, 312–1453* (Englewood Cliffs, 1972), 205.

55. Miller, *Manuelis Philae carmina*, I, 18–21.

56. See R. Nelson, *The Iconography of Preface and Miniature in the Byzantine Gospel Book* (New York, 1980), 33.

57. H. F. von Soden, *Die Schriften des Neuen Testaments*, I, 1 (Göttingen, 1911), 382.

58. Miller, *Manuelis Philae carmina*, I, 19.

59. On the Virgin's role as an intercessor in art, see especially C. Walter, "Further Notes on the Deësis," *Revue des études byzantines* 28 (1970), 161–87; I. Kalavrezou, "Images of the Mother: When the Virgin Mary Became *Meter Theou*," *Dumbarton Oaks Papers* 44 (1990), 165–72; N. P. Ševčenko, "Close Encounters: Contact between Holy Figures and the Faithful as Represented in Byzantine Works of Art," in *Byzance et les images*, ed. J. Durand (Paris, 1994), 255–85.

60. Miller, *Manuelis Philae carmina*, I, 376; trans. by A.-M. Talbot, "Epigrams of Manuel Philes on the Theotokos tes Peges and its Art," *Dumbarton Oaks Papers* 48 (1994), 146.

61. G. A. Soteriou and M. G. Soteriou, *Hē Basilikē tou Hagiou Dēmētriou Thessalonikēs*, I (Athens, 1952), 195; II, pl. 66.

62. *Miniature della Bibbia Cod. Vat. Regin. greco I e del Salterio Cod. Vat. Palat. greco 381*, Collezione paleografica vaticana I (Milan, 1905), 5. The epigrams are discussed by T. F. Mathews, "The Epigrams of Leo Sacellarios and an Exegetical Approach to the Miniatures of Vat. Reg. gr. I," *Orientalia Christiana periodica* 43 (1977), 94–133.

63. *Miniature della Bibbia Cod. Vat. Regin. greco I*, 5; the miniature is discussed by Ševčenko, "Close Encounters," 264–66.

64. *Miniature della Bibbia Cod. Vat. Regin. greco I*, 5.

65. F. Halkin, "Saint Antoine le Jeune et Pétronas le vainqueur des Arabes en 863," *Analecta Bollandiana* 62 (1944), 217–18.

66. A. Papadopoulos-Kerameus, *Analekta hierosolymitikēs stachyologias*, IV (St. Petersburg), 324–25.

67. On the cult, see C. L. Connor, *Art and Miracles in Medieval Byzantium: The Crypt at Hosios Loukas and Its Frescoes* (Princeton, 1991).

68. I. Ševčenko and N. Ševčenko, *The Life of St. Nicholas of Sion* (Brookline, 1984), 52.

Chapter 3

1. See J.-C. Cheynet and C. Morrisson, "Texte et image sur les sceaux byzantins," in *Studies in Byzantine Sigillography*, IV, ed. N. Oikonomides (Washington, D. C., 1995), 9–32, esp. 9–10.

2. G. M. Browne et al., *The Oxyrhynchus Papyri*, XLI (London, 1972), 79; P. J. Sijpesteijn, *The Wisconsin Papyri*, II (Zutphen, 1977), 137–38; J. R. Rea, *The Oxyrhynchus Papyri*, XLVI (London, 1978), 99.

3. On the Eye and other motifs intended to ward off envy in the ancient world, see K.M.D. Dunbabin and M. W. Dickie, "*Invida rumpantur pectora*: The Iconography of Phthonos/Invidia in Graeco-Roman Art," *Jahrbuch für Antike und Christentum* 26 (1983), 7–37.

4. C. C. McCown, *The Testament of Solomon* (Leipzig, 1922), 58*.

5. R.P.H. Greenfield, *Traditions of Belief in Late Byzantine Demonology* (Amsterdam, 1988), 36–43. On demons in Byzantium, see also C. Mango, "Diabolus Byzantinus," *Dumbarton Oaks Papers* 46 (1992), 215–23.

6. *Acta SS*, Nov. IV, 240A–B.

7. *De individia*, 4; PG 31, col. 380C. See the discussion by M. W. Dickie, "The Fathers of the Church and the Evil Eye," in *Byzantine Magic*, ed. H. Maguire (Washington, D. C., 1995), 9–34.

8. P. van den Ven, "La vie grecque de S. Jean le Psichaïte," *Le Museon* 21 (1902), 123.

9. For a more extensive treatment of this topic, see H. Maguire, "From the Evil Eye to the Eye of Justice: The Saints, Art, and Justice in Byzantium," in *Law and Society in Byzantium, Ninth-Twelfth Centuries*, eds. A. E. Laiou and D. Simon (Washington, D. C., 1994), 217–39.

10. PG 98, cols. 641B–652C.

11. J. L. van Dieten, *Nicetae Choniatae historia*, I (Berlin, 1975), 110–13; trans. by H. J. Magoulias, *O City of Byzantium. Annals of Niketas Choniates* (Detroit, 1984), 63.

12. P. Lemerle, *Les plus anciens recueils des miracles de Saint Démétrius*, I (Paris, 1979), 61.

13. D. Z. Sophianos, *Hosios Loukas—Ho bios tou Hosiou Louka tou Steiriōtē* (Athens, 1989), 199–201.

14. G. Anrich, *Hagios Nikolaos*, I (Leipzig, 1913), 23–27 (*Vita Nicolai Sionitae*), 243–44 (*Vita per Metaphrasten*), 303–304 (*Vita Lycio-Alexandrina*), 400–401 (*Encomium Neophyti*).

15. For a discussion of the iconography, see N. P. Ševčenko, *The Life of Saint Nicholas in Byzantine Art* (Turin, 1983), 95.

16. V. Laurent, *La vita retractata et les miracles posthumes de Saint Pierre d'Atroa*, Subsidia Hagiographica 31 (Brussels, 1958), 159.

17. *Epistola XIII*; Jean Chrysostome, *Lettres à Olympias*, ed. A. M. Malingrey, Sources chrétiennes 13 (Paris, 1968), 330.

18. Ibid., 308.

19. *Theodori Studitae epistulae*, II, ed. G. Fatouros (Berlin, 1992), 544.

20. Van Dieten, *Nicetae Choniatae historia*, I, 113; translation after Magoulias, *O City of Byzantium*, 64.

21. A. Stylianou and J. Stylianou, *The Painted Churches of Cyprus* (London, 1985), 486, fig. 294; A. W. Carr and L. J. Morrocco, *A Byzantine Masterpiece Recovered, The Thirteenth-Century Murals of Lysi, Cyprus* (Austin, 1991), 54, pl. 15, fig. 16.

22. Trans. by G. Downey; "Nikolaos Mesarites: Description of the Church of the Holy Apostles at Constantinople," *Transactions of the American Philosophical Society*, n.s. 47, 6 (1957), 901.

23. J. A. Cramer, *Anecdota graeca*, IV (Oxford, 1841), 290.

24. On magic and art in the early Byzantine period, see E. Kitzinger, "The Cult of Images in the Age before Iconoclasm," *Dumbarton Oaks Papers* 8 (1954), 81–150 (repr. in E. Kitzinger, *The Art of Byzantium and the Medieval West* [Bloomington, 1976], 90–156); J. Engeman, "Zur Verbreitung magischer Übelabwehr in der nichtchristlichen und christlichen Spätantike," *Jahrbuch für Antike und Christentum* 18 (1975), 22–48; G. Vikan, "Art, Medicine, and Magic in Early Byzantium," *Dumbarton Oaks Papers* 38 (1984), 65–86; E. D. Maguire et al., *Art and Holy Powers in the Early Christian House* (Urbana, 1989); H. Maguire, "Garments Pleasing to God: The Significance of Domestic Textile Designs in the Early Byzantine Period," *Dumbarton Oaks Papers* 44 (1990), 215–24; A. Stauffer, *Spätantike und koptische Wirkereien* (Bern, 1992), esp. 19–22; H. Maguire, "Magic and the Christian Image," in *Byzantine Magic*, ed. H. Maguire (Washington, D.C., 1995), 51–71.

25. On this question, see S. J. Tambiah, *Magic, Science, Religion, and the Scope of Rationality* (Cambridge, 1990). For the early Byzantine period, a particularly useful discussion is found in D. E. Aune, "Magic in Early Christianity," in *Aufstieg und Niedergang der römischen Welt*, II/23, 2, ed. W. Haase (Berlin, 1980), 1507–57, esp. 1510–16.

26. R. W. Daniel and F. Maltomini, *Supplementum Magicum*, I, Papyrologica coloniensia 16, 1 (Opladen, 1990), 23–24.

27. On repeating letters see, in general, F. Dornseiff, *Das Alphabet in Mystik und Magie* (Berlin, 1925). For repeating ring-signs and crosses, see Daniel and Maltomini, *Supplementum Magicum*, I, 74–75, 102–103.

28. R. W. Daniel, *Two Greek Magical Papyri in the National Museum of Antiquities in Leiden* (Opladen, 1991), 70, fig. on p. 71.

29. Daniel and Maltomini, *Supplementum Magicum*, I, 39–40.

30. Ibid., 50.

31. On "iconographically anonymous" images in early Christian art, see G. Vikan, "Early Byzantine Pilgrimage *Devotionalia* as Evidence of the Appearance of Pilgrimage Shrines," in *PEREGRINATIO: Pilgerreise und Pilgerziel. Akten des 12. Internationalen Kongresses für Christliche Archäologie, Bonn, 1991, Jarbuch für Antike und Christentum*, Ergänzungsband (1993) (forthcoming).

32. C. Bonner, *Studies in Magical Amulets, Chiefly Graeco-Egyptian* (Ann Arbor, 1950), 307.

33. Ibid., 309.

34. P. Perdrizet, *Negotium perambulans in tenebris: études de démonologie gréco-orientale* (Strasbourg, 1922), 27, fig. 7.

35. Bonner, *Studies in Magical Amulets*, 307.

36. *Homilia I*; PG 40, cols. 165–168.

37. *De providentia oratio IV*; PG 83, cols. 617D–620A.

38. *Naturalis historia*, 37.124.

39. See A. F. Kendrick, *Victoria and Albert Museum: Catalogue of Textiles from Burying-Grounds in Egypt*, III (London, 1922), 81, pl. 25 (identification as St. Michael); M. Martiniani-Reber, *Lyon, Musée historique des tissus, soieries sassanides, coptes, et byzantines, Ve–XIe siècles* (Paris, 1986), 91–93 (Christ); A. Gonosová, in *Beyond the Pharaohs*, ed. F. D. Friedman, exh. cat., Rhode Island School of Design (Providence, 1989), 218 (St. George).

40. *De providentia oratio IV*; PG 83, cols. 617D–620A.

41. On tapestry weaves imitating silks, see Gonosová, "Textiles," in *Beyond the Pharaohs*, 65–72, esp. 72.

42. On the "untidiness" of pre-iconoclastic icons, see P. Brown, "A Dark-Age Crisis: Aspects of the Iconoclastic Controversy," *English Historical Review* 88 (1973), 1–34, esp. 23.

43. *Homilia I*; PG 40, col. 168A. Trans. by C. Mango, *The Art of the Byzantine Empire, 312–1453*

(Toronto, 1986), 51. See also T. K. Thomas, *Textiles from Medieval Egypt, A.D. 300–1300* (Pittsburgh, 1990), 20.

44. F. Halkin, *Euphémie de Chalcédoine* (Brussels, 1965), 4–8.

45. See M. T. Fögen, "Balsamon on Magic: From Roman Secular Law to Byzantine Canon Law," in *Byzantine Magic*, ed. H. Maguire (Washington, D. C., 1995), 99–115, esp. 105–108.

46. *Ad illuminandos catechesis II*, 5 (PG 49, col. 240); *In epistolam ad Colossenses cap. III homilia VIII*, 5 (PG 62, col. 358).

47. *In epistolam I ad Corinthios homilia XII*, 7; PG 61, col. 106.

48. *Homilia I*; PG 40, col. 168B–C.

49. *In Matheum 23*, 5–7; PL 26, col. 175.

50. On the inadmissibility of ambiguous images, see G. Dagron, "L'image de culte et le portrait," in *Byzance et les images*, ed. J. Durand (Paris, 1994), 121–50, esp. 144.

51. *In epistolam I ad Corinthios homilia XII*, 7; PG 61, col. 106.

52. Ibid., col. 105.

53. *In epistolam ad Colossenses cap. III homilia VIII*, 5; PG 62, col. 358.

54. S. N. Schoinas, *Nikodēmou Hagioreitou Biblos Barsanouphiou kai Ioannou* (Volos, 1960), 214. See also P. Brown, *The Rise of Western Christendom* (Oxford, 1996), 249.

55. Lemerle, *Les plus anciens recueils des miracles de Saint Démétrius*, I, 61; Greenfield, *Traditions of Belief in Late Byzantine Demonology*, 277, note 952.

56. *Ad illuminandos catechesis II*, 5; PG 49, col. 240.

57. J.-A. Bruhn, *Coins and Costume in Late Antiquity* (Washington, D. C., 1993), 45–46.

58. PG III, 777C–784A.

59. Marcellus Empiricus, *De medicamentis liber*, 10.70; *Marcellus über Heilmittel*, eds. M. Niedermann and E. Liechtenhan, Corpus medicorum latinorum 5 (Berlin, 1968), 200.

60. P. J. Alexander, "The Iconoclastic Council of St. Sophia (815) and its Definition (*Horos*)," *Dumbarton Oaks Papers* 7 (1953), 43, 60.

61. *De Spiritu sancto*, 18; PG 32, col. 149C.

62. For a general discussion of the problem, see D. Freedberg, *The Power of Images: Studies in the History and Theory of Response* (Chicago, 1989), esp. 378–428.

63. Halkin, *Euphémie de Chalcédoine*, 96.

64. L. Deubner, *Kosmas und Damian* (Leipzig and Berlin, 1907), 137–38; J. D. Mansi, *Sacrorum*

conciliorum nova et amplissima collectio, XIII (Florence, 1767), col. 68. The story is discussed by Kitzinger, "The Cult of Images in the Age before Iconoclasm," esp. 107, note 89, and 147–48, and by L. Brubaker, "The Sacred Image," in *The Sacred Image East and West*, eds. R. Ousterhout and L. Brubaker (Urbana, 1995), 1–24, esp. 7.

65. *Antirrheticus III*, 3; PG 99, col. 421A.

66. S. A. Paschalides, *Ho Bios tēs hosiomyroblytidos Theodōras tēs en Thessalonikē* (Thessaloniki, 1991), 90–92; trans. by A.-M. Talbot in *Holy Women of Byzantium: Ten Saints' Lives in English Translation* (Washington, D. C., 1995).

67. J. O. Rosenqvist, *The Life of St. Irene, Abbess of Chrysobalanton* (Uppsala, 1986), 88–100.

68. *Acta SS*, Iul. III, col. 552B.

69. For further discussion of later iconodule theory, which stressed that the icon did not have an essential relationship with the prototype, see C. Barber, "From Transformation to Desire: Art and Worship after Byzantine Iconoclasm," *Art Bulletin* 75 (1993), 7–16, and idem, "From Image into Art: Art after Byzantine Iconoclasm," *Gesta* 34, 1 (1995), 5–10.

70. Mansi, *Sacrorum conciliorum nova et amplissima collectio*, XIII, col. 328; trans. in S. Gero, *Byzantine Iconoclasm during the Reign of Constantine V* (Louvain, 1977), 86.

71. Mansi, *Sacrorum conciliorum nova et amplissima collectio*, XIII, cols. 329–32; Gero, *Byzantine Iconoclasm*, 87.

72. Summary in H. Delehaye, *Synaxarium ecclesiae Constantinopolitanae*, in *Propylaeum ad Acta Sanctorum Novembris* (Brussels, 1902), col. 850.

73. L. Duchesne, *Le Liber pontificalis*, II (Paris, 1892), 2, 146; see also M. Martiniani-Reber, "Textiles," in *Byzance*, exh. cat., Musée du Louvre (Paris, 1992), 192, 371.

74. Mansi, *Sacrorum conciliorum nova et amplissima collectio*, XIII, col. 244 B; trans. in D. J. Sahas, *Icon and Logos: Sources in Eighth-Century Iconoclasm* (Toronto, 1986), 77.

Chapter 4

1. M. Aubineau, *Les homélies festales d'Hésychius de Jérusalem*, II (Brussels, 1980), 817–18.

2. For a discussion of modes of narration in western depictions of saints' Lives, see C. Hahn, "Picturing the Text: Narrative in the *Life* of the Saints," *Art History* 13, 1 (1990), 1–33.

3. M. C. Ross, *Catalogue of the Byzantine and Early Mediaeval Antiquities in the Dumbarton Oaks Collection*, II, *Jewelry, Enamels, and Art of the Migration Period* (Washington, D.C., 1965), 58–59.

4. Ibid.

5. G. Vikan, "Art, Medicine, and Magic in Early Byzantium," *Dumbarton Oaks Papers* 38 (1984), 65–86, esp. 76–83; idem, "Art and Marriage in Early Byzantium," *Dumbarton Oaks Papers* 44 (1990), 145–63, esp. 160–61.

6. C. C. McCown, *The Testament of Solomon* (Leipzig, 1922), 53★, 55★–6★.

7. E. Kitzinger, "Reflections on the Feast Cycle in Byzantine Art," *Cahiers Archéologiques* 36 (1988), 51–73, esp. 61–62.

8. J. Bollig and P. de Lagarde, *Iohannis Euchaitorum Metropolitae quae in Codice Vaticano graeco 676 supersunt* (Göttingen, 1882), 2.

9. On the iconography of the infancy of the Virgin, see J. Lafontaine-Dosogne, *Iconographie de l'enfance de la Vierge dans l'Empire byzantin et en Occident* (Brussels, 1992).

10. *Protevangelium*, I,1–IV,2.

11. *De cerimoniis*, II, 15; PG 112, col. 1049B–C.

12. *De cerimoniis*, II, 21; PG 112, cols. 1149B–1152A.

13. *Protevangelium*, VII,2–VIII,1.

14. George of Nicomedia, *Oratio VII, in sanctissimae Dei Genitricis Ingressum in templum*; PG 100, col. 1448A.

15. Ibid., col. 1446A.

16. *Oratio III, in Conceptionem ac Nativitatem sanctissimae Dominae nostrae Dei Genitricis semper virginis Mariae*; PG 100, cols. 1396D–1397A.

17. *Oratio I, in Beatae Mariae Nativitatem*; PG 107, cols. 1D–4A.

18. *Protevangelium*, II,3–IV,1.

19. J. C. Anderson, "The Illustrated Sermons of James the Monk: Their Dates, Order, and Place in the History of Byzantine Art," *Viator* 22 (1991), 69–120; I. Hutter and P. Canart, *Das Marienhomiliar des Mönchs Jakobos von Kokkinobaphos, Codex Vaticanus Graecus 1162*, Codices e vaticanis selecti 79 (Zürich, 1991).

20. *Oratio in Conceptionem sanctissimae Deiparae*; PG 127, col. 560A–B.

21. *Oratio in Annuntiationem sanctissimae Deiparae*; PG 127, col. 640C–D.

22. Ibid., cols. 644A–645A.

23. Ibid., cols. 645B–648C.

24. Ibid., cols. 649D–652C.

25. Ibid., cols. 652C–653A.

26. *Laudatio Marciani I*, 51–52; *Choricii Gazaei Opera*, eds. R. Foerster and E. Richsteig, (Leipzig, 1929), 16; trans. by C. Mango, *The Art of the Byzantine Empire, 312–1453* (Toronto, 1986), 65.

27. *Descriptio terrae sanctae*, PG 133, col. 957D.

28. The fundamental study of St. Nicholas narratives in Byzantine art is N. P. Ševčenko, *The Life of St. Nicholas in Byzantine Art* (Turin, 1983). See also H. Maguire, "From the Evil Eye to the Eye of Justice: The Saints, Art, and Justice in Byzantium," in *Law and Society in Byzantium, 9th–12th Centuries*, eds. A. Laiou and D. Simon (Washington, D. C., 1994), 217–39, esp. 227–38; idem, "Two Modes of Narration in Byzantine Art," in *Byzantine East, Latin West: Art-Historical Studies in Memory of Kurt Weitzmann*, eds. C. Moss and K. Kiefer (Princeton, 1995), 385–91.

29. E. Miller, *Manuelis Philae carmina*, I (Paris, 1855), 79.

30. See Ševčenko, *The Life of St. Nicholas in Byzantine Art*, 161–62, 172–73; Maguire, "From the Evil Eye to the Eye of Justice," esp. 235–38.

31. A. Dmitrievskij, *Opisanie liturgičeskih rukopisej*, I (Kiev and St. Petersburg, 1895), 332. On the Evergetis Monastery, see *The Theotokos Evergetis and Eleventh-century Monasticism*, ed. M. Mullett and A. Kirby (Belfast, 1994).

32. On the influence of the Evergetis Monastery on other foundations, see J. P. Thomas, "Documentary Evidence from the Byzantine Monastic *Typika* for the History of the Evergetine Reform Movement," in *The Theotokos Evergetis and Eleventh-century Monasticism*, 246–73.

33. S. Eustratiades, "Typikon tēs Monēs tou hagiou megalomartyros Mamantos," *Hellenika* I (1928), 297.

34. G. Anrich, *Hagios Nikolaos*, I (Leipzig, 1913), 235.

35. Ibid., I, 252–54.

36. Ibid., I, 255–58.

37. Ibid., I, 258–62.

38. Ibid., I, 118–23 (*Vita per Michaëlem*), 157–58 (*Encomium Methodii*), 221–23 (*Vita compilata*), 239–42 (*Vita per Metaphrasten*), 395–96 (*Encomium Neophyti*), II, 550–52 (*Methodius ad Theodorum*).

39. Ibid., I, 12–16 (*Vita Nicolai Sionitae*), 304–305 (*Vita Lycio-Alexandrina*), 396–97 (*Encomium Neophyti*).

40. Miller, *Manuelis Philae carmina*, II, 421.

41. See the discussions by H. Belting, "An Image and its Function in the Liturgy: The Man of Sorrows in Byzantium," *Dumbarton Oaks Papers* 34–35 (1980–81), 1–16; idem *The Image and Its Public in the Middle Ages* (New York, 1990), esp. 91–129.

42. *Epistula LIII*; *The Correspondence of Athanasius I Patriarch of Constantinople*, ed. and trans. by A.-M. Talbot (Washington, D.C., 1975), 120; Belting, *The Image and its Public*, 101.

43. *Epistula LXXI*; *The Correspondence of Athanasius I*, 178; Belting, *The Image and its Public*, 101–102.

44. Miller, *Manuelis Philae carmina*, I, 290–91.

45. Ševčenko, *The Life of St. Nicholas in Byzantine Art*, 87.

46. Ibid., 109.

47. Ibid., 91.

48. Ibid.

49. The visual lives are surveyed by T. Mark-Weiner, "Narrative Cycles of the Life of St. George in Byzantine Art," (Ph.D. diss., New York University, 1977).

50. K. Krumbacher, *Der heilige Georg in der griechischen Überlieferung* (Munich, 1911), 46 ("Normal" text); PG 115, cols. 149D–152A (Symeon Metaphrastes).

51. Krumbacher, *Der heilige Georg*, 51 ("Normal" text), 77 (Theodore Daphnopates).

52. For a more extensive discussion of these juxtapositions, see H. Maguire, "Art of Comparing in Byzantium," *Art Bulletin* 70 (1988), 88–103, esp. 94–99.

53. Krumbacher, *Der heilige Georg*, 45 ("Normal" text); PG 115, col. 149A (Symeon Metaphrastes).

54. Krumbacher, *Der heilige Georg*, 46 ("Normal" text).

55. Ibid., 80.

56. A. K. Orlandos, *Byzantina mnēmeia tēs Kastorias* (Athens, 1939), 56; partly revised text in S. Pelekanidis and M. Chatzidakis, *Kastoria* (Athens, 1985), 39.

57. PG 115, col. 152B.

58. Ibid., col. 161A.

CHAPTER BIBLIOGRAPHIES

Chapter 1

Belting, H. *Likeness and Presence: A History of the Image before the Era of Art.* Chicago, 1994.

Brubaker, L. "Byzantine Art in the Ninth Century: Theory, Practice, and Culture." *Byzantine and Modern Greek Studies* 13 (1989): 23–93.

———. "Perception and Conception: Art, Theory and Culture in Ninth-century Byzantium." *Word and Image* 5, 1 (1989): 19–32.

Buchtal, H. "Some Notes on Byzantine Hagiographical Portraiture." *Gazette des Beaux-Arts* 62 (1963): 81–90.

Cameron, A. "The Language of Images: The Rise of Icons and Christian Representation." In *The Church and the Arts*, ed. D. Wood, 1–42. Oxford, 1992 (= *Studies in Church History* 28).

Cormack, R. "The Mosaic Decoration of St. Demetrios, Thessaloniki: A Re-Examination in the Light of the Drawings of W.S. George." *Annual of the British School at Athens* 64 (1969): 17–52.

Dagron, G. "Holy Images and Likeness." *Dumbarton Oaks Papers* 45 (1991): 23–33.

———. "Le culte des images dans le monde byzantin." In *Histoire vécue du peuple chrétien*, I, ed. J. Delumeau, 133–60. Toulouse, 1979. Reprinted in G. Dagron, *La romanité chrétienne en Orient*, London, 1984.

———. "L'image de culte et le portrait." In *Byzance et les images*, ed. J. Durand, 121–50. Paris, 1994.

———. "L'ombre d'un doute: L'hagiographie en question, VIe–XIe siècle." *Dumbarton Oaks Papers* 46 (1992): 59–68.

Demus, O. "Two Palaeologan Mosaic Icons in the Dumbarton Oaks Collection." *Dumbarton Oaks Papers* 14 (1960): 87–119.

Galavaris, G. "The Portraits of St. Athanasius of Athos." *Byzantine Studies* 5 (1978): 96–124.

Grigg, R. "Byzantine Credulity as an Impediment to Antiquarianism." *Gesta* 26 (1987): 3–9.

Hadermann-Misguich, L. *Kurbinovo. Les fresques de Saint-Georges et la peinture byzantine du XIIe siècle.* Brussels, 1975.

Kazhdan, A. "'Constantin imaginaire': Byzantine Legends of the Ninth Century about Constantine the Great." *Byzantion* 57 (1987): 196–250.

Kazhdan, A., and H. Maguire. "Byzantine Hagiographical Texts as Sources on Art." *Dumbarton Oaks Papers* 45 (1991): 1–22.

Kitzinger, E. "Some Reflections on Portraiture in Byzantine Art." *Zbornik Radova Vizantološkog Instituta* 8 (1963): 185–93.

Lowden, J. *Illuminated Prophet Books: A Study of Byzantine Manuscripts of the Major and Minor Prophets.* University Park, 1988.

Mavrodinova, L. "Saint Théodore, évolution et particularités de son type iconographique dans la peinture médiévale." *Bulletin de l'Institut des Arts,* Académie Bulgare des Sciences 13 (1969): 33–52.

Mouriki, D. "The Portraits of Theodore Studites in Byzantine Art." *Jahrbuch der Österreichischen Byzantinistik* 20 (1971): 249–80.

Parry, K. "Theodore Studites and the Patriarch Nicephoros on Image-Making as a Christian Imperative." *Byzantion* 59 (1989): 164–183.

Spatharakis, I. *The Portrait in Byzantine Illuminated Manuscripts.* Leiden, 1976.

Tomeković, S. "Le 'Portrait' dans l'art byzan-

tin: exemple d'effigies de moines du Ménologue de Basile II à Dečani." in *Dečani et l'art byzantin au milieu du XIVe siècle*, ed. V. Djurić, 121–133. Belgrade, 1989.

Winfield, D. C. "Middle and Later Byzantine Wall Painting Methods. A Comparative Study." *Dumbarton Oaks Papers* 22 (1968): 61–139.

Zeitler, B. "Cross-cultural Interpretations of Imagery in the Middle Ages." *Art Bulletin* 76 (1994): 680–94.

Chapter 2

Connor, C. L. *Art and Miracles in Medieval Byzantium: The Crypt at Hosios Loukas and Its Frescoes*. Princeton, 1991.

Demus, O. *The Mosaics of Norman Sicily*. London, 1949.

Galatariotou, C. *The Making of a Saint: The Life, Times, and Sanctification of Neophytos the Recluse*. Cambridge, 1991.

Heijer, J. den. "Miraculous Icons and Their Historical Background." In *Coptic Art and Culture*, ed. H. Hondelink, 89–100. Cairo, 1990.

Kessler, H. L. "Medieval Art as Argument." In *Iconography at the Crossroads*, ed. B. Cassidy, 59–70. Princeton, 1993.

Kitzinger, E. *Byzantine Art in the Making: Main Lines of Stylistic Development in Mediterranean Art, 3rd–7th Century*. Cambridge, Mass., 1977.

———. "Byzantine Art in the Period between Justinian and Iconoclasm." *Berichte zum XI. Internationalen Byzantinisten-Kongress, München 1958* (Munich), 4,1 (1958): 1–50. Reprinted in E. Kitzinger, *The Art of Byzantium and the Medieval West*, Bloomington, 1976.

———. "On Some Icons of the Seventh Century." In *Late Classical and Mediaeval Studies in Honor of Albert Mathias Friend, Jr.*,

ed. K. Weitzmann et al., 132–50. Princeton, 1955. Reprinted in E. Kitzinger, *The Art of Byzantium and the Medieval West*, Bloomington, 1976.

Maguire, H. "Disembodiment and Corporality in Byzantine Images of the Saints." In *Iconography at the Crossroads*, ed. B. Cassidy 75–83. Princeton, 1993.

Nelson, R. *The Iconography of Preface and Miniature in the Byzantine Gospel Book*. New York, 1980.

Parry, K. "Theodore Studites and the Patriarch Nicephoros on Image-Making as a Christian Imperative." *Byzantion* 59 (1989): 164–83.

Sheerin, D. "Lines and Colors: Painting as Analogue to Typology in Greek Patristic Literature." In *The 17th International Byzantine Congress, Abstracts of Short Papers*, 317–18. Washington, D.C., 1986.

Talbot, A.-M. "Epigrams of Manuel Philes on the Theotokos tes Peges and Its Art." *Dumbarton Oaks Papers* 48 (1994): 135–65.

Walter, C. "Further Notes on the Deësis." *Revue des études byzantines* 28 (1970): 161–87.

Weitzmann, K. "The Classical in Byzantine Art as a Mode of Individual Expression." In *Byzantine Art, An European Art, Ninth Exhibition Held under the Auspices of the Council of Europe. Lectures*, 149–77. Athens, 1966. Reprinted in K. Weitzmann, *Studies in Classical and Byzantine Manuscript Illumination*, Chicago, 1971.

Winfield, D. C. "Middle and Later Byzantine Wall Painting Methods. A Comparative Study." *Dumbarton Oaks Papers* 22 (1968): 61–139.

Chapter 3

Barber, C. "From Transformation to Desire: Art and Worship after Byzantine Iconoclasm." *Art Bulletin* 75 (1993): 7–16.

Bonner, C. *Studies in Magical Amulets, Chiefly Graeco-Egyptian*. Ann Arbor, 1950.

Brown, P. "A Dark-Age Crisis: Aspects of the Iconoclastic Controversy." *English Historical Review* 88 (1973): 1–34.

Bruhn, J.-A. *Coins and Costume in Late Antiquity*. Washington, D. C., 1993.

Carr, A. W., and L. J. Morrocco. *A Byzantine Masterpiece Recovered. The Thirteenth-Century Murals of Lysi, Cyprus*. Austin, 1991.

Dornseiff, F. *Das Alphabet in Mystik und Magie*. Berlin, 1925.

Dunbabin, K.M.D., and M. W. Dickie. "*Invida rumpantur pectora*: The Iconography of Phthonos-Invidia in Graeco-Roman Art." *Jahruch für Antike und Christentum* 26 (1983): 7–37.

Engeman, J. "Zur Verbreitung magischer Übelabwehr in der nichtchristlichen und christlichen Spätantike." *Jahrbuch für Antike und Christentum* 18 (1975): 22–48.

Freedberg, D. *The Power of Images: Studies in the History and Theory of Response*. Chicago, 1989.

Gero, S. *Byzantine Iconoclasm during the Reign of Constantine V*. Louvain, 1977.

Gonosová, A. "Textiles." In *Beyond the Pharaohs: Egypt and the Copts in the 2nd to 7th Centuries A.D.*, exh. cat., Rhode Island School of Design, ed. F. D. Friedman, 65–72. Providence, 1989.

Greenfield, R.P.H. *Traditions of Belief in Late Byzantine Demonology*. Amsterdam, 1988.

Kitzinger, E. "The Cult of Images in the Age before Iconoclasm." *Dumbarton Oaks Papers* 8 (1954): 81–150. Reprinted in E. Kitzinger, *The Art of Byzantium and the Medieval West*, Bloomington, 1976.

Maguire, E. D., et al. *Art and Holy Powers in the Early Christian House*. Urbana, 1989.

Maguire, H. "From the Evil Eye to the Eye of Justice: The Saints, Art, and Justice in Byzantium." In *Law and Society in Byzantium, Ninth-Twelfth Centuries*, eds. A. Laiou and D. Simon, 217–39. Washington, D.C., 1994.

———. "Garments Pleasing to God: The Significance of Domestic Textile Designs in the Early Byzantine Period." *Dumbarton Oaks Papers* 44 (1990): 215–224.

———, ed. *Byzantine Magic*. Washington, 1995.

Mango, C. "Diabolus Byzantinus." *Dumbarton Oaks Papers* 46 (1992): 215–23.

Martiniani-Reber, M. "Textiles." In *Byzance*, exh. cat., Louvre, 148–51, 192, 370–73, 486. Paris, 1992.

Ousterhout, R., and L. Brubaker, eds. *The Sacred Image East and West*. Urbana, 1995.

Perdrizet, P. *Negotium perambulans in tenebris: études de démonologie gréco-orientale*. Strasbourg, 1922.

Stauffer, A. *Spätantike und koptische Wirkereien: Untersuchungen zur ikonographischen Tradition in spätantiken und frühmittelalterlichen Textilwerkstätten*. Bern, 1992.

Tambiah, S. J. *Magic, Science, Religion, and the Scope of Rationality*. Cambridge, 1990.

Thomas, T. K. *Textiles from Medieval Egypt. A.D. 300–1300*. Pittsburgh, 1990.

Vikan, G. "Art, Medicine, and Magic in Early Byzantium." *Dumbarton Oaks Papers* 38 (1984): 65–86.

———. "Early Byzantine Pilgrimage *Devotionalia* as Evidence of the Appearance of Pilgrimage Shrines." In PEREGRINATIO: *Pilgerreise und Pilgerziel. Akten des 12. Internationalen Kongresses für Christliche Archäologie, Bonn, 1991. Jahrbuch für Antike und Christentum*, Ergänzungsband (1993).

Chapter 4

Anderson, J. C. "The Illustrated Sermons of James the Monk: Their Dates, Order, and Place in the History of Byzantine Art." *Viator* 22 (1991): 69–120.

Belting, H. "An Image and Its Function in

the Liturgy: The Man of Sorrows in Byzantium." *Dumbarton Oaks Papers* 34–35 (1980–81): 1–16.

———. *The Image and its Public in the Middle Ages*. New York, 1990.

Hahn, C. "Picturing the Text: Narrative in the *Life* of the Saints." *Art History* 13, 1 (1990): 1–33.

Hutter, I., and P. Canart. *Das Marienhomiliar des Mönchs Jakobos von Kokkinobaphos, Codex Vaticanus Graecus 1162*. Codices e vaticanis selecti 79. Zürich, 1991.

Kitzinger, E. "Reflections on the Feast Cycle in Byzantine Art." *Cahiers archéologiques* 36 (1988): 51–73.

Lafontaine-Dosogne, J. *Iconographie de l'enfance de la Vierge dans l'Empire byzantin et en Occident*. Brussels, 1992.

Maguire, H. "The Art of Comparing in Byzantium." *Art Bulletin* 70 (1988): 88–103.

———. "From the Evil Eye to the Eye of Justice: The Saints, Art, and Justice in Byzantium." In *Law and Society in Byzantium, Ninth-Twelfth Centuries*, eds. A. Laiou and D. Simon, 217–39. Washington, D. C., 1994.

———. "Two Modes of Narration in Byzantine Art." In *Byzantine East, Latin West: Art-Historical Studies in Memory of Kurt Weitzmann*, eds. C. Moss and K. Kiefer, 385–91. Princeton, 1995.

Mark-Weiner, T. "Narrative Cycles of the Life of St. George in Byzantine Art." Ph. D. diss., New York University, 1977.

Ševčenko, N. *The Life of Saint Nicholas in Byzantine Art*. Turin, 1983.

Vikan, G. "Art and Marriage in Early Byzantium." *Dumbarton Oaks Papers* 44 (1990): 145–63.

———. "Art, Medicine, and Magic in Early Byzantium." *Dumbarton Oaks Papers* 38 (1984): 65–86.

SAINTS' LIVES IN TRANSLATION

EXCERPTS AND COLLECTED LIVES

Mango, C. *The Art of the Byzantine Empire
312–1453*. Englewood Cliffs, 1972.
Reprinted Toronto, 1986.

Talbot, A.-M., ed. *Holy Women of Byzantium:
Ten Saints' Lives in English Translation*.
Washington, D.C., 1995.

———. *Byzantine Defenders of Images: Seven
Saints' Lives in English Translations*.
Washington, D.C., 1997.

INDIVIDUAL LIVES

ANDREW THE FOOL. Cesaretti, P. In *I
Santi Folli di Bisanzio*, 99–257. Milan, 1990.
Ryden, L. *The Life of Andrew the Fool*, 2
vols. Uppsala, 1995.

EUTHYMIOS THE GREAT. Festugière,
A. J. In *Les moines de Palestine*, 55–144.

Paris, 1962. Price, R. M. In *Cyril of
Scythopolis: The Lives of the Monks of
Palestine*, 1–92. Kalamazoo, 1991.

IRENE OF CHRYSOBALANTON.
Rosenqvist, J. O. *The Life of St. Irene,
Abbess of Chrysobalanton*. Uppsala, 1986.

LUKE THE YOUNGER OF STIRIS,
Connor, C. L., and W. R. Connor. *The
Life and Miracles of Saint Luke of Steiris*.
Brookline, Mass., 1994.

NICHOLAS OF SION. Ševčenko, I., and
N. P. Ševčenko. *The Life of Saint Nicholas of
Sion*. Brookline, Mass., 1984.

NIKON OF SPARTA. Sullivan, D. F. *The
Life of Saint Nikon*. Brookline, Mass., 1987.

THEODORE OF SYKEON. Festugière,
A.M.J. *Vie de Théodore de Sykéon*. 2 vols.
Brussels, 1970. Dawes, E., and N. Baynes.
In *Three Byzantine Saints*, 88–192 (partial
translation). Crestwood, N.Y., 1977.